D0791820

The Mammoth Book of Street Art

Edited by

WITHDRAWN

ROBINSON

RUNNING PRESS
PHILADELPHIA · LONDON

Constable & Robinson Ltd
55–56 Russell Square, London WC1B 4HP
www.constablerobinson.com

Running Press Book Publishers
2300 Chestnut Street, Philadelphia, PA 19103-4371

First published in the UK by Robinson, an imprint of
Constable & Robinson Ltd, 2012

© 2012 in artworks: individual artists
© 2012 in photographs: as indicated on respective pages
© 2012 in all text and selection: JAKe
© 2012 Constable & Robinson Ltd

The right of JAKe to be identified as the author of this work
has been asserted by him in accordance with the Copyright,
Designs & Patents Act 1988.

All rights reserved. This book is sold subject to the condition
that it shall not, by way of trade or otherwise, be lent, re-sold,
hired out or otherwise circulated in any form of binding or cover
other than that in which it is published and without a similar
condition including this condition being imposed on the
subsequent purchaser.

A copy of the British Library Cataloguing in Publication Data
is available from the British Library

UK ISBN: 978-1-78033-389-2 (paperback)
UK ISBN: 978-1-78033-654-1 (ebook)

1 3 5 7 9 10 8 6 4 2

Contributing photographer: Mark Rigney
www.hookedblog.co.uk

Design and layout by Sam Blunden
www.samblunden.com

Printed and bound in Italy

First published in the United States in 2012 by Running Press
Book Publishers, a Member of the Perseus Books Group.

All rights reserved under the Pan-American and International
Copyright Conventions

*This book may not be reproduced in whole or in part, in any
form or by any means, electronic or mechanical, including
photocopying, recording, or by any information storage and
retrieval system now known or hereafter invented, without
written permission from the publisher.*

Books published by Running Press are available at special
discounts for bulk purchases in the United States by
corporations, institutions, and other organizations. For more
information, please contact the Special Markets Department
at the Perseus Books Group, 2300 Chestnut Street, Suite
200, Philadelphia, PA 19103, or call (800) 810-4145, ext.
5000, or e-mail special.markets@perseusbooks.com.

US ISBN: 978-0-7624-4599-8
US Library of Congress Control Number: 2011939294

9 8 7 6 5 4 3 2 1

Digit on the right indicates the number of this printing

www.runningpress.com
Visit us on the web!

List of Artists

All Bode art © Mark Bode 2012

In the Beginning . . .

The word on the street is that street art is dead. But before we write its obituary let's take it back – way back. Ever since we first sheltered in caves, humankind has had the primitive urge to make marks on walls, but our story begins some time later, in 1967 to be precise. It was then that the cartoon character Cheech Wizard made his first appearance in print. Often accompanied by a lizard character called Razzberry, Cheech Wizard was the creation of an underground comic book artist from New York, Vaughn Bode.

In 1970s' New York an artistic revolution was taking place. Mysterious names like TAKI 183 and STAY HIGH 149 were being scrawled on walls all over the city. Then, Phase 2, Tracy 168, Dondi, Seen, Lee Quinones and many more artists began to bomb the New York City subway cars. The trains were emblazoned with a new art form, spraypainted "window downs", "top to bottoms", "whole cars" and eventually "wildstyle". This was the birth of New York Subway Graffiti, one of the fundamental elements of hip hop, alongside DJ-ing, MC-Ing and b-boying, or breaking. Pioneering writers like Dondi would incorporate Bode's characters into their pieces – for one of his most infamous later pieces, "Children of the Grave, Part 3", Dondi lifted a character from one of Bode's comic panels. Bode's fluid lines and rounded forms lent themselves perfectly to the new aerosol aesthetic. At the same time, DJ Kool Herc and Grandmaster Flash were rocking crowds at Bronx block parties with alchemy from two turntables, but it was records, movies and books that really spread this new culture beyond the confines of the city, allowing it to explode worldwide: Blondie's *Rapture*, Sugarhill Records, *The Escapades of Futura 2000*, movies such as *Wild Style* and later *Style Wars*, but most importantly for graffiti, the book *Subway Art*, which, along with its sequel *Spraycan Art*, electrified a generation.

I was still at school when *Subway Art* shone a light on the hidden world of graffiti lore, with its talk of fatcaps and skinnies, throw-ups, end-to-end burners, kings and toys. I can clearly remember being obsessed with the book, endlessly practising handstyles as I attempted to mimic this new art. My own experience mirrors that of so many writers, biters and scrawlers I have spoken to over the years. Given that *Subway Art* suggested that true writers should "rack" (graff slang for "steal") paint, it's no wonder that it is rumoured to be the most stolen book ever. Certainly my copy never made it back to the school library.

Back in NYC, Keith Haring was chalking dancing figures on the underground and a young Jean-Michel Basquiat had begun to spray SAMO© all over SoHo; both were to lead the charge above ground and into the galleries. Graffiti swiftly became a worldwide movement, the letter styles evolving into new forms as the decades passed. Bode's characters became a b-boy touchstone, paid tribute to in hundreds of pieces and immortalized in rhyme by the likes of The Beastie Boys and Aesop Rock.

In 1981, a year after Dondi had painted "Children of the Grave, Part 3", a French artist, Xavier Prou, inspired by the stencil techniques of Italian fascist propagandists, began to paint rats around the 14th and 18th Arrondissements of Paris, adopting the tag Blek le Rat. Years later, a British street artist, a young boy in Bristol at the time, would take stencilled rats to an infinitely wider audience, adopting the tag Banksy . . .

This was how grafitti began, but this book is about street art as a whole, rather than graffiti alone. So what exactly is the definition of street art and how does it differ from grafitti? No one seems able to agree. When I began work on this book I canvassed opinions from friends, writers and graff aficionados. I was told more than once, "Street art is dead." Mostly this was said to me by artists who have stopped hiding behind tags and pseudonyms and who now exhibit in galleries under

their own names. But rather than accept the death of street art as a given, let's take its pulse. I could have filled a book twice or even three times the extent of this already weighty collection; that's not bad for a genre considered, by some at least, to be on its last legs.

Street art seems to have been born of a desire for liberation from the tight codes of graffiti which had begun to seem dogmatic and restrictive. A new breed of urban artist started to reject or ignore "the rules". Characters or logos became the focus of their art instead of letterforms; and stickers, stencils and wheatpasted posters became as common as spraypaint. These artists often "hacked" the urban environment, doctoring billboards, mimicking civic signage or simply making work that responded to its surroundings.

It's hard to pinpoint exactly when and where this began. In 1992, I was in Paris with London writer Memo when we kept noticing a life-size character painted on a wall called Mr A. This idea of tagging a city with a character instead of a tag seemed radical to me at the time. Soon afterwards, I started using my own character, scrawling

The original Vaughn Bode comic panel used by Dondi in "Children Of The Grave, Part 3"

a face, almost a street logo, instead of a tag. Mr A, or André, was painting his character at around the same time that Shepard Fairey had begun pasting stickers of wrestler André the Giant (no relation), which bore the motto "André Has a Posse". This was the precursor to the now infamous OBEY campaign, Fairey's ubiquitous sticker propaganda in support of nothing.

During the 1990s, stickers, wheatpastes and the emerging trend of characters and logos in place of tags began to feel like a distinct movement. When I visited Barcelona, Paris and New York, these cities were swarming with exciting new urban artists, working alongside more established graffiti writers. In 1996, when I moved into a studio in Shoreditch in East London, then a run-down area popular with artists because of its cheap rents, I found myself at the centre of an explosion of street art. At first it was stickers – Zeel, Solo One, a fresh-faced D*Face, Eine, Culprit, Toasters, Dave the Chimp, Gasr, Pinky and many more would leave characters and logos plastered on lamposts and doors. It was fun: a stack of stickers in your pocket wherever you travelled; a way of meeting and identifying other like-minded artists. Artists from other countries would also hit East London – André, Shepard Fairey, The London Police, Invader, Twist, Bast and Faile. I had a gallery literally on my doorstep.

As the Internet became more accessible, a website called StickerNation.net began to document this new worldwide sticker phenenomon. For a time I was its London correspondent, taking photos (on film!), painstakingly scanning them and uploading them to the site. When digital cameras became more common, a host of other curators began to cover the city much faster than I could. The growth of the Internet went hand in hand with the exponential growth in popularity of street art. Ekosytem.org and WoosterCollective.com were other websites which played a major role in documenting this wave of new art.

In Shoreditch, the graff and street art haunt of choice was the Dragon Bar, and it was not uncommon on any given night to spy UK graff stalwarts like Mode 2, Eine, and Busk propping up the bar alongside a gaggle of London's practising street artists and vandals. Memo would roll up and supply imported paint, and one night he introduced me to a friend of his. The friend knew my work, but, as we chatted, he seemed reluctant to say much about what he painted, something that struck me as rare amongst most artists I'd met. After 15 minutes or so, his black-paint-splattered fingers and Bristol accent led me to ask if he was Banksy, an artist whose star was in the ascendant and who was making increasingly ambitious work. He smiled and nodded politely. I doubt either of us imagined that night just how well-known he would later become. When Banksy became huge, I'd occasionally bump into him, and once told him that I kept meeting people who claimed to "know Banksy". "Apparently you're a woman," I told him, "or a big black guy with a gold tooth." He laughed and said, "Yeah, let's keep it that way."

This is not to say that street art and graffiti are entirely separate; to my mind they are often interlinked and this book does not totally exclude graffitti. There are many artists whose work appears on the street who defy definition: long-time graffiti veterans who have embraced new methods, or whose artwork has incorporated signwriting, psychedelia and myriad other influences – artists such as ESPO, Kid Acne and Pinky. Then there are old-school writers like Dreph who still keep the faith, but whose character work could be regarded as street art. I love graffiti and always will. If you'll forgive the analogy, let's think of graffiti as a moody, rebellious teenager, unconcerned with approval from anyone but his or her peers, and street art as the slightly awkward, but pleasant young adult, more inclined to communicate to a wider audience. Maybe some of the youthful rawness has been lost, and, compared to the risky methods of graffiti, today's street artists often operate in a safer environment,

painting shop shutters legally. In some cases these are even secured by gallery owners, keen to promote an upcoming show.

Street art appears to be in rude health, but it is easy to be cynical. East London is covered with a dizzying variety of styles and artists will often paint a giant piece in a legal spot, only for the screenprint of the artwork to go on sale the next day. Mobstr's piece "This Will Be Available on Canvas Later" perhaps articulates this phenomenon best. Prints by street artists now raise staggering amounts at fine art auction houses like Bonhams and Sotheby's. There is a lot of posturing by comfortable, middle-aged artists, their work wrapped in second-hand rebel chic, but saying nothing. As London burned at the hands of rioters and looters in 2011, I spoke to artist D*Face about how he felt about his 2009 piece "I need a... Riot" now that he had seen the results of actual rioting on London's streets: "Would I paint that piece now? Probably not. It felt like something could kick off. The 'idea' of a riot seemed anti-authority. But the reality was different. It didn't seem to achieve anything."

This book is proof that reports of street art's death have been greatly exaggerated. East London, where I still live and work, like many other areas around the globe, is awash with new work: some glorious, some dreadful. Truly, the good, the bad and the ugly are on display, but, as we all know, beauty is in the eye of the beholder. I have attempted to capture in a snapshot the diversity of work from many different parts of the world, but no collection can be definitive. There are a number of well-known names, but hopefully also a few artists you won't have heard of yet, along with representatives of a younger generation, painting purely for the illicit thrill of "getting up". Welcome to an eye-popping urban theme park, a democratic, living, breathing, ever-evolving gallery. Street art is dead? I don't think so. Long live street art!

Photograph: Nick Sinclair

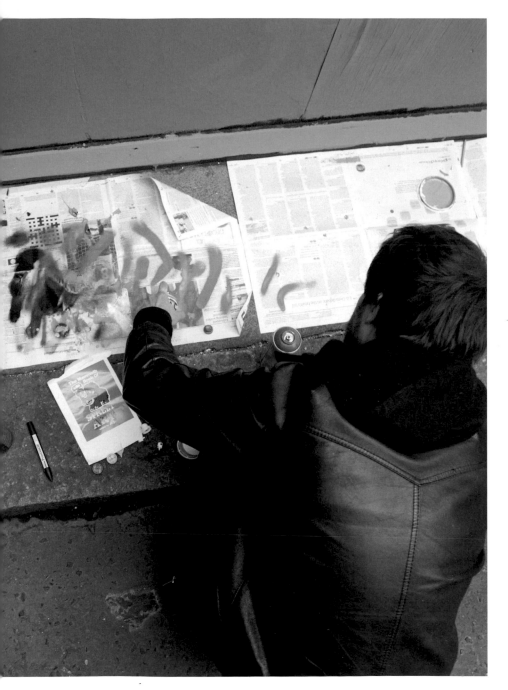

THIS WILL BE AVAILAI

LE ON CANVAS LATER

Dom Murphy/TAK!
The Internet
www.bit.ly/stickernation

StickerNation.net was established by
Dom Murphy, aka TAK!, back in 2000
as a means to distribute pre-formatted
sticker-sheet PDFs between like-minded
artists. Using the internet, visitors could
share, print and paste artwork in places
the artists themselves would never go.
The site documented and nurtured the
growing sticker scene by means of
photographs submitted by visitors to
the site and by using a beta technology
– back then – called Blogger to share art
news among its growing community.
A complete site re-design enabled
membership and encouraged
photographers to document their
local scene. At its end, StickerNation
showcased a staggering 35,000 images
from over 5,000 artists in more than
150 countries. To view some of the
finest examples of sticky self-identity
visit the "Best of" archive at the web
address given above.

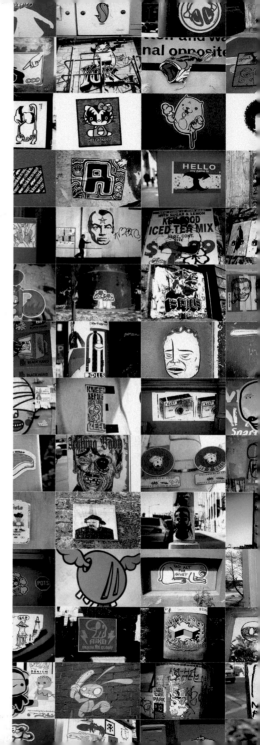

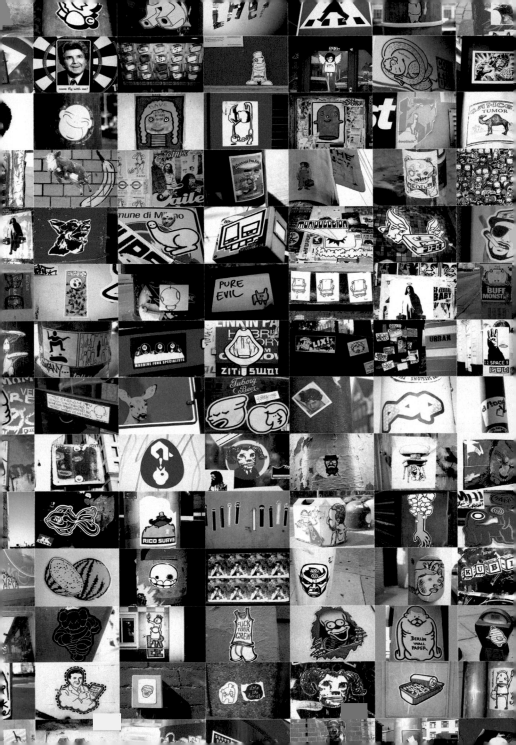

London, UK

This page, clockwise from top left: Echo, Vhils, unknown, Xylo, Toasters.

Opposite, clockwise from top left: A.CE, InkFetish, CodeFC, unknown, unknown, Don.

Photographs: JAKe, Mark Rigney

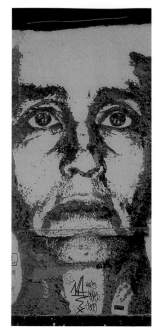

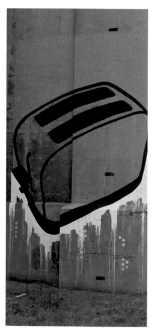

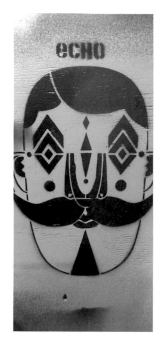

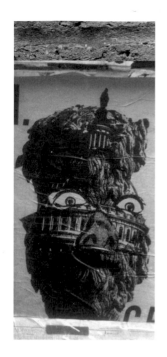

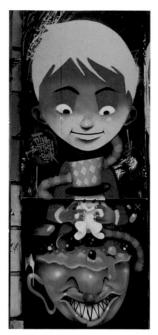

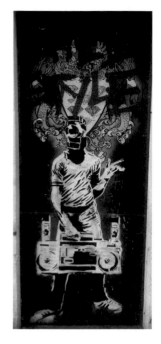

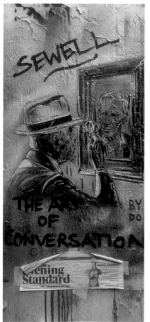

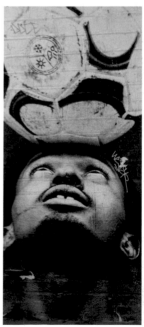

Mobstr

London, UK
www.mobstr.org

Mobstr was born in Newcastle Upon Tyne but now lives in London. I first noticed his playful "collaborations" with Newcastle City Council, as he revisited "buffed" pieces, in a visual call-and-response which read like a petulant city sticking its tongue out at the authorities. His mimimalist stencilled graffitti, billboard hacking and other street modifications (often ignored by passers-by inured to ubiquitous advertising) relies on sharp copywiting, and a wry desire to subvert public space. We start the book with Mobstr's piece "This Will Be Available on Canvas Later" as he seems to be one of the few artists willing to ask questions about the current state of commercial street art.

Photographs: Mobstr

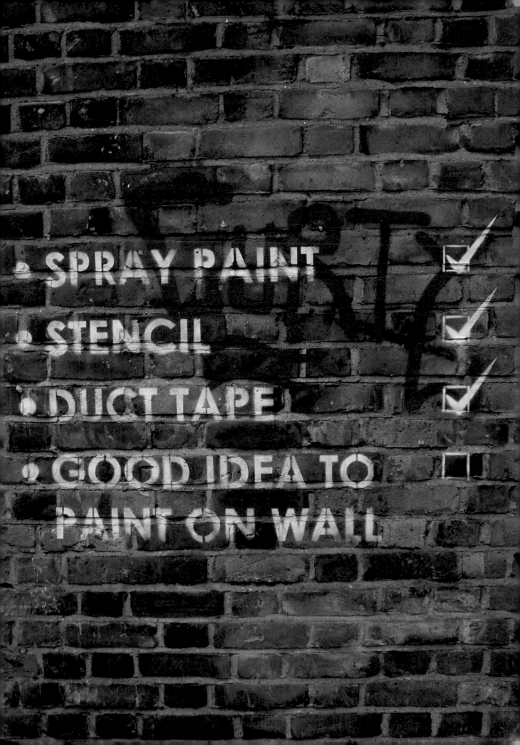

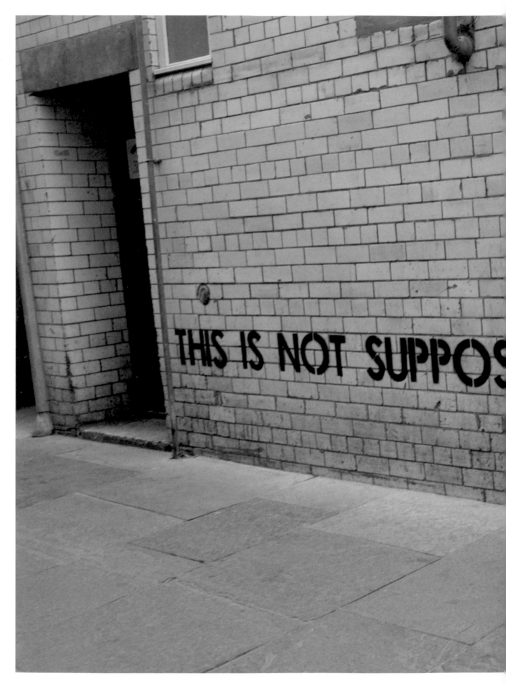

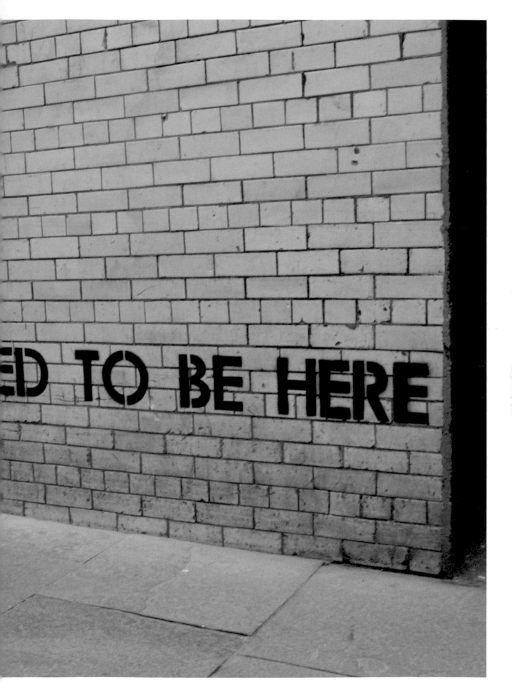

STIK

London, UK

www.stik.org.uk

When I first saw the aptly named STIK's simply rendered figures dotted around Hackney, I was a little dismissive. Initially, I wrote them off as the latest in a long line of lazily drawn, two-colour characters that seemed to be hitching a ride on the now commercially profitable street-art bandwagon. I subsequently learnt that the artist was homeless when he first painted the characters, and as more "STIK people" appeared, portrayed sleeping or waiting for medical treatment, I realised that despite their simplicity, STIK's characters could be imbued with a surprising degree of emotional impact; they could also depict male or female and different ethnicities with minimal modification. STIK's work first made the leap into galleries with a show at Imitate Modern Gallery, helping to provide an income to an artist who not only works on the street, but has slept there, too.

Photographs: Claudie Crommelin, JAKe

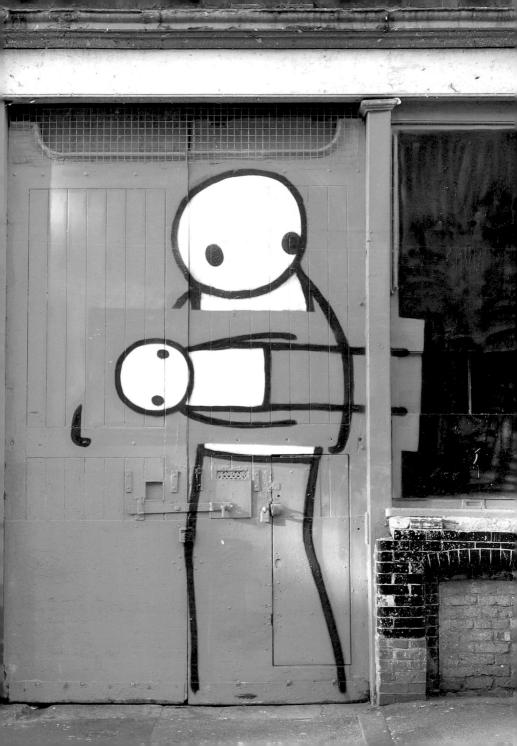

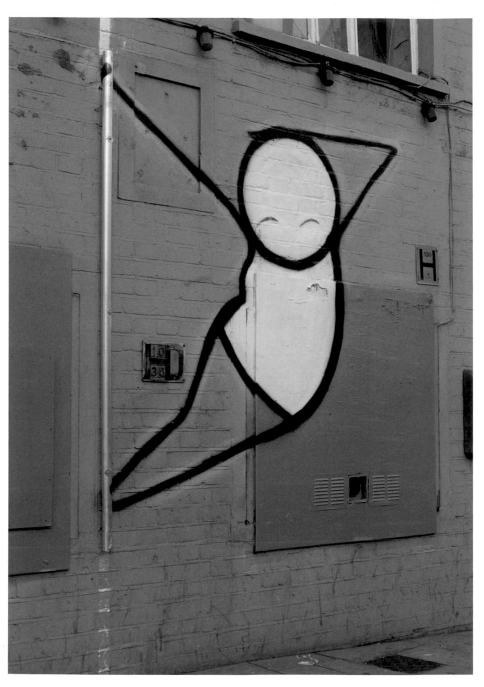

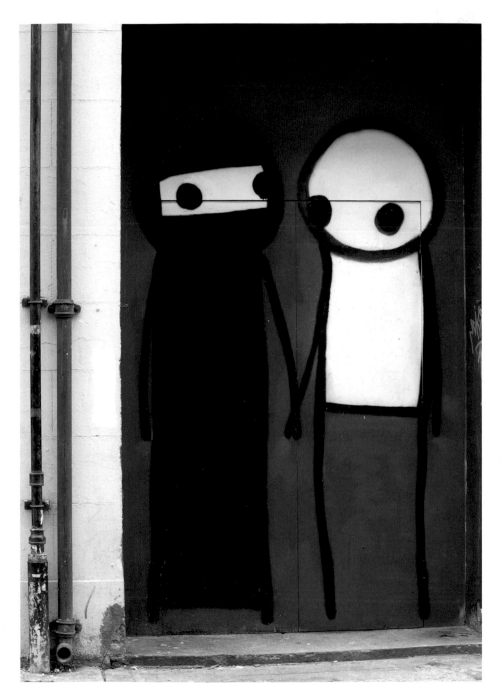

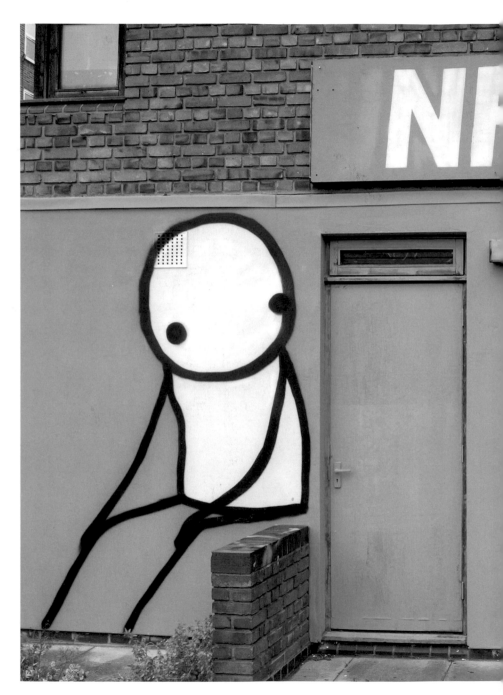

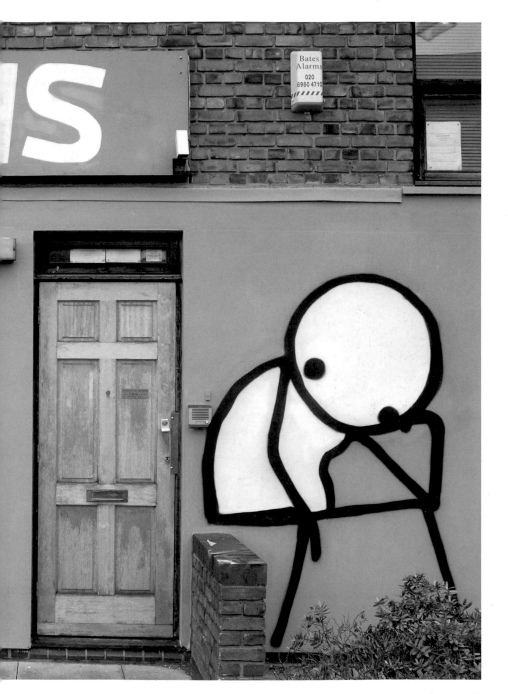

Eine

Hastings, UK
www.einesigns.co.uk

I first met Ben Eine when he was painting Shoreditch club 333 back in the late 90s. He was already a graff veteran, with a string of arrests to his name, but neither of us could have predicted then that one day an Eine painting would be hanging in The White House. Shortly after that first encounter, Eine's signature neon-and-black stickers and larger-scale stencilled/wheatpasted FrankenstEine heads became a common sight as part of the first wave of street art in East London. He then began to hit London hard with his trademark untagged single letters on shop shutters until full alphabets, reminiscent of Victorian letterpress or circus typography, dominated Hackney Road, Petticoat Lane and elsewhere.

In the summer of 2010, Eine suddenly achieved much greater notoriety as both tabloid and broadsheet newspapers reported that recently elected British Prime Minister David Cameron had given visiting US President Barack Obama an Eine canvas depicting letters spelling out "TWENTYFIRSTCENTURYCITY". Eine's response was to paint a piece on roadside hoardings that read "THESTRANGESTWEEK". The following pages show Eine getting up worldwide: London, Hastings, San Francisco, Mexico City and Osaka.

Photographs: JAKe, Ben Eine, Gareth Gooch, William Perle

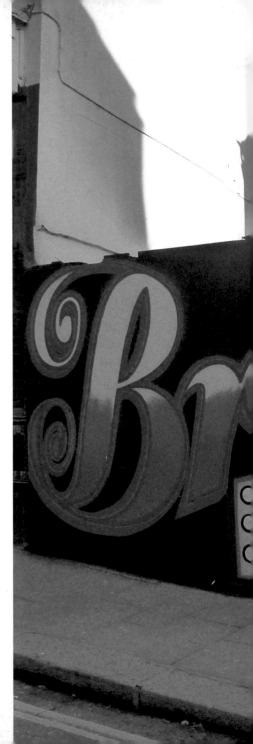

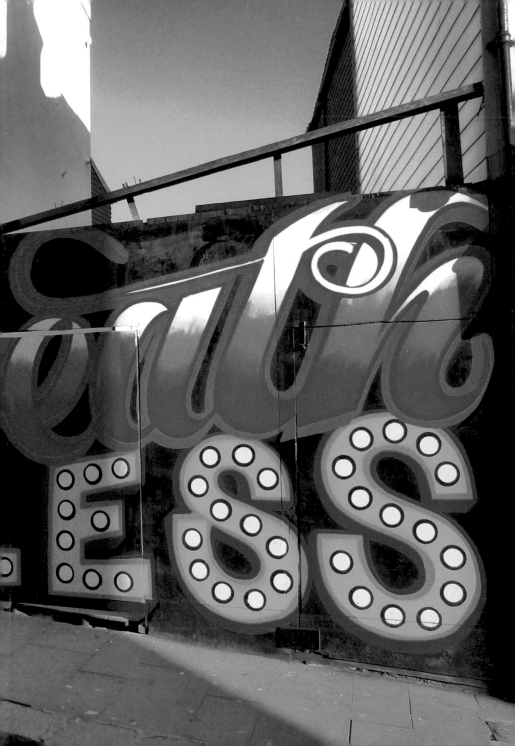

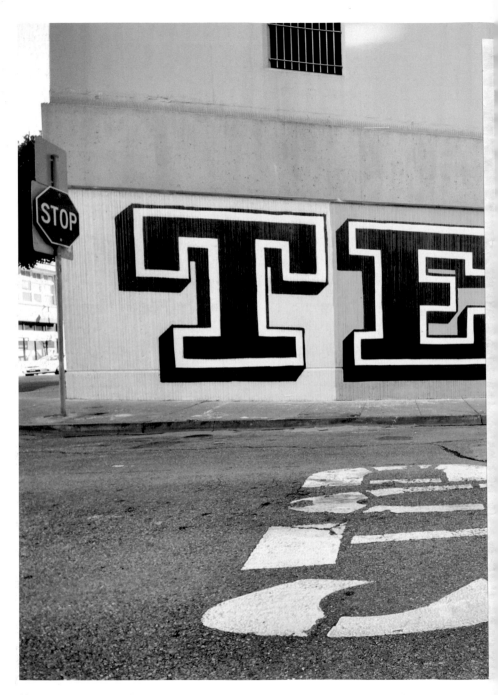

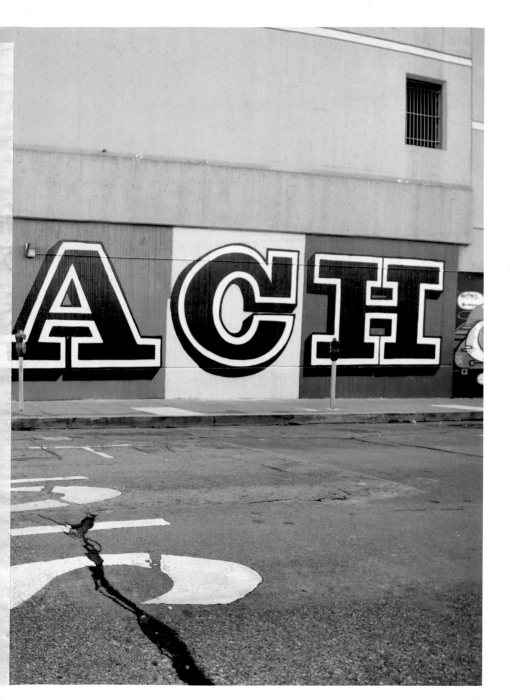

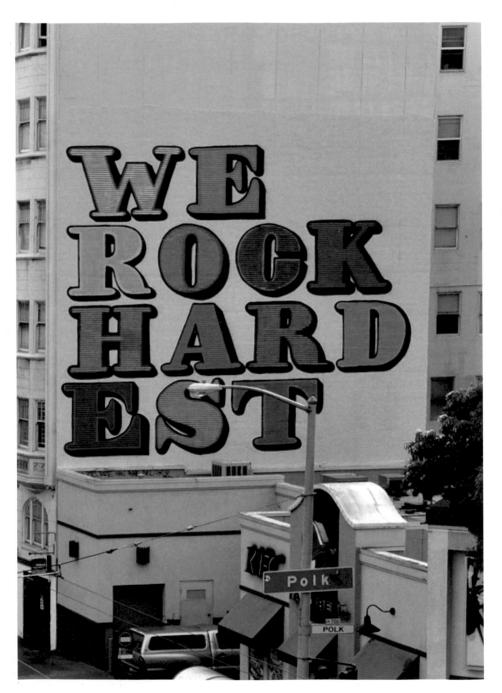

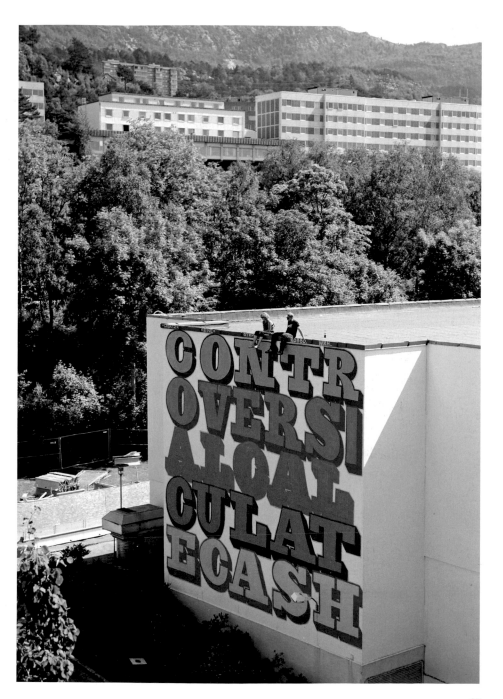

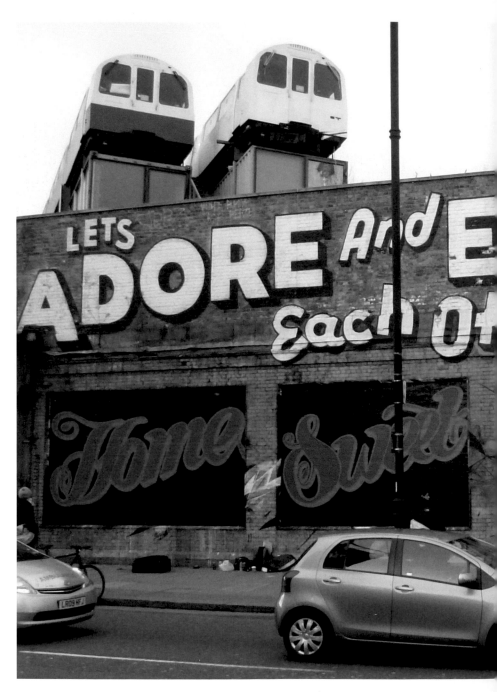

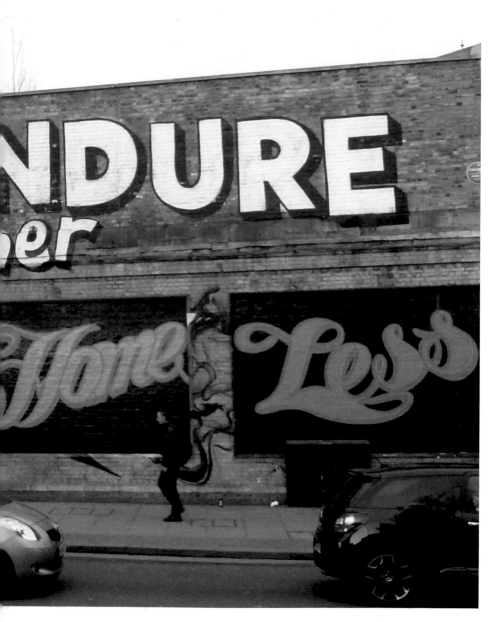

Ronzo

London, UK

www.ronzo.co.uk

Originally from Munich, German artist Ronzo's stickers and wheatpasted posters had long been a fixture on the London street art scene, but in 2010, inspired by the statues of dragons that guard London's Square Mile, the financial heart of the city, he took a step forward with his three-dimensional work, installing the first of his sculptural "Credit Crunch Monsters" on the boundaries of London's financial district. "Crunchy", one of these "Credit Crunch Monsters", currently keeps a watchful eye on Great Eastern Street (last photograph).

Photographs: Ronzo

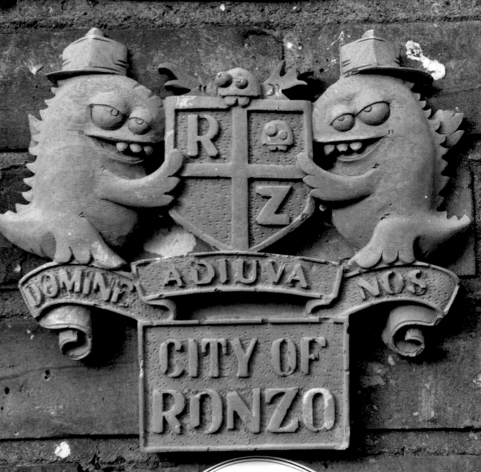

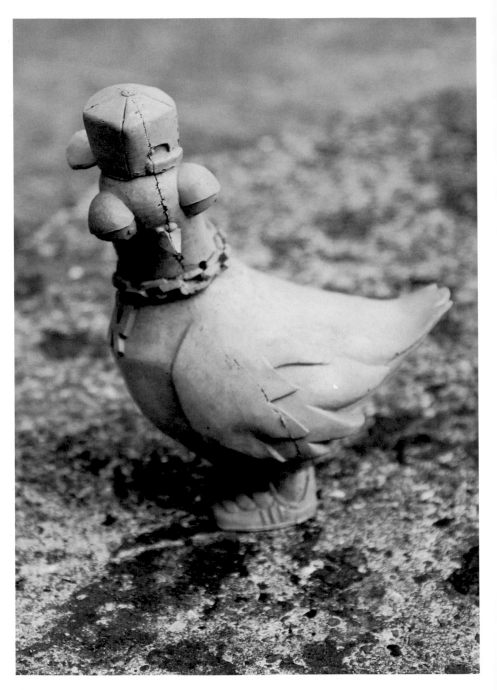

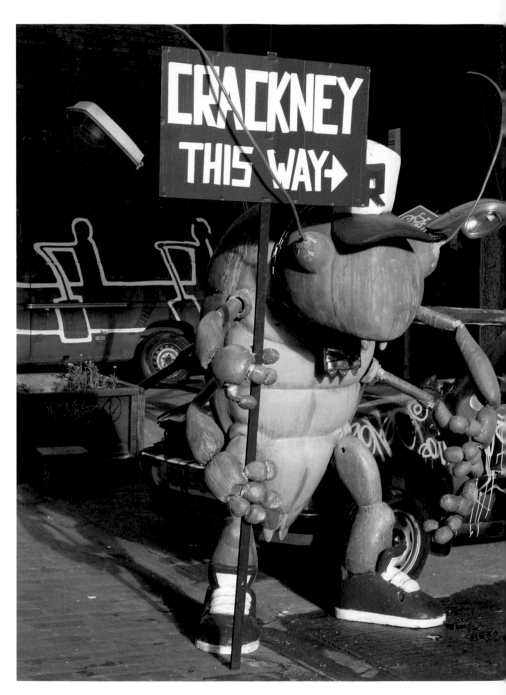

Eelus

Wigan, UK

www.eelus.com

Graphic artist Eelus is probably better known for his stencil work, but I've chosen to showcase his work in a more pastoral setting where the markings are almost tribal in nature.

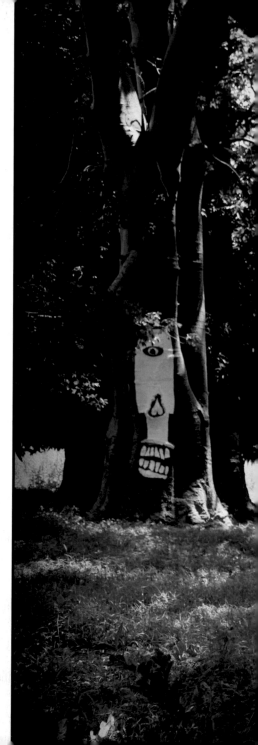

Photograph: Lee Pennington

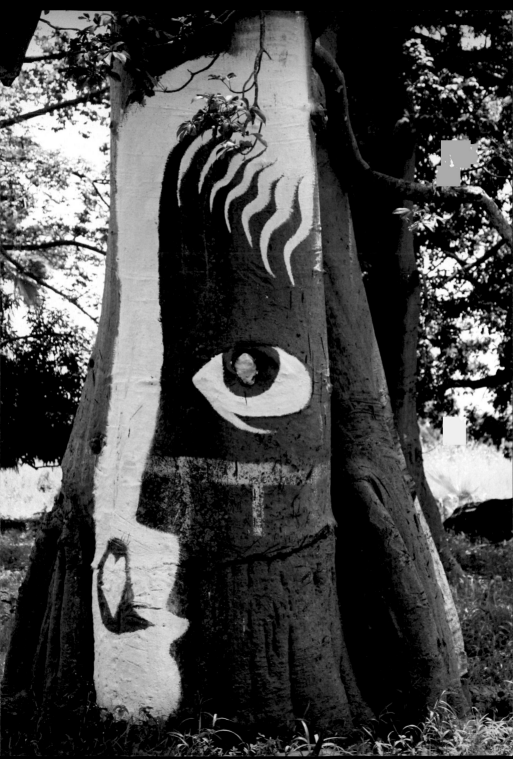

Pure Evil

London, UK

www.pureevilclothing.com

Said to be descended from Sir Thomas More, the Lord Chancellor beheaded by King Henry VIII, Charley Uzzell Edwards, aka Pure Evil, started by spraying and stencilling his childishly rendered fanged-rabbit character around East London, but now runs the Pure Evil Gallery on Shoreditch's Leonard Street. His appearance on BBC TV programme *The Apprentice,* which whipped the street-art Twitterati into a froth of indignation, offered the surreal spectacle of curmudgeonly tycoon Lord Sugar repeatedly uttering the words, "Pure Evil". I'm sure Charley revelled in the incongruity.

Photograph: Pure Evil

D*Face
London, UK
www.dface.co.uk

Like some lurching Frankenstein's monster, stitched together from discarded fragments of a Lichtenstein painting and the putrefying corpse of punk, D*Face gleefully mashes pop culture icons with his own signature D-Dog character. I first met D*Face in the 90s, after our stickers had already crossed paths. After a few drunken nights, we decided to think a little bigger and hatched a plan to go out together and wheatpaste gigantic photocopies across town. When D*Face turned up on the planned evening, he came equipped: a borrowed jeep, wallpaper paste and extendable brushes for those hard-to-reach spots. What struck me that night was his ambition. He talked about wanting to do ever bigger pieces, and by the end of the night was talking in hushed tones about one day opening a London gallery dedicated to street art. It was only a few years later that he achieved that ambition, opening The Outside Institute with an inaugral show by New York graffiti pioneer Seen. D*Face is totally committed to street art as the stunts on the next few pages, in London, Hollywood and Quito, in Ecuador, reveal.

Photographs: D*Face

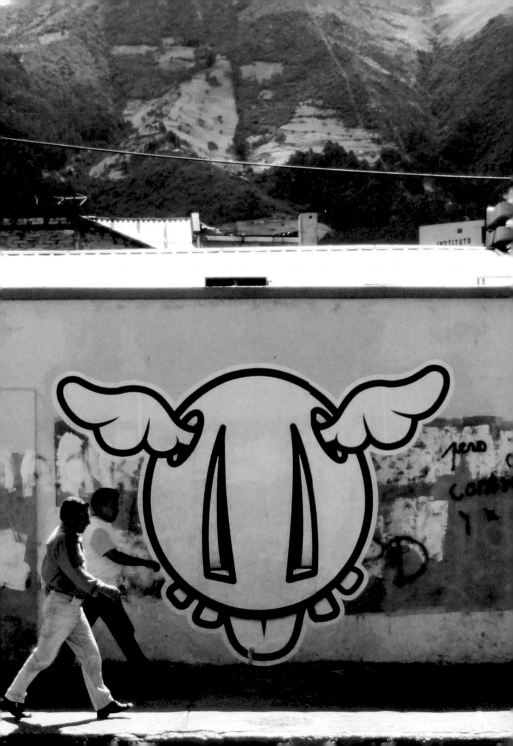

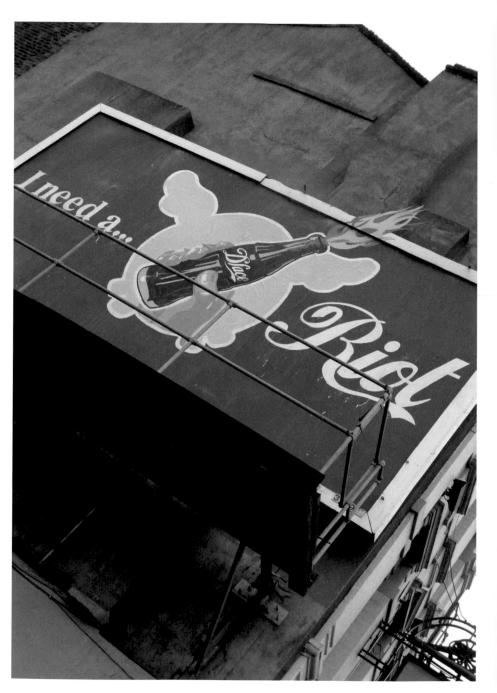

Mjar

London, UK

www.flickr.com/photos/mjar75

Mjar is an artist from Galway, Ireland, who
has long been a regular contributor to
London's street art scene, hitting grubby
spots with stickers and paste-ups
featuring his trademark bacterial beasties.

Photograph: Mark Rigney

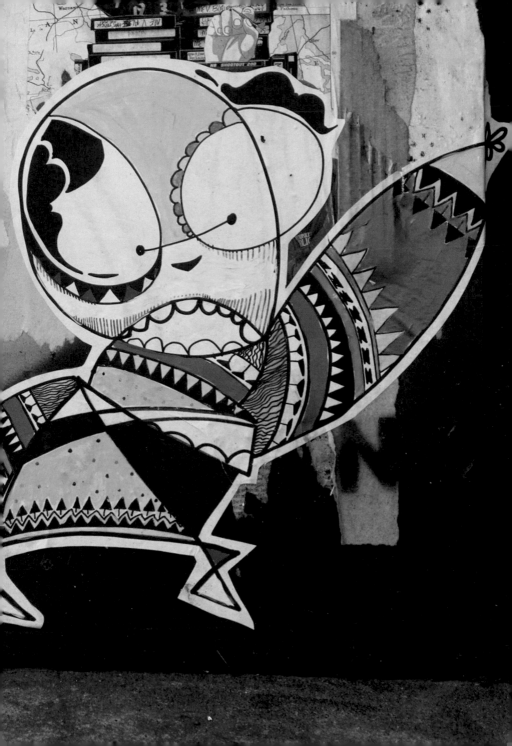

Hin

London, UK
www.hin-art.com

Hin is a Hong Kong-born artist who
has lived in England since the age of 12.
Now living and working in London,
Hin wheatpastes the streets with images
that combine ultra-detailed portraits,
childlike drawings and collages
incorporating diverse elements.

Photograph: JAKe

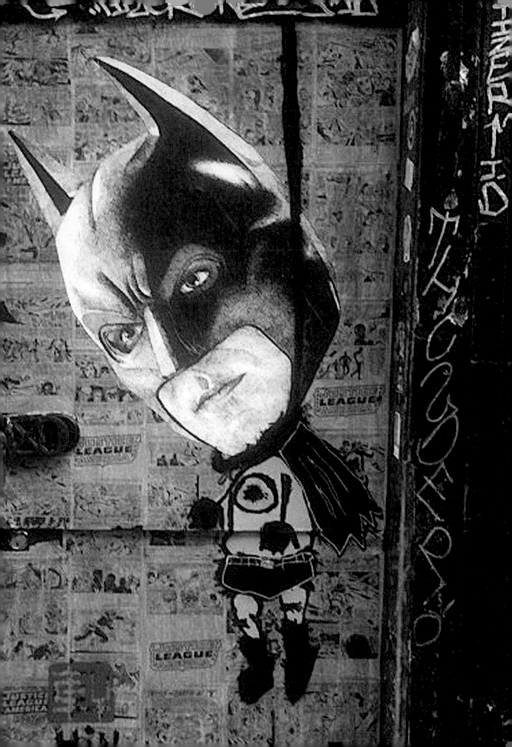

Joe Keeler

London, UK
www.jkeela.com

An illustration student in his early twenties on the FDA course of Camberwell University of Arts, London, Joe Keeler wheatpastes his intricately rendered bio-mechanical creatures onto the walls of South London. With draughtsmanship skills more impressive than some established street artists twice his age, Keeler is an artist to keep an eye on.

Photograph: Joe Keeler

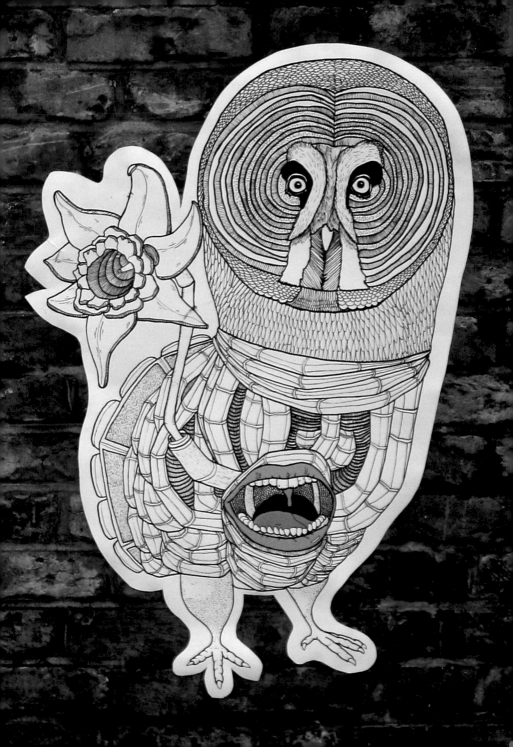

Malarky
London, UK
www.malarky.blogspot.co.uk

Influenced by the work of Barcelona street artists like Zosen, Malarky's colourful creations, often painted in tandem with artist Lucas, began to appear in East London a couple of years ago. They soon became unmissable, dominating the areas round Brick Lane, Redchurch Street and Petticoat Lane. No one had hit the shutters of East London's shops quite so hard since Eine's heyday. When tagged over by other artists, Malarky simply returns under cover of night and rocks brand new characters over his defaced art. Younger than many more established London artists, Malarky's attitude appears a welcome throwback to the more innocent early days of graff, of painting for the love of painting.

Photographs: JAKe, Mark Rigney, Malarky

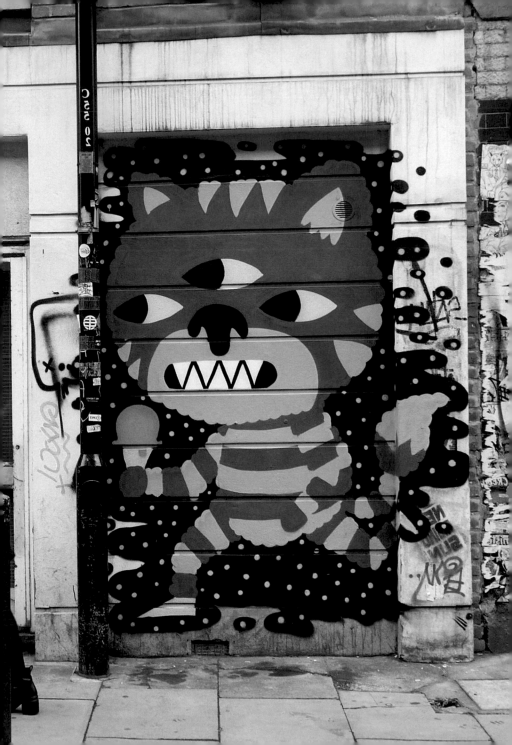

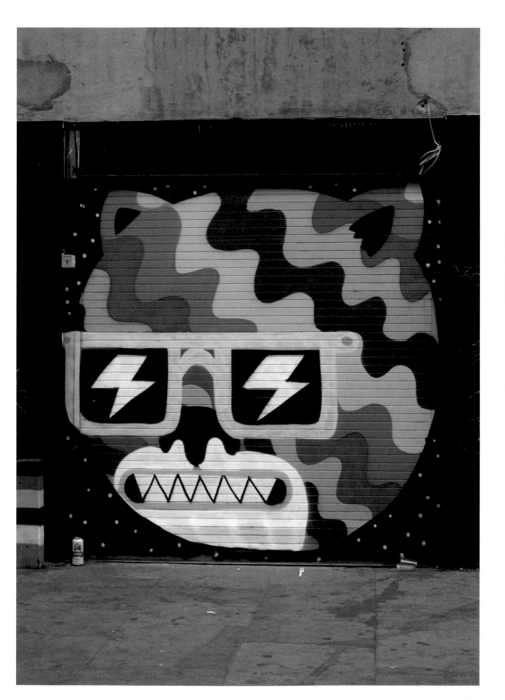

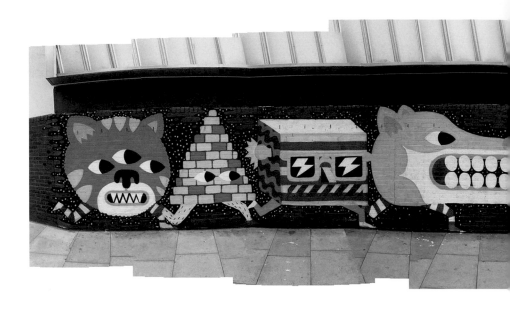

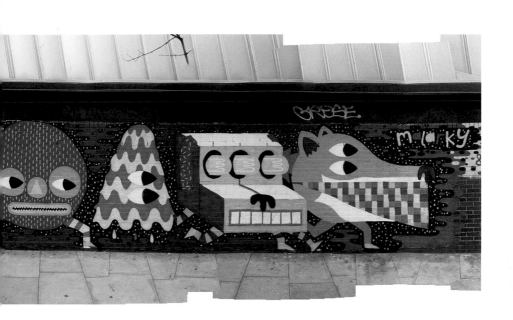

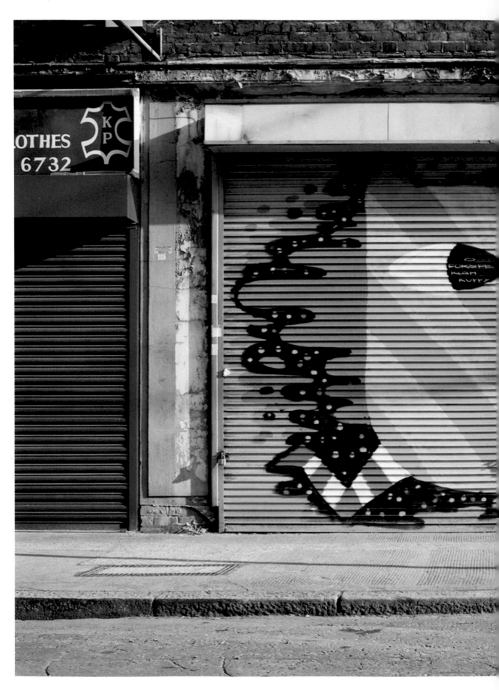

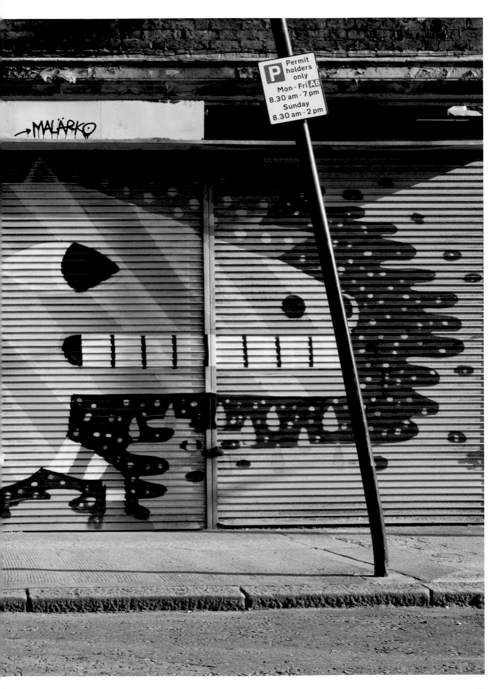

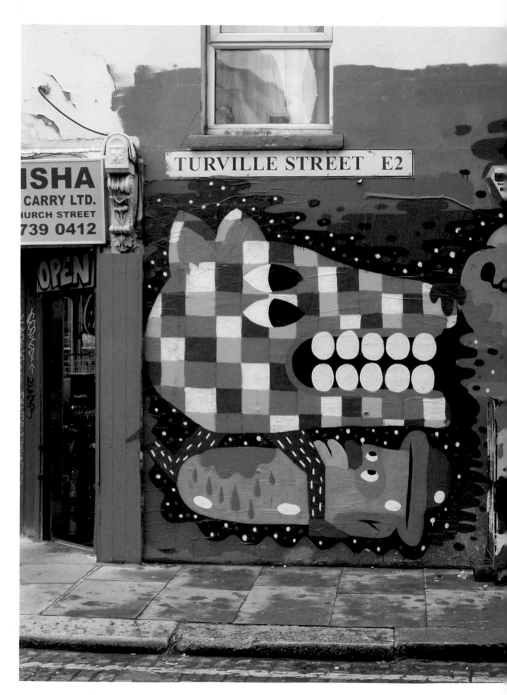

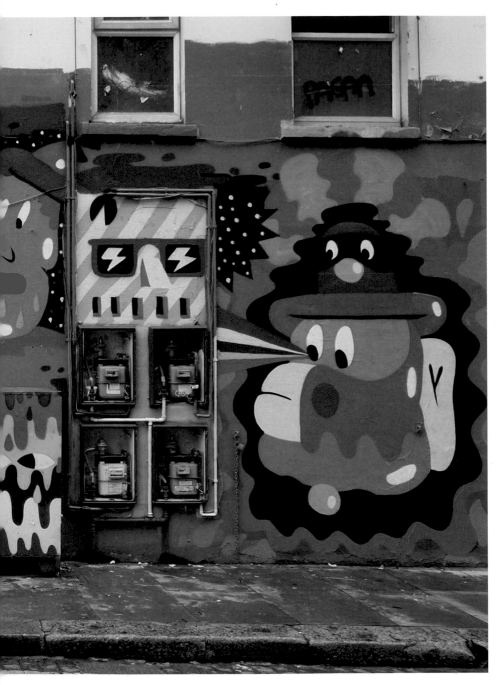

Slinkachu

London, UK
www.slinkachu.com

Bow down to the mighty Slinkachu.
Literally bow down. Low. Otherwise you
may easily walk past one of the Slink's
miniature street scenarios, which are
so tiny that even the most eagle-eyed
observer may struggle to spot them.
Slinkachu has been "abandoning little
people on the street since 2006", placing
then photographing his meticulously
remodelled and repainted figures from
toy train sets in Manchester, Stavanger,
Amsterdam, Marrakech and Barcelona.
The little characters in these photographs
were all let loose in London.

Photographs: Slinkachu

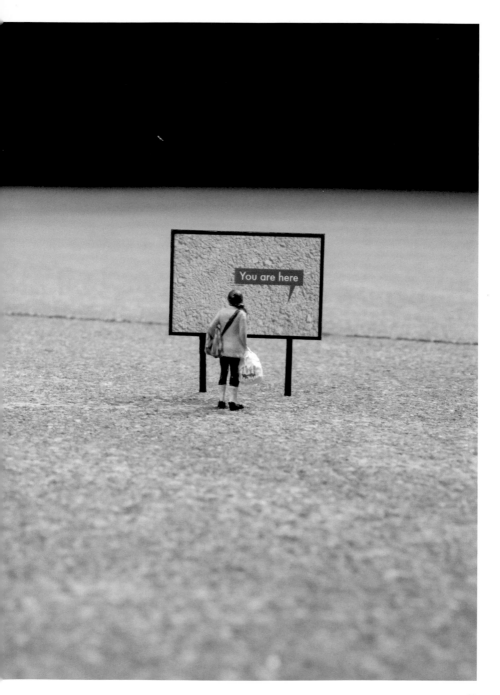

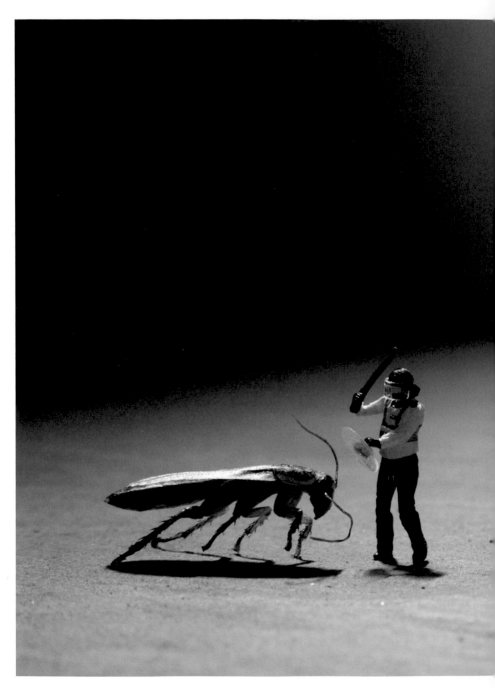

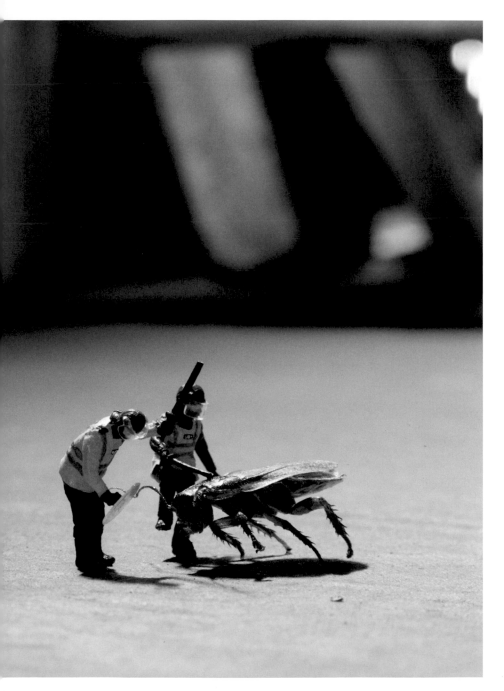

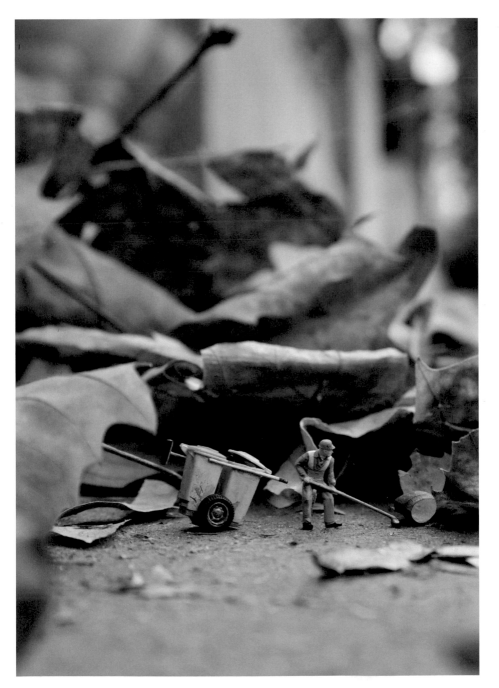

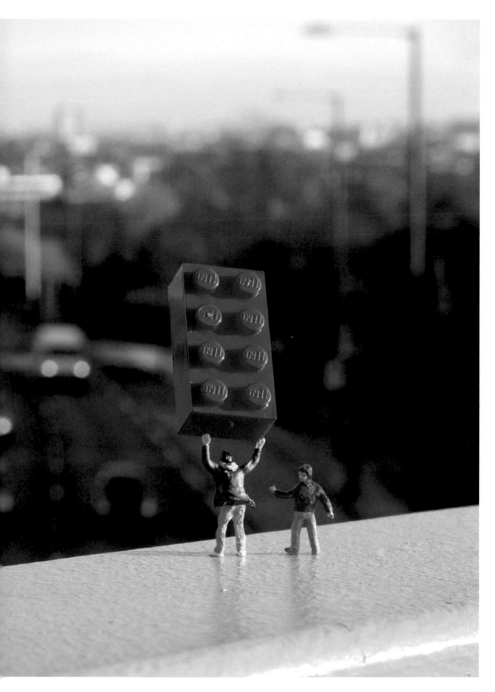

Evol

Berlin, Germany
www.evoltaste.com

Berlin-based artist Evol takes mundane urban fixtures and transforms them into minature replicas of "plattenbauten", Berlin's communist-era prefab towerblocks. He uses a scalpel to cut tiny, intricate, layered stencils which he pastes onto electrical boxes or concrete blocks before spraypainting. These tiny recreations of larger-scale architecture come complete with lifelike stencilled shadows, satellite dishes and vanishingly small grafitti, throw-ups and tags. These images are from a trip Evol made to London. It's all too easy to imagine Slinkachu's characters returning here to sleep after a hard day throwing Lego from motorway bridges.

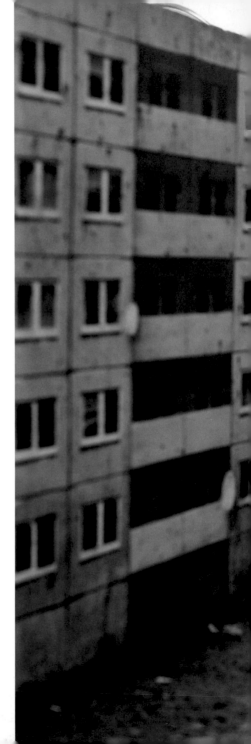

Photographs: Mark Rigney

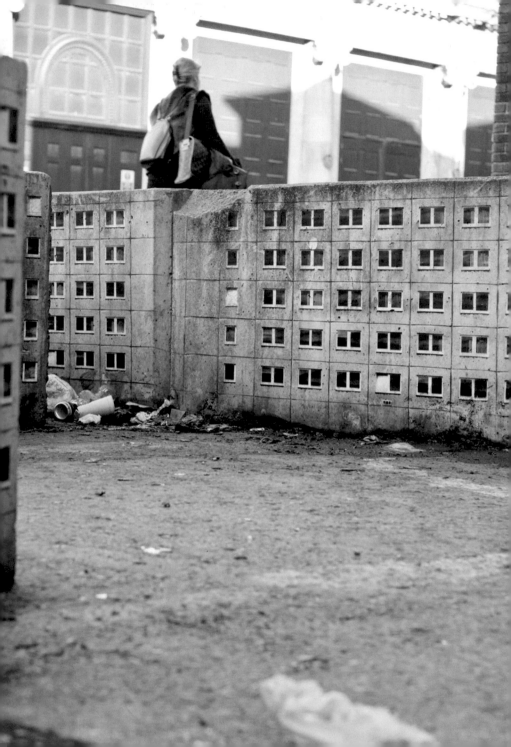

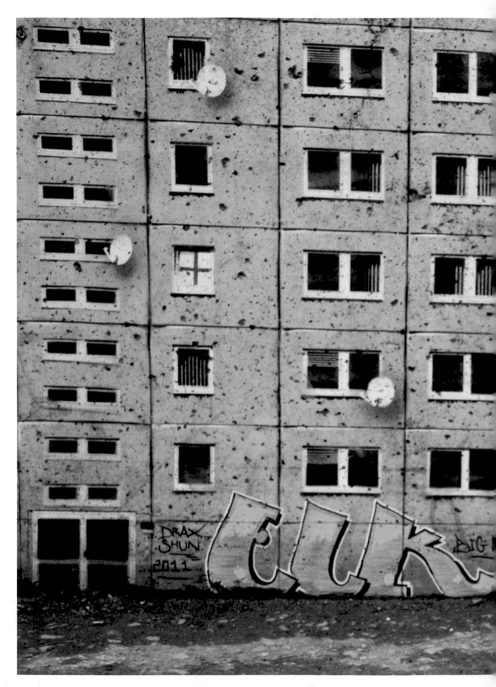

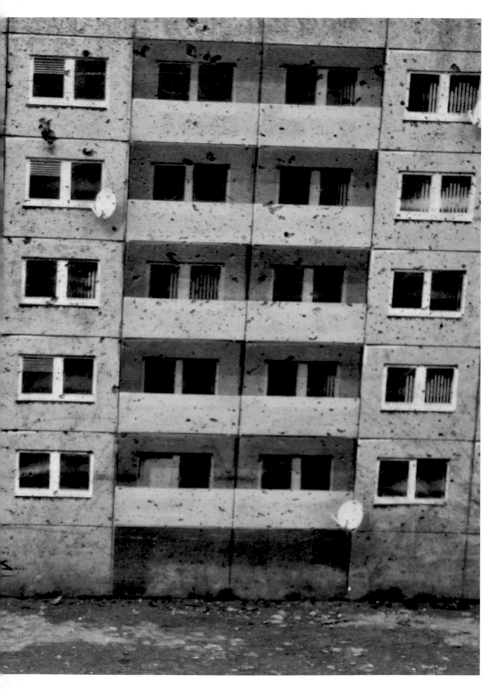

Pablo Delgado

London, UK
www.pablodelgadomc.com

Mexican artist Pablo Delgado pastes tiny photographic figures on the streets of London, to which he adds ingenious painted shadows, which certainly tricked *my* eye the first time I walked past one. His characters have appeared in the Whitechapel and Aldgate areas of London, a grimly chilling reminder in the areas where Jack the Ripper perpetrated his atrocities against Victorian prostitutes.

Photographs: Mark Rigney, Claudie Crommelin

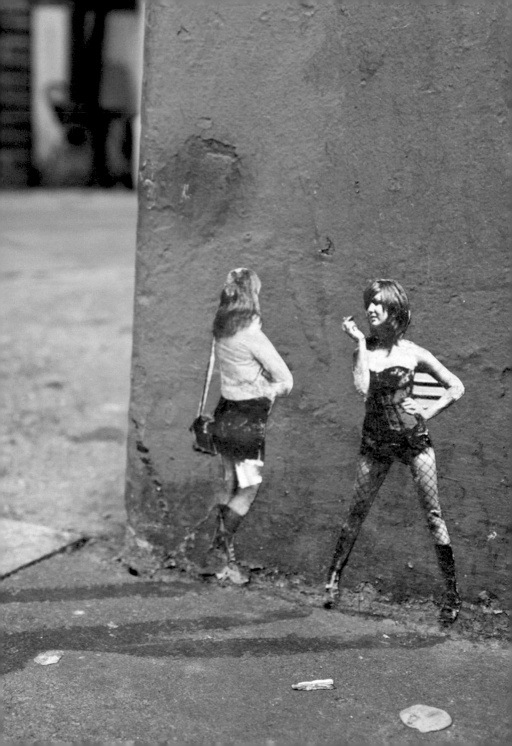

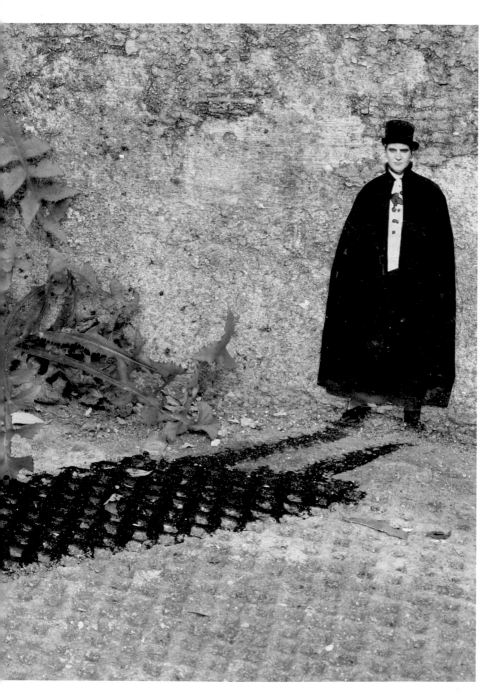

Roa

Ghent, Belgium
www.roaweb.tumblr.com

Roa is a Belgian artist who paints giant monochrome animals, slumbering, dying, hiding or peering out from semi-derelict buildings in New York, Berlin, Warsaw and Paris. Roa has hit the East End of London hard in the last couple of years. This beady-eyed critter still keeps watch on a carpark near London's famous Brick Lane.

Photograph: Mark Rigney

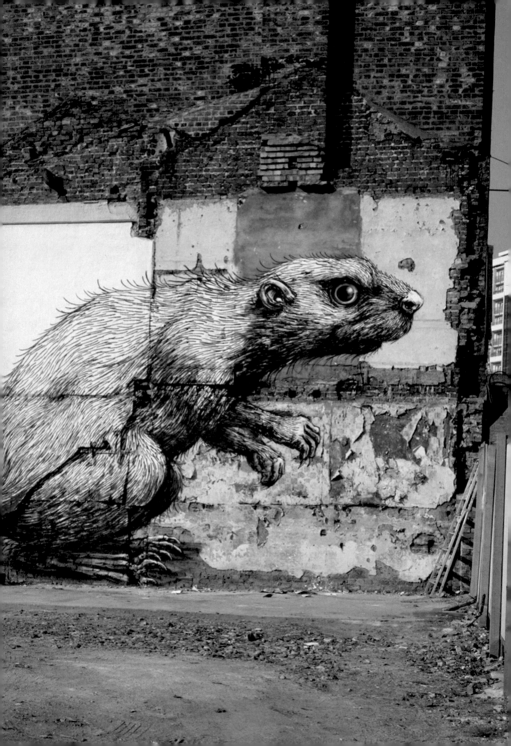

What Crew: 45rpm/Richt

Bristol, UK

www.thebearded45.co.uk

www.flickr.com/photos/whatcollective

Richt and 45rpm are two members of Bristol's What Crew. As well as their more traditional aerosol productions, these pages show 45rpm's snow doodles, which have their own easy, ephemeral charm.

Photographs: What Crew

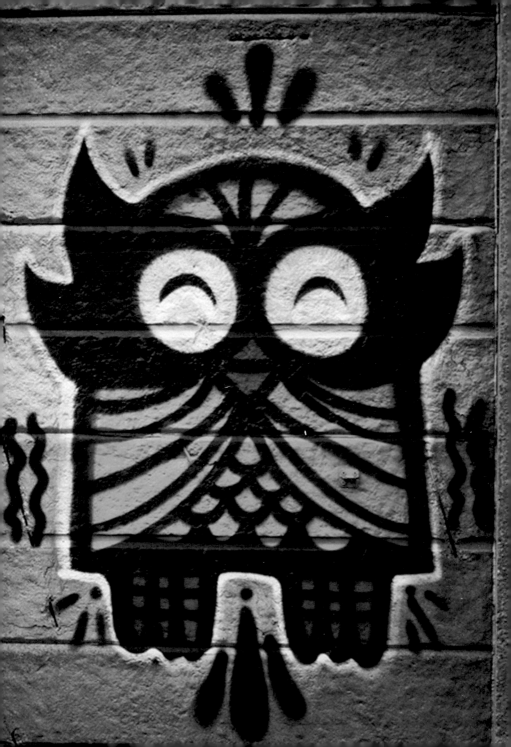

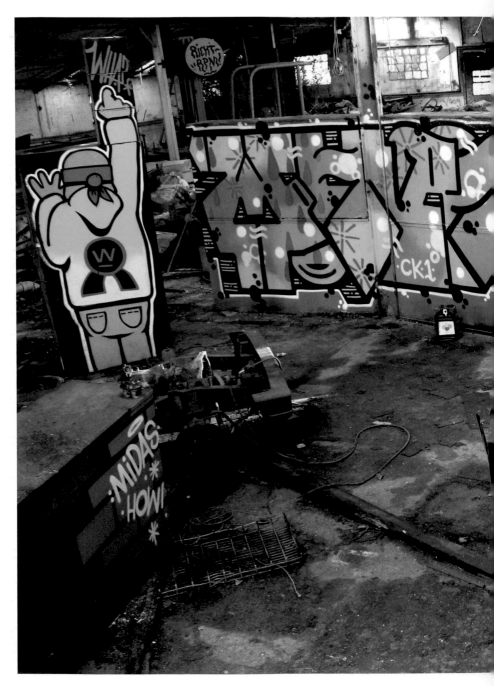

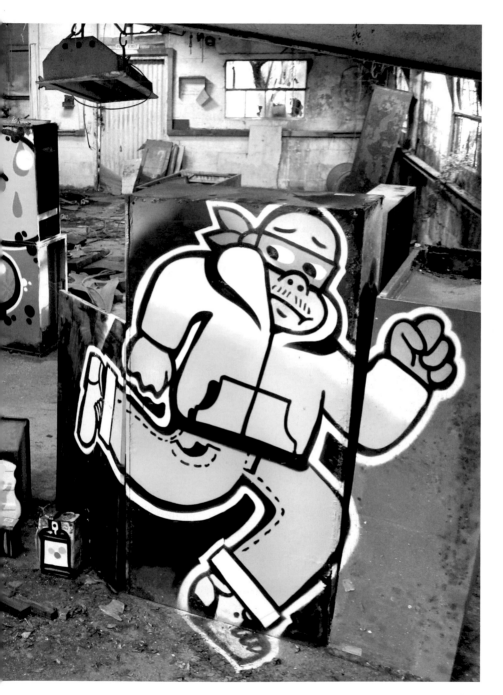

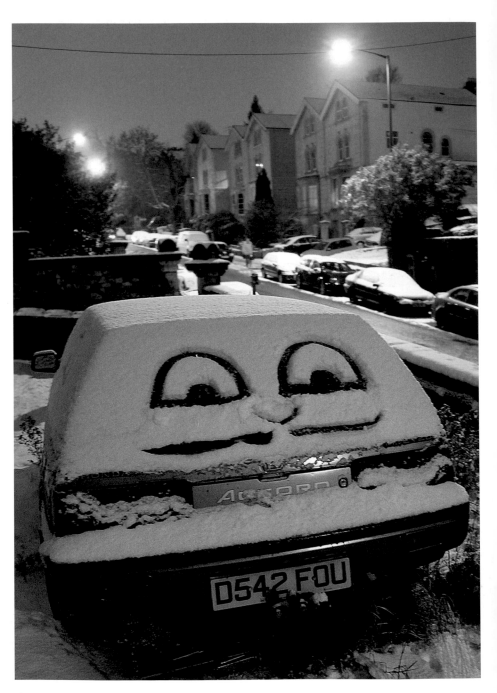

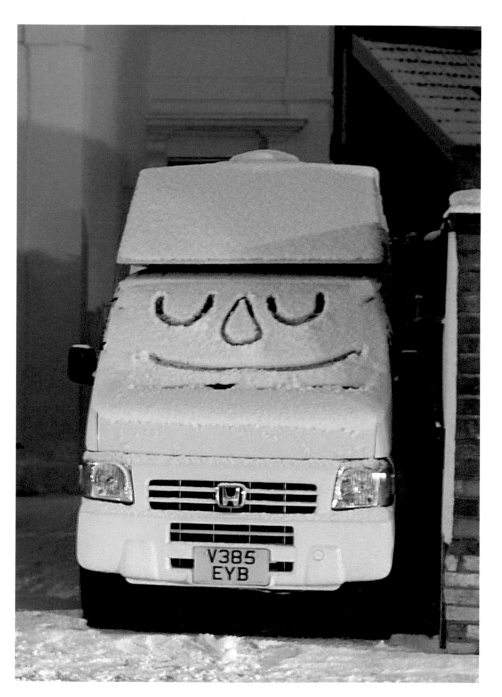

SweetToof

London, UK
www.sweettoof.com

If you ever find yourself passing a giant set of neon gnashers painted on a wall, then chances are you've just encountered the dental daubs of the man known as SweetToof, whose trademark "teef and gums" are a regular fixture of East London's street art scene.

Photograph: Mark Rigney

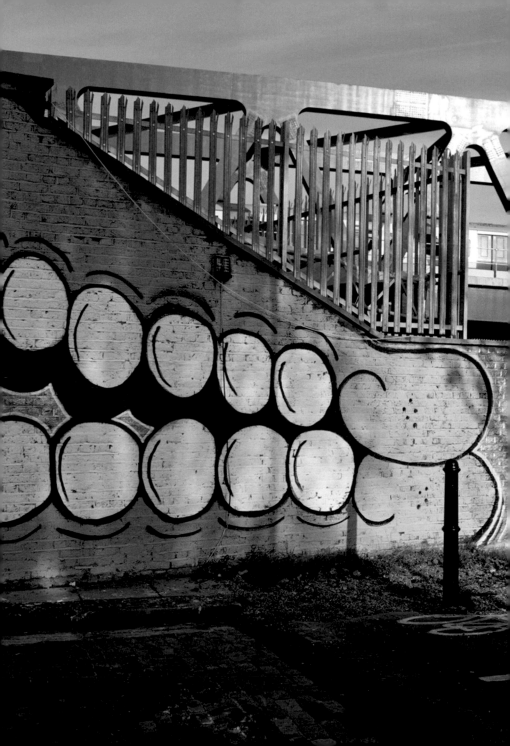

Conor Harrington
Cork, Ireland
www.conorharrington.com

From Cork, in south-west Ireland, Conor Harrington uses a mixture of spraypaint and emulsion to create uniquely striking imagery which, in Conor's view, explores the idea of "masculinity in urban culture". Conor's male figures, which could have stepped out of a modernist painting, utilise opposing elements combined with markings conventionally associated with the visual language of graffiti. The following pages shine a spotlight on a selection of pieces from London, Cork, Dublin and Grottaglie, in Italy.

Photographs: Ciro Quaranta, Ian Cox

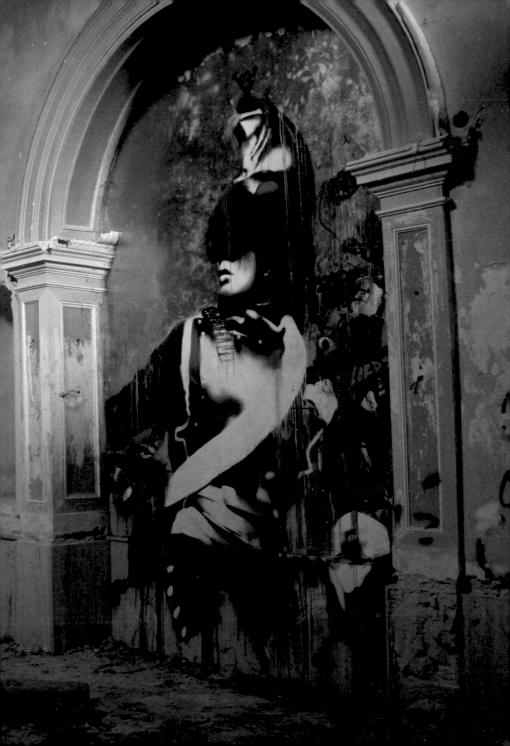

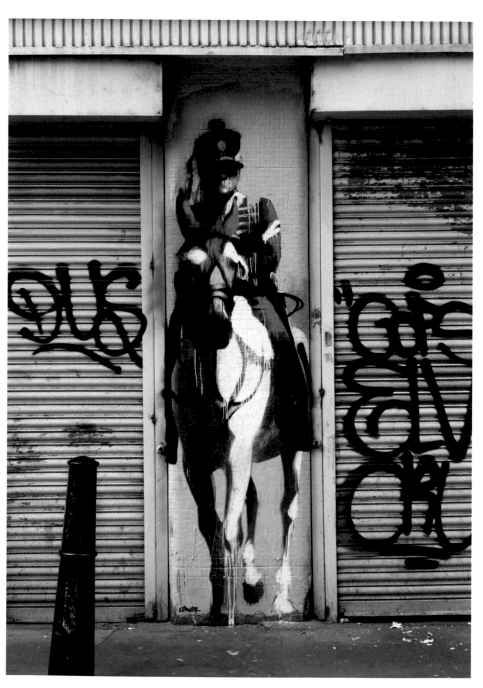

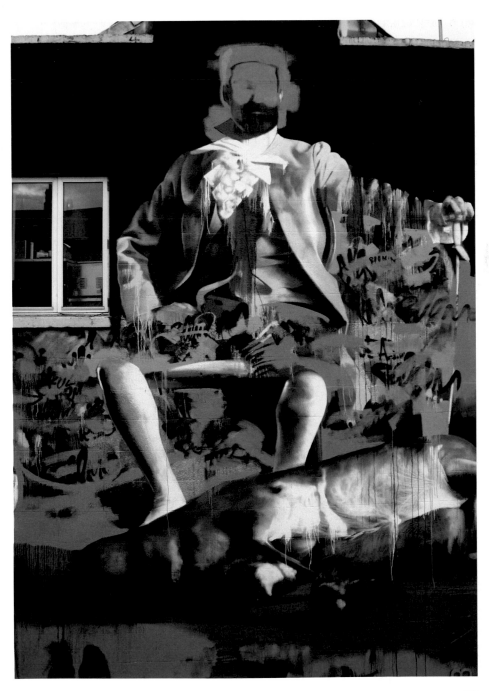

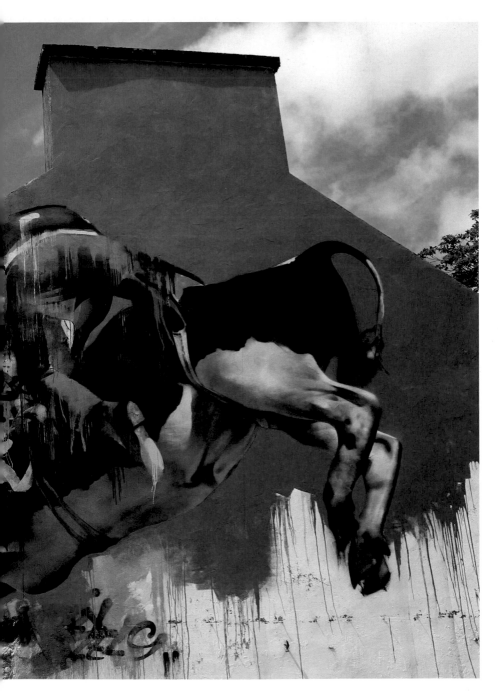

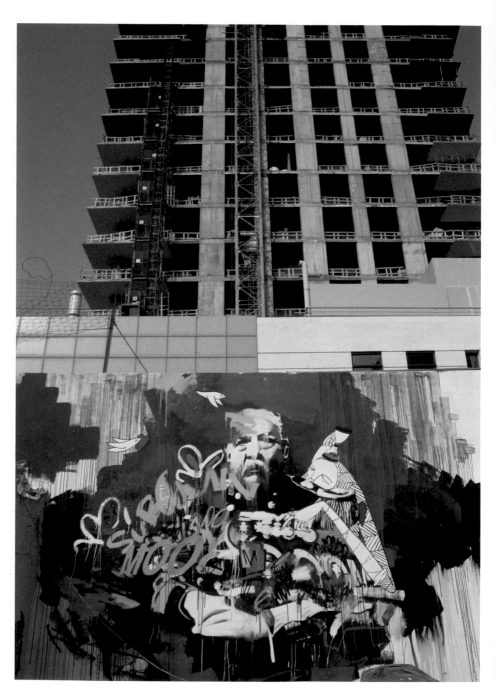

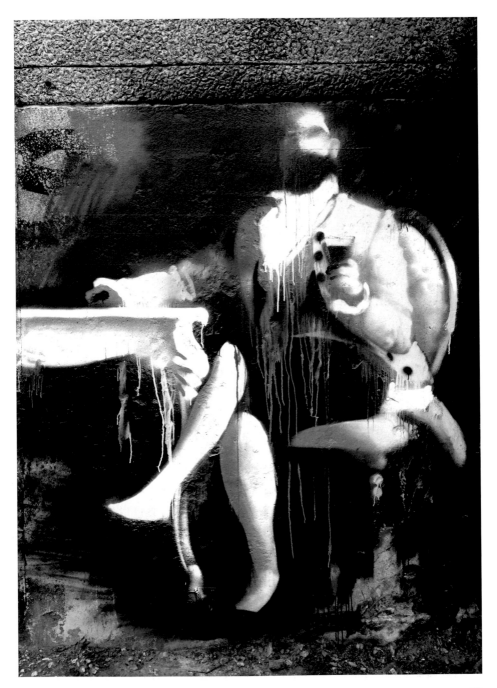

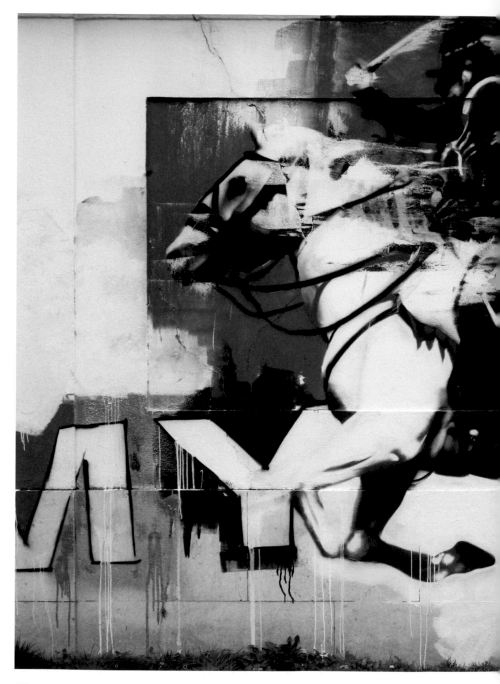

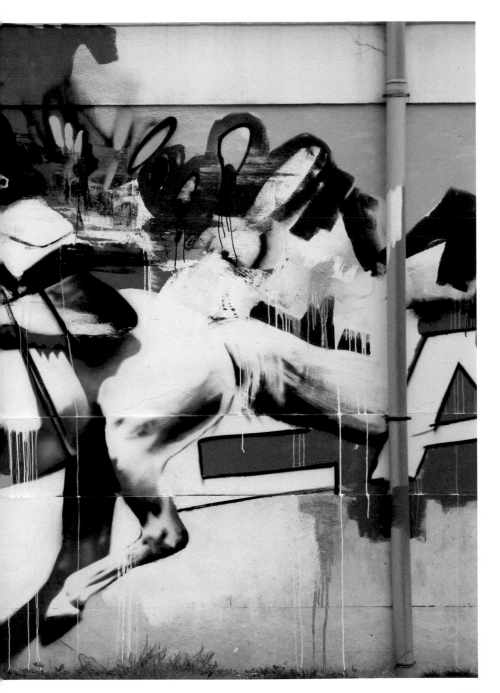

Dscreet

London, UK
www.prescriptionart.com

Dscreet's owls are a common sight in London, England, and have now migrated to quite a few other countries besides. Deftly sidestepping praise, his biography claims that "with his quintessentially mediocre doodles of birds on other people's walls he aims to reinvigorate and purify democracy and to achieve world peace forcefully."

Photograph: Dscreet

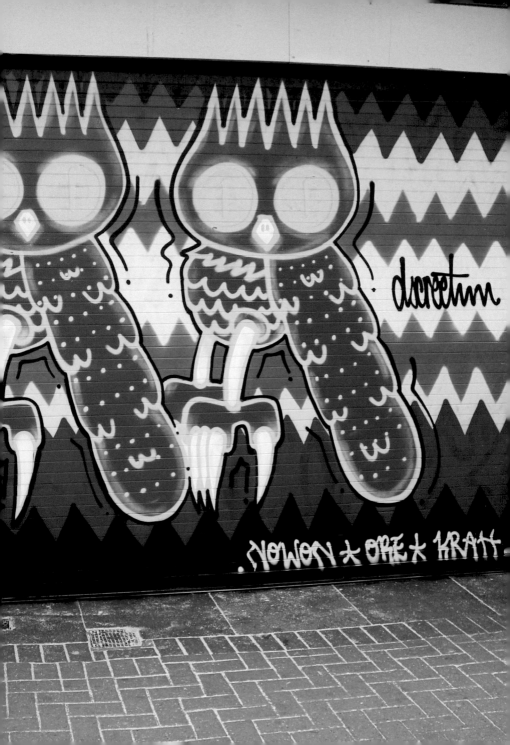

Culprit

Edinburgh, UK
www.culprittech.blogspot.co.uk

Illustrator Matt Pattinson has been using the Culprit tag to identify his stickers and paste-ups since the 90s when he was part of the first wave of sticker art in London. Now based in Edinburgh, Scotland, the images with which he chooses to grace walls are from the futuristic "Culprit-Tech" side of his oeuvre, a collage of diagrams, infographics and hand-drawn lines which channel the spirit of comics artist Moebius, futurist Syd Mead and the sci-fi ethos of Japanese Mecha.

Photographs: JAKe

精密

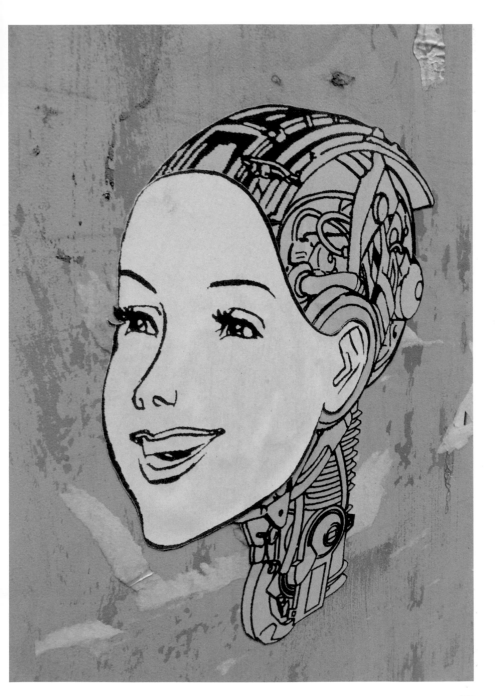

Nick Walker

Bristol, UK

www.theartofnickwalker.com

A longtime veteran of Bristol's graffiti scene, Nick Walker's work was familiar to me from my many visits to Bristol, but I'd also seen his handiwork on London hip-hop club fliers, and was aware of the impressive fact that he'd been hired to "distress" the set of fictional future metropolis Mega City One for the 1995 Hollywood movie adaptation of Brit comic icon *Judge Dredd*. Nick spent weeks covering the film backlot with the tags and stencils of rival, warring gangs to achieve a realistic, lived-in future cityscape; he later did further "set dressing" for Stanley Kubrick's final film, *Eyes Wide Shut*. I would cite Nick as a major Banksy influence, as Nick was already using stencils in Bristol whilst Bansky was still doing freehand graffiti in the same city. The images on the following pages show Nick's skills on display in a number of locations: Bristol (the large piece was part of Inkie's See No Evil event in 2011) Los Angeles, Chicago and Paris.

Photographs: Nick Walker, Tyler Curtis

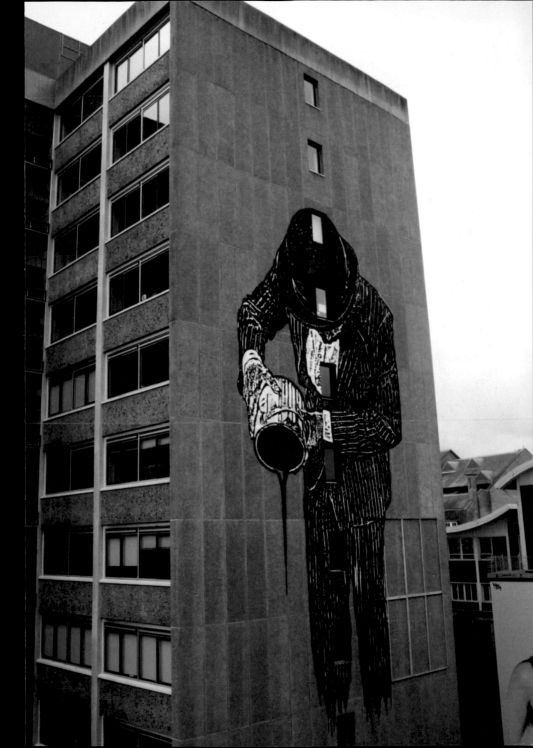

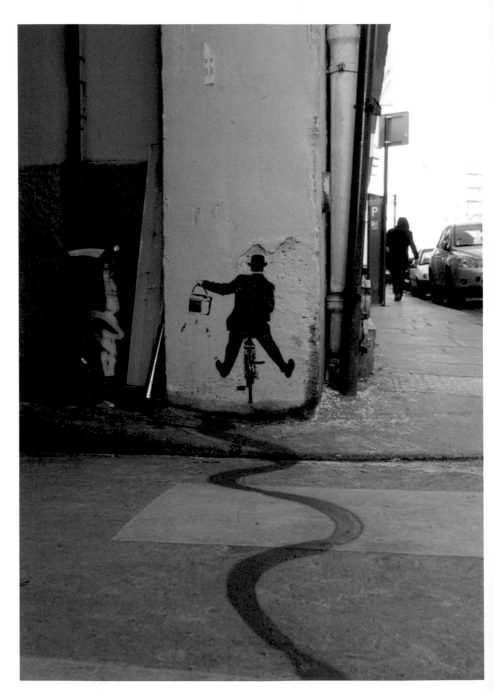

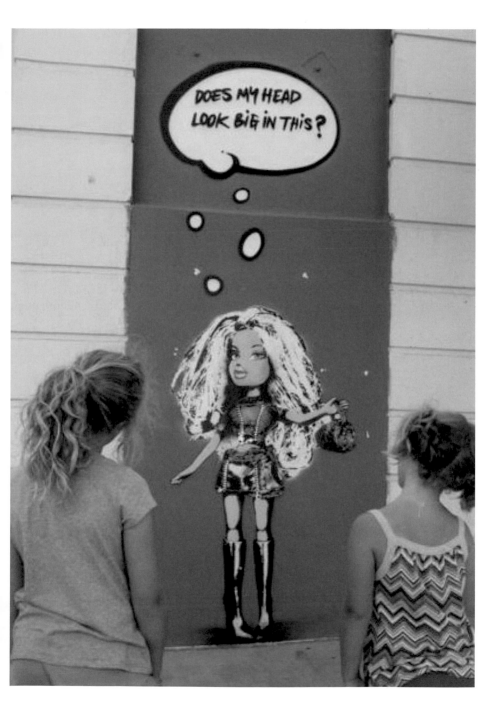

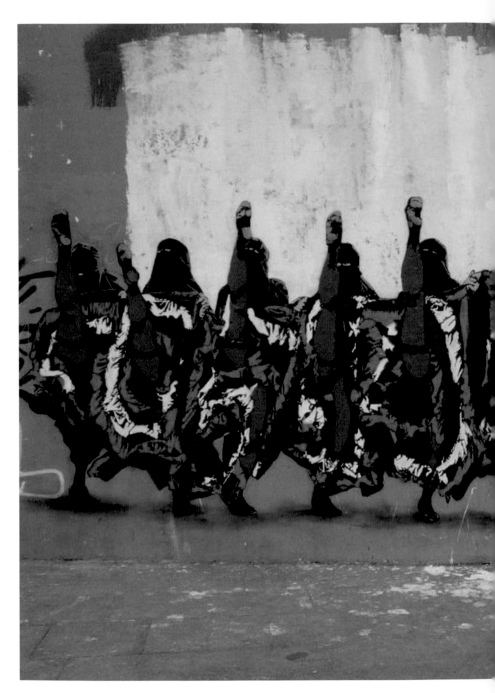

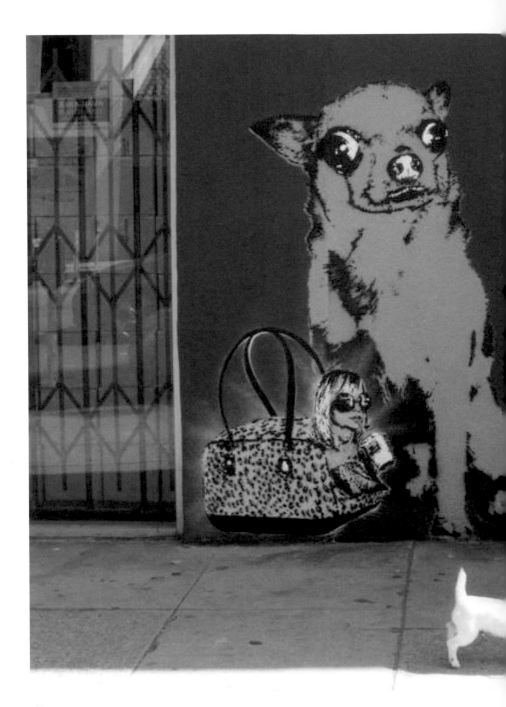

Pinky
Brighton, UK
www.pinkyvision.com

Cutting a distinctive dash with his
Dylanesque afro, Pinky is a veteran
writer from Hull's graffiti scene, whose
DRA crew were as much influenced by
2000 AD's ABC Warriors and the Beatles
as by hip hop. Pinky, now living in
Brighton, mixes brightly-hued modern
psychedelia with some of the crispest
can-control I've ever seen. As Pinky
himself puts it, "No smoke and mirrors."
Just tight aerosol graphics. See the
world in Pinkyvision – fresh is the word.

Photographs: Mister Pinks, Lonnie Pop

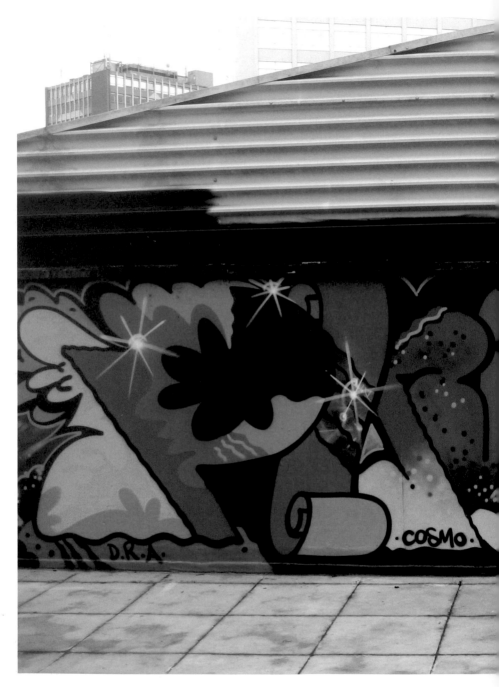

Kid Acne
Sheffield, UK
www.kidacne.com

Straight outta' South Yorkshire, Sheffield's very own hip-hop Renaissance man, Kid Acne, aka Edna, is not only a painting veteran, but raps and makes beats too, having released two idiosyncratic albums on Warp offshoot Lex Recordings. A self-confessed "procrastibator", Acne has not allowed this to impede his work-rate. The following pages showcase a selection of his street work, including his "Stabby Women" wheatpastes and large-scale slogan pieces which reveal a very northern (English) style of self-deprecation.
The following pages show "Ackers" getting up in Sheffield, London, Paris and Barcelona.

Photographs: Kid Acne, JAKe

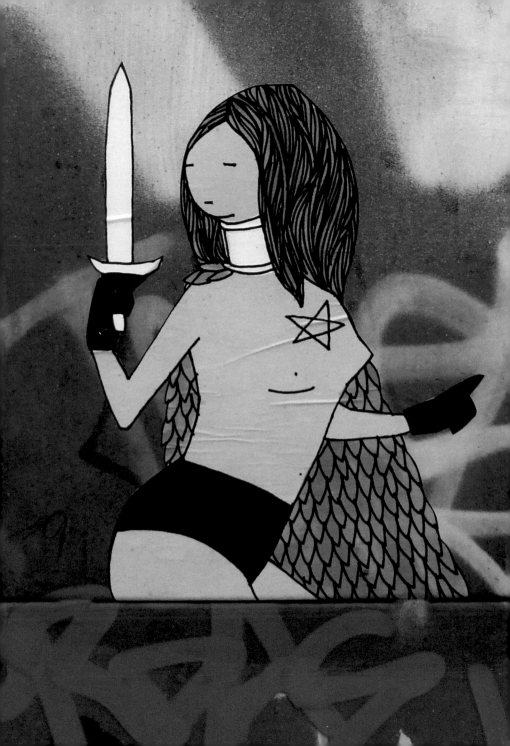

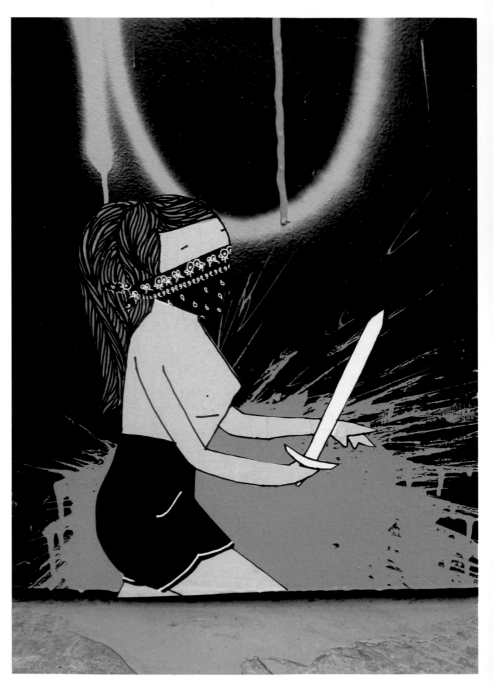

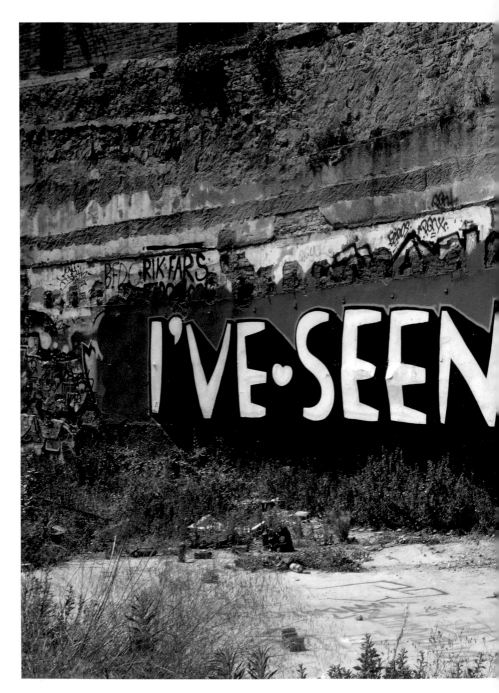

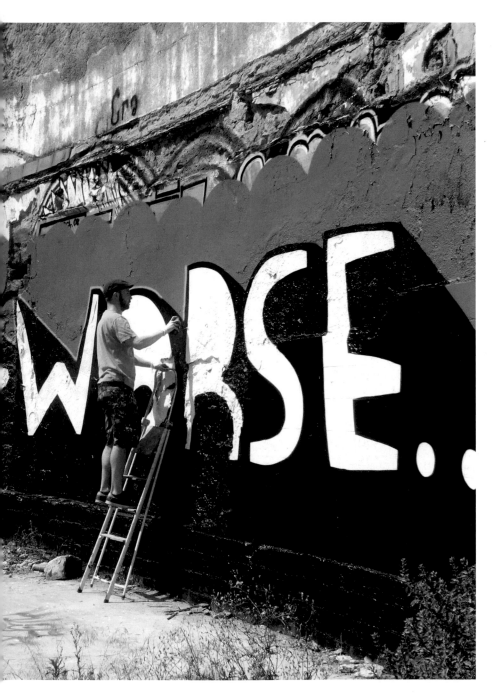

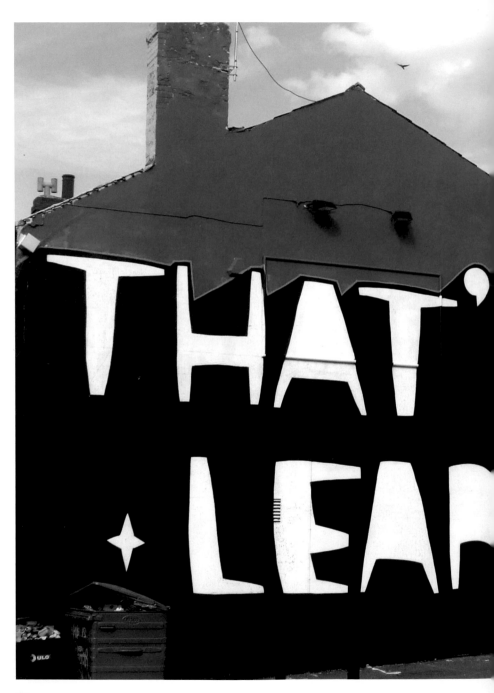

Ema/Florence Blanchard

New York, USA

www.florenceblanchard.com

Florence Blanchard adopted the moniker Ema in the early 1990s when she began spraypainting the walls of her home town Montpellier, in France. It wasn't long before her works adorned buildings and trains in the south of France, Barcelona, Paris and elsewhere in Europe. She then moved to North America. The following pages show Ema's character work in London, Beijing and Paris.

Photographs: Mark Rigney, Nigel Bendle

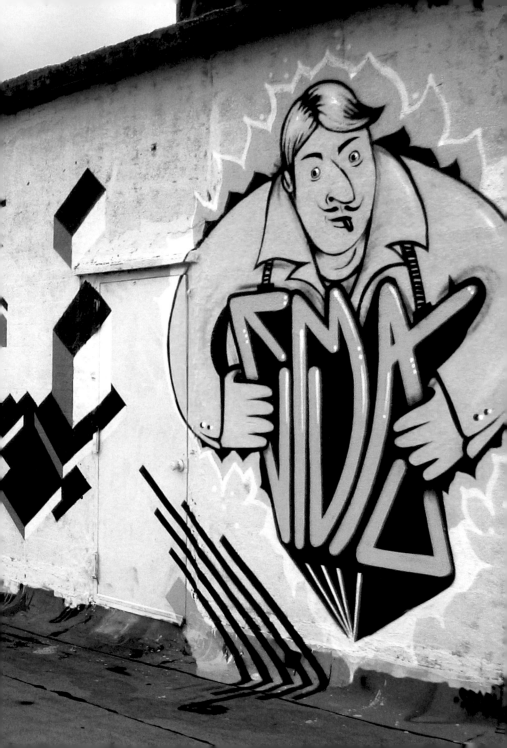

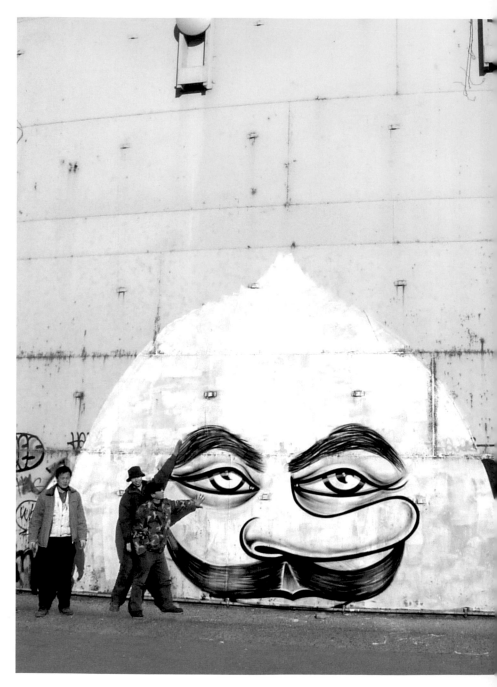

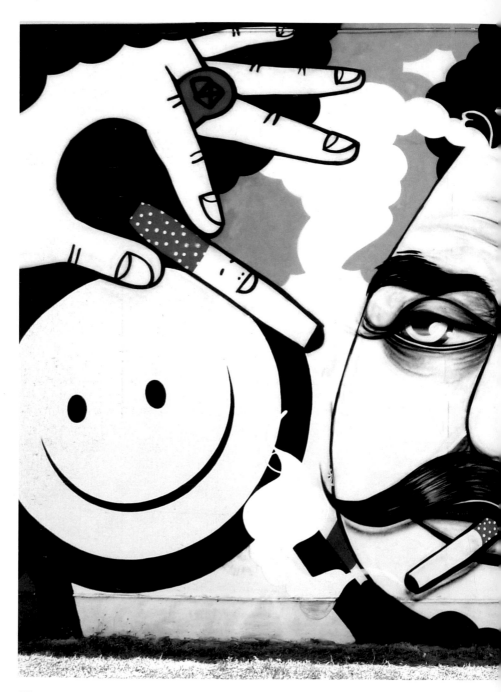

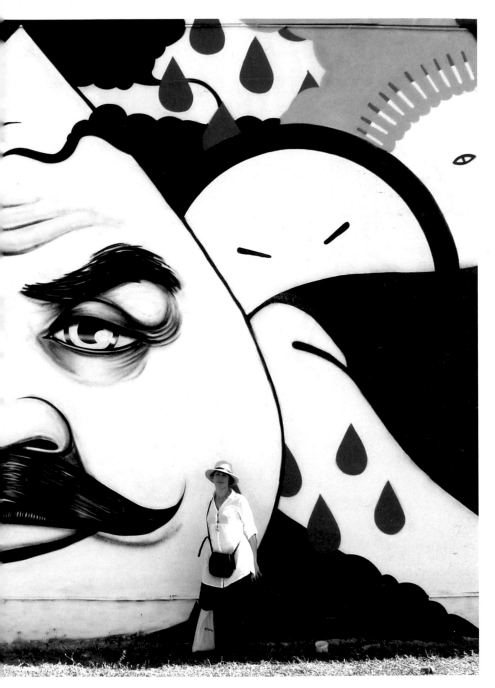

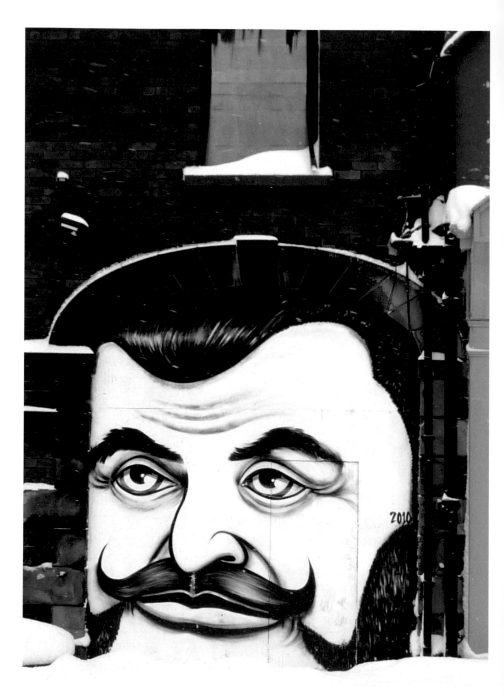

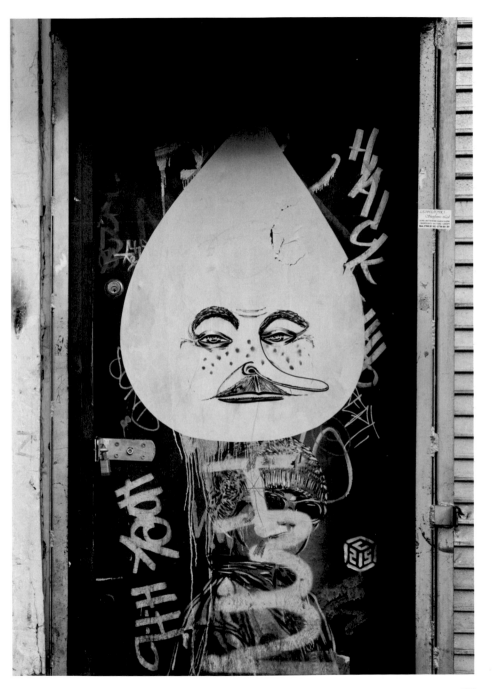

Zeel

Hastings, UK
www.zeel.co.uk

Little is known about the mysterious Zeel: comics artist, toymaker, sticker pioneer and CEO of Zeel Industries. Right at the begining of the 90s' street art/sticker explosion, Zeel's potato-printed character stickers, often proclaiming "Feel The Zeel", were unmissable on the streets of London. His recent, spooky pieces form part of a loose narrative series called "The White Death", inspired by voodoo fetishes and other cursed magical effigies found in museums around the world. Currently putting the fear into the good people of the London borough of Camberwell, the Cult of Zeel shows no signs of abating.

Photographs: The Followers of Zeel

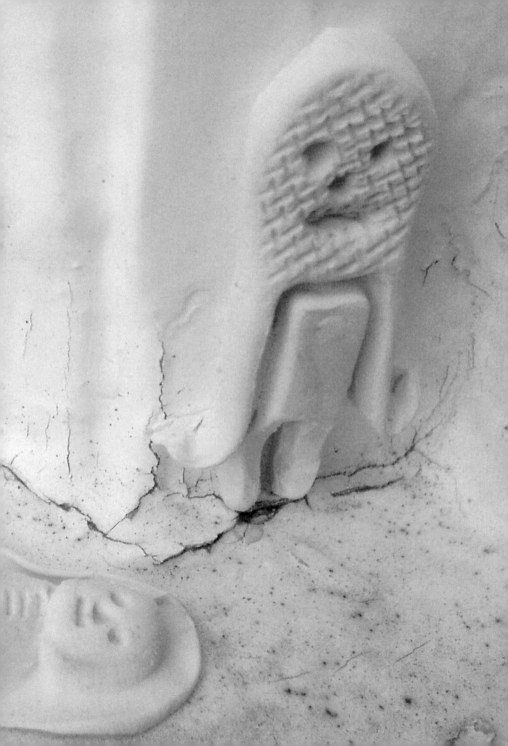

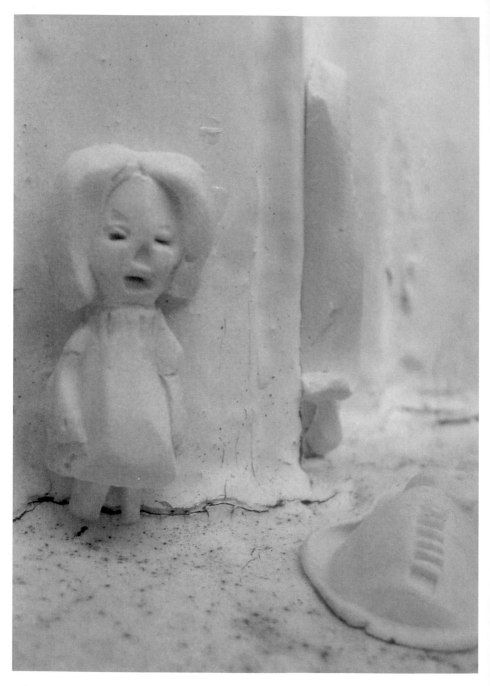

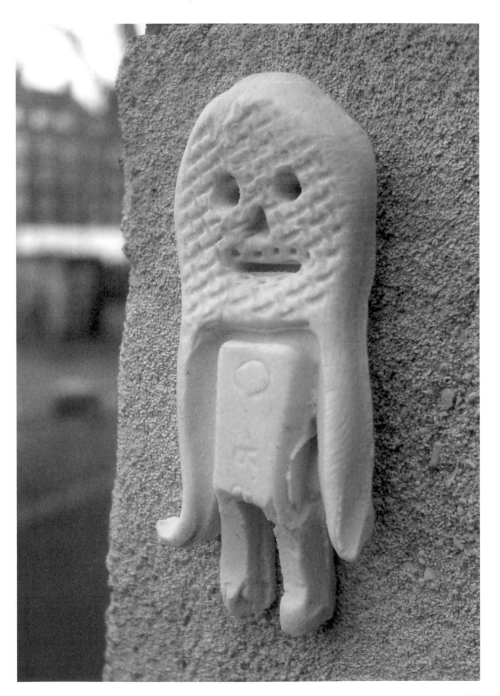

Lucy McLauchlan
Birmingham, UK
www.beat13.co.uk

British-born, Birmingham-based,
Lucy McLauchlan is an internationally-
recognised artist and founder member
of the Beat 13 art collective. Although her
work has been shown in many galleries
throughout the world, Lucy still creates
site-specific work both out-of-doors
and indoors. Here is some of Lucy's fluid,
monochrome line-work on location in
Birmingham, UK, in The Gambia,
in Africa, and Lisbon, Portugal.

Photographs: Matthew Watkins, Mat Beckett and John Rodger

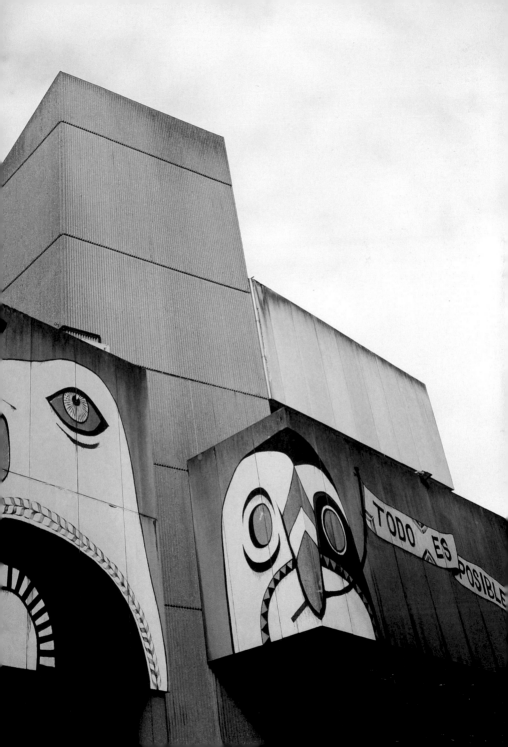

091601

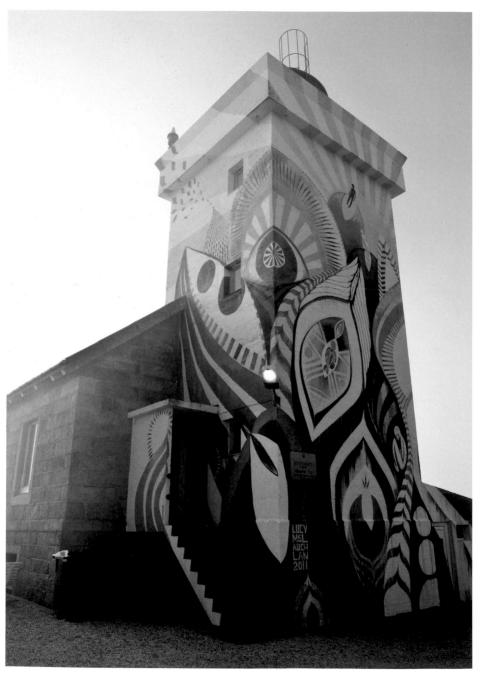

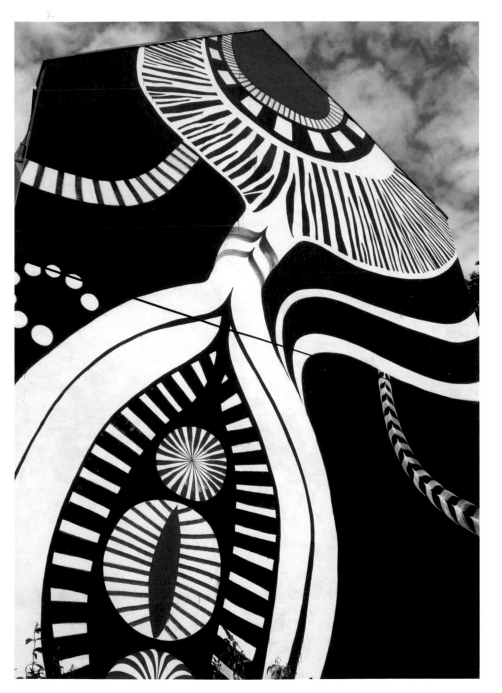

Mysterious Al

Melbourne, Australia
www.mysteriousal.com

British artist Mysterious Al spent
many years sticking and scrawling
his trademark drippy-eyed zombie
characters around the dingier parts
of London. He was one of the founder
members of the now defunct Finders
Keepers collective, alongside Dave the
Chimp and D*Face. Since painting at
the 2011 "See No Evil" event in Bristol,
England, Al has relocated to Australia,
where he continues to unleash his
undead army, flanked now by his fluoro
green "Franks".

Photographs: Ian Cox

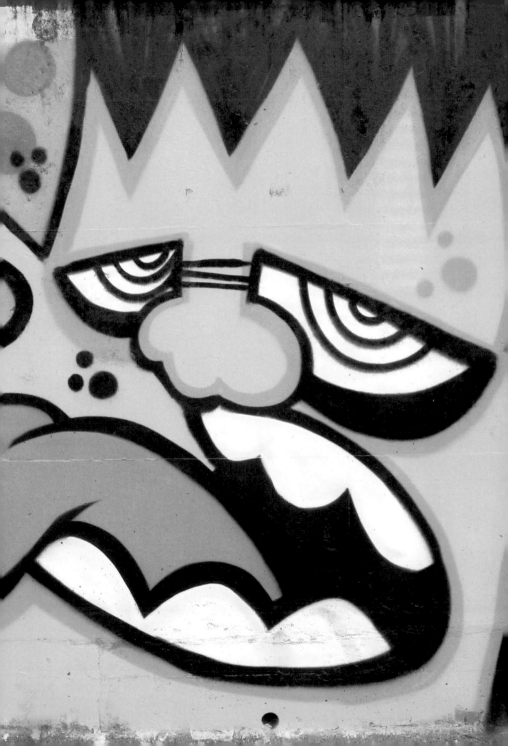

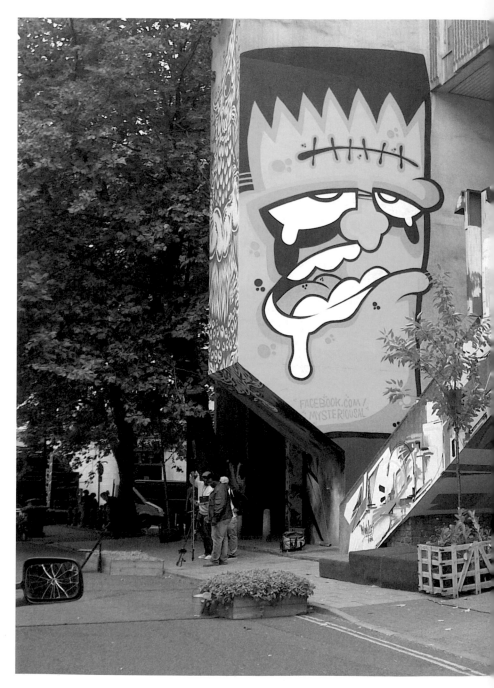

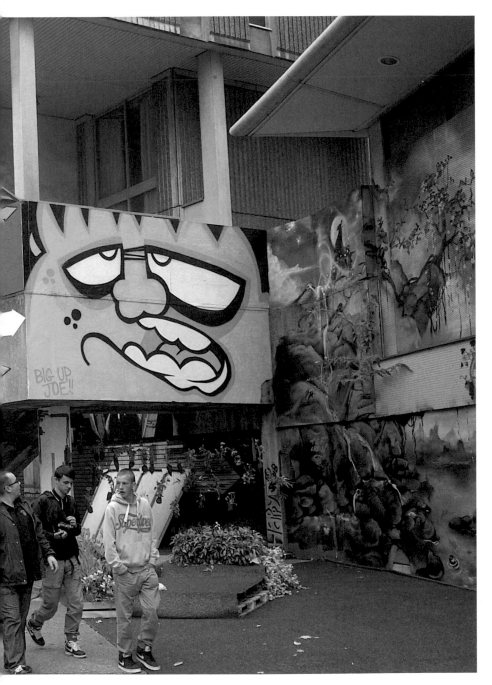

Morcky

Amsterdam, Netherlands

www.morcky.com

Morcky is an Italian artist who has
been living and working in the
Netherlands since 2002. The following
pages show his distinctive line work,
and Morcky's collaborations with
other artists. The pieces shown here
were painted in Amsterdam, in the
Netherlands, and Perugia, Italy.

Photographs: Morcky

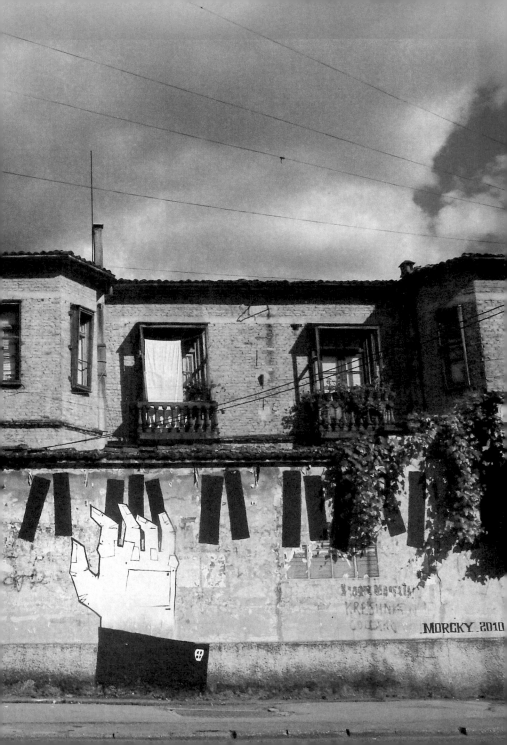

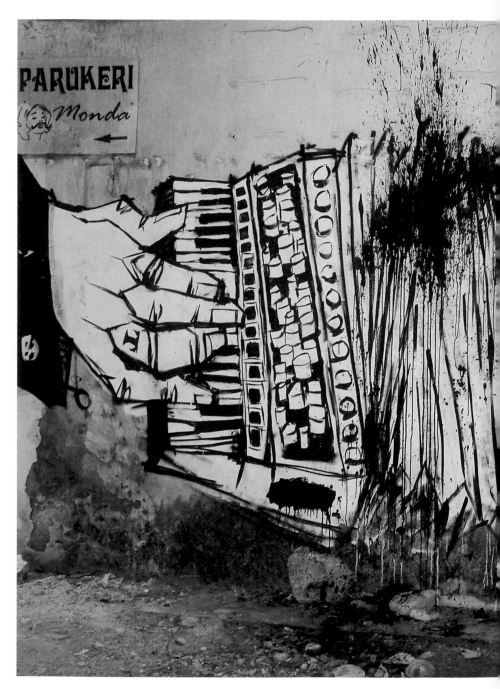

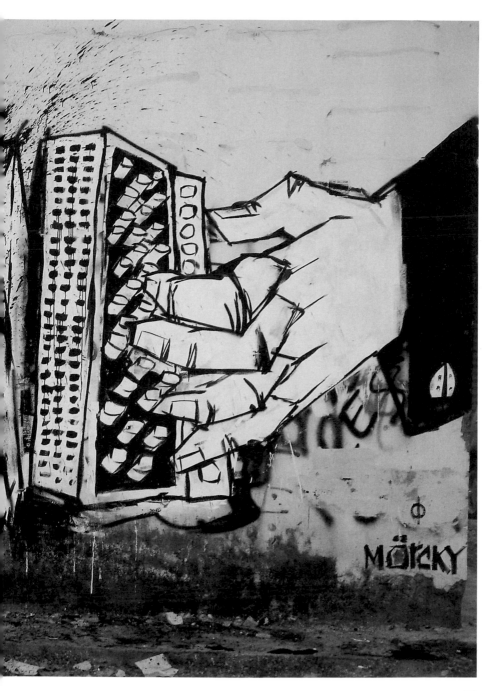

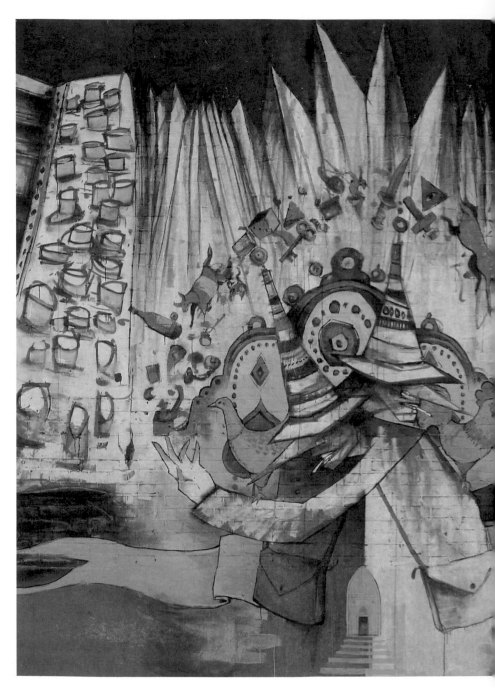

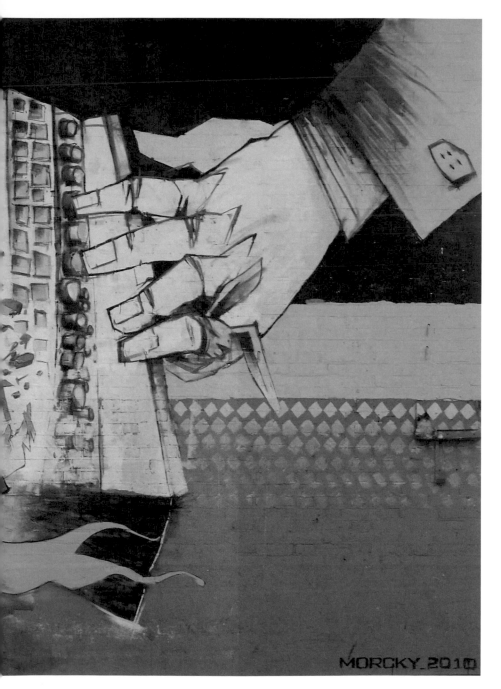

MORCKY_2010

The London Police

Amsterdam, The Netherlands
www.thelondonpolice.com

The London Police, or TLP, started
when two "English geezers" moved
from London to Amsterdam in 1998.
They have been hitting walls worldwide
ever since with their trademark smiley-
faced "lads" character. This photograph
shows a collaboration with Morcky and
Ovni on the giant side of a building in
Perugia, Italy.

Photograph: Morcky

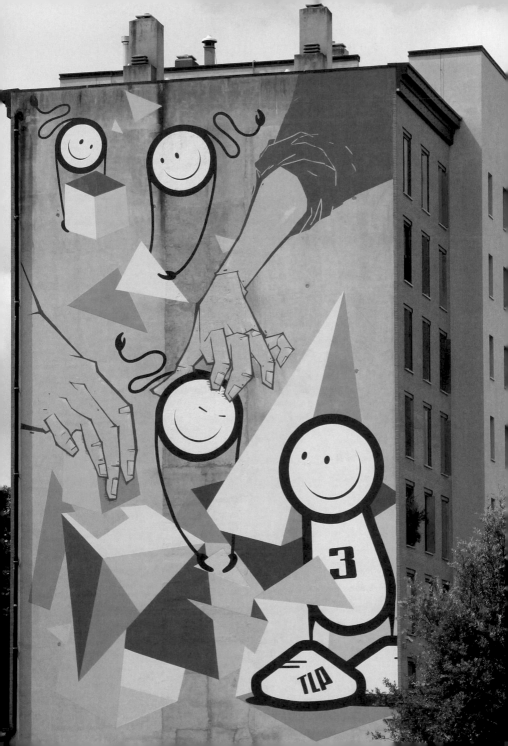

Phlegm

Sheffield, UK

www.phlegmcomics.com

Born in Wales, now living in Sheffield, England, illustrator and comic artist Phlegm spraypaints giant monochrome character designs which often look as though they have stepped from the pages of a delightfully eerie European children's book.

Photographs: Phlegm, JAKe, Mark Rigney

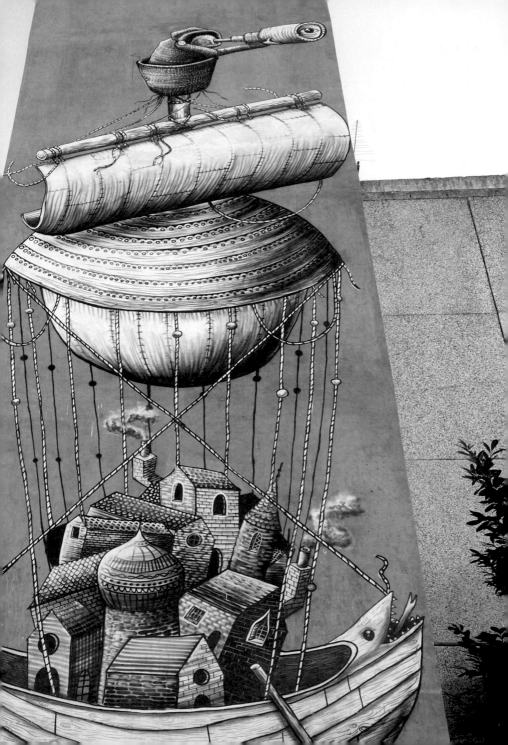

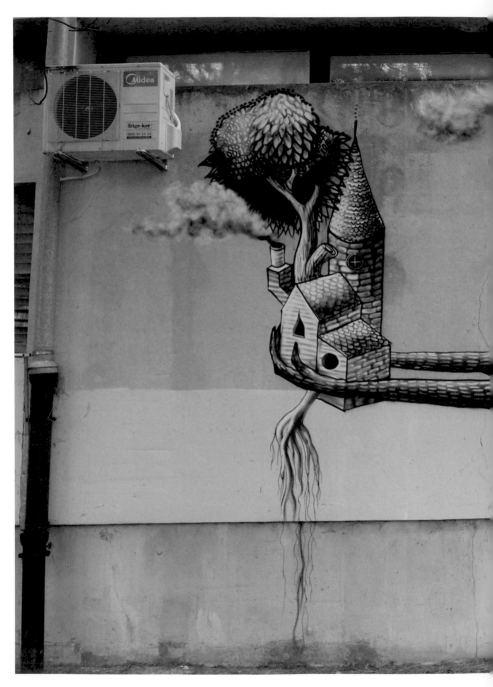

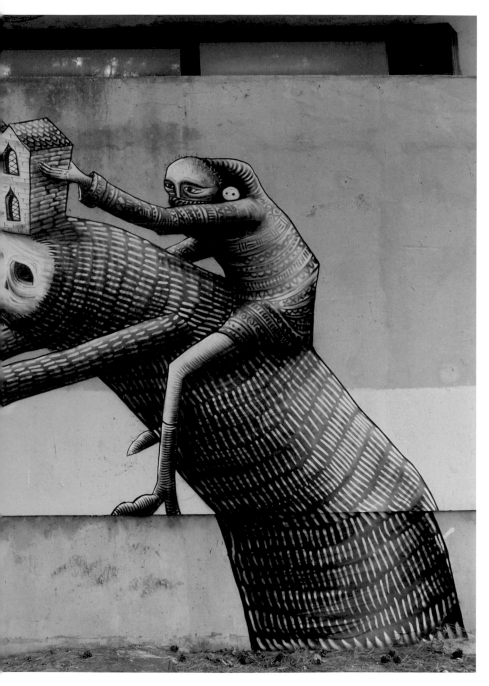

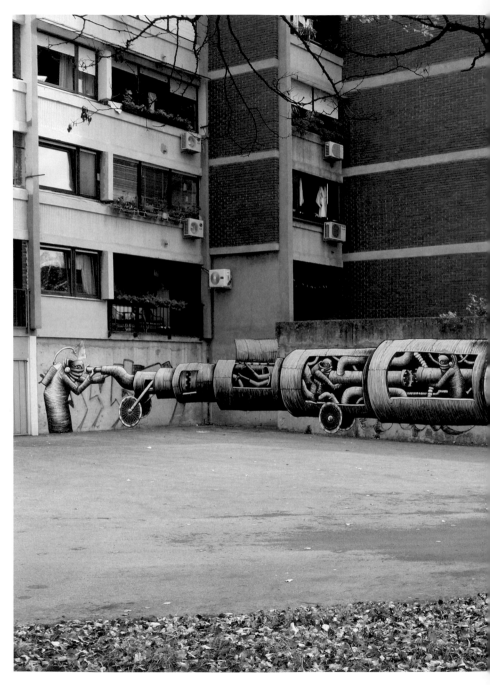

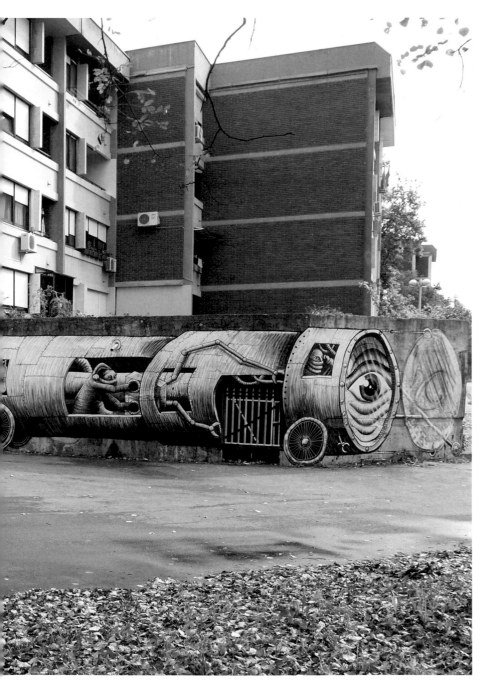

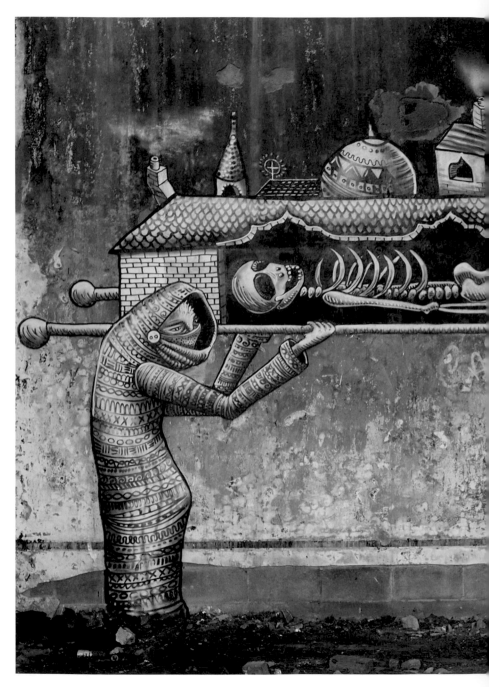

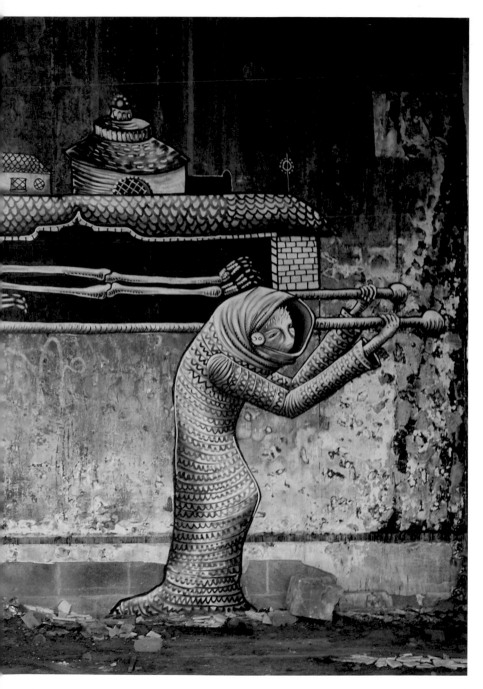

Dreph
Windsor, UK
www.dreph.co.uk

Nottingham-born Neequaye Dreph is
a British graff veteran who has painted
classic letter pieces worldwide since the
early nineties. I have chosen to show
his character work, particularly the
site-specific portrait of a down-and-out
on the following pages, titled "Taste of
Britain", which proves that Dreph cannot
easily be categorized.

Photographs: Dreph

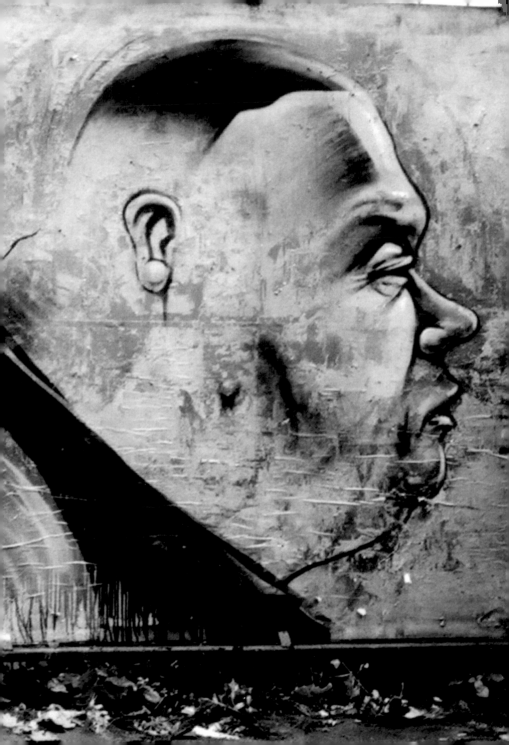

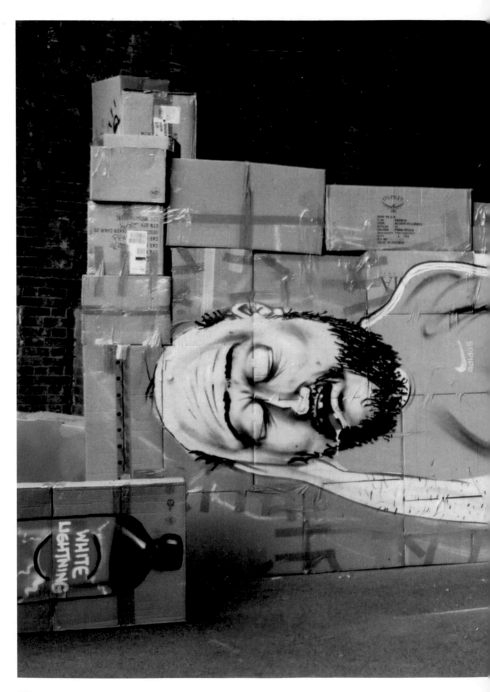

Finsta

Stockholm, Sweden
www.finstafari.com

Swedish artist Finsta has a style that
appears to have been influenced by
underground comix of the 1970s.
He makes work in a variety of media,
including stencils and spraypaint, applied
using an unusual stippling technique.

Photographs: Finsta

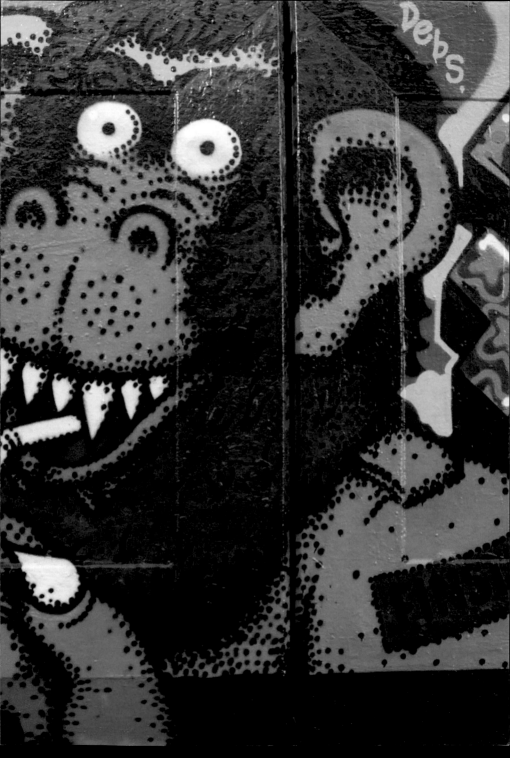

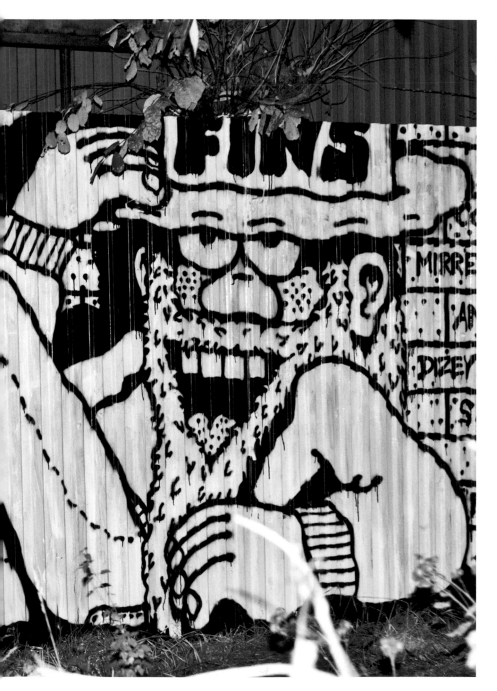

Paris, France

This page, clockwise from top left: Unknown, unknown, Os Gemeos, Everywhere, Invader.

Opposite, clockwise from top left: Unknown, Invader, unknown, Chanoir, Expos, unknown.

Photographs: Woodrow Phoenix

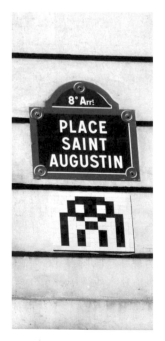

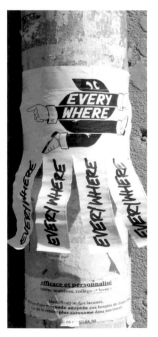

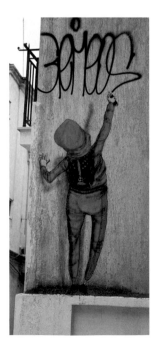

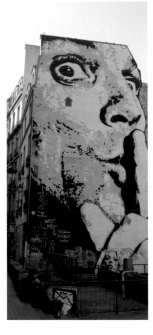

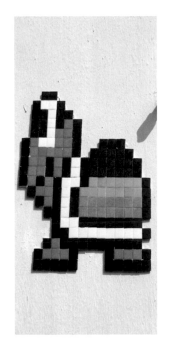

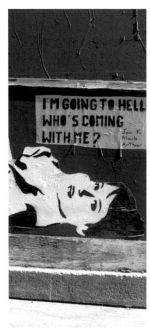

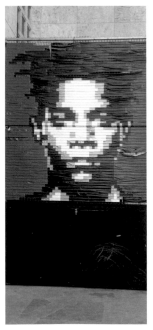

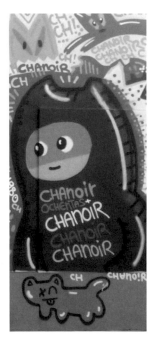

199

André/Monsieur A
Paris, France
www.monsieura.com

In the early 1990s, when I visited Paris, André was one of the first artists that I had seen who used a character instead of a tag, a practice subsequently widely adopted in street art. This photograph, taken in London, shows an early version of Mr A, but the character was later to cut a sharper, more dashing figure, dressed in top hat and winklepickers.

Photograph: Mark Rigney

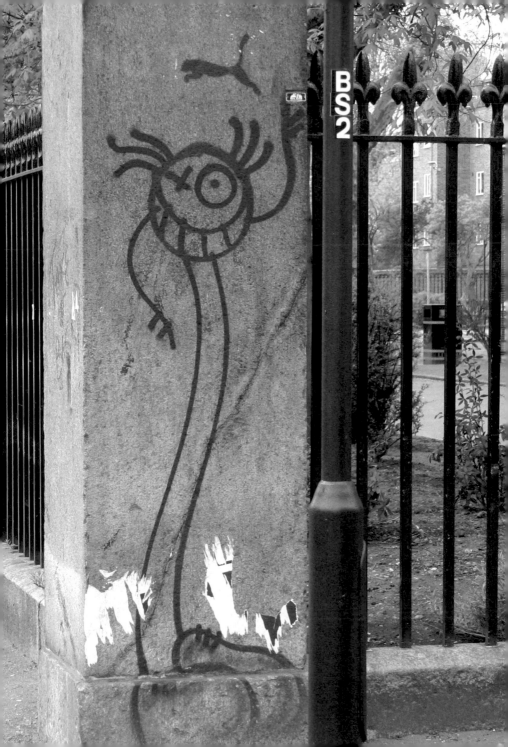

Blek le Rat

Paris, France

bleklerat.free.fr

In 1982, Xavier Prou, inspired by the cartoon character Blek le Roc, adopted the moniker Blek le Rat and began spraypainting stencilled rats around the 14th and 18th Arrondissements of Paris. Initially influenced by the early grafitti in New York City, the stencil technique adopted by Blek was a more fitting response to the architectural styles of Parisian buildings. Blek was one of the first French grafitti artists and his influence on Banksy in particular and on street art in general cannot be underestimated.

Photographs: Sybille Prou, Rosine Klatzman

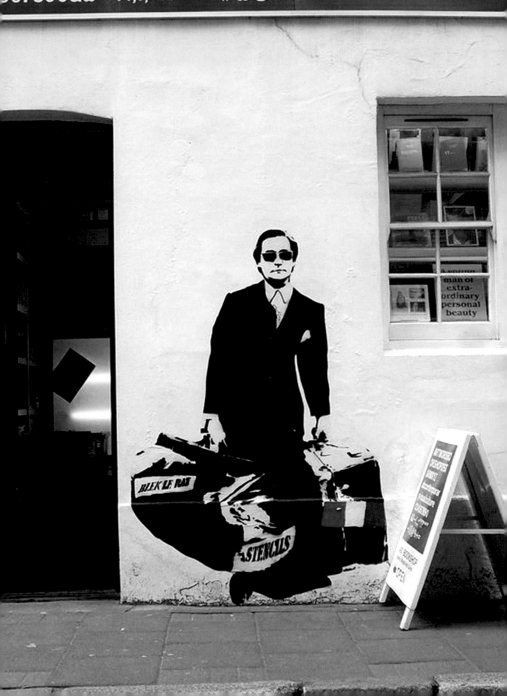

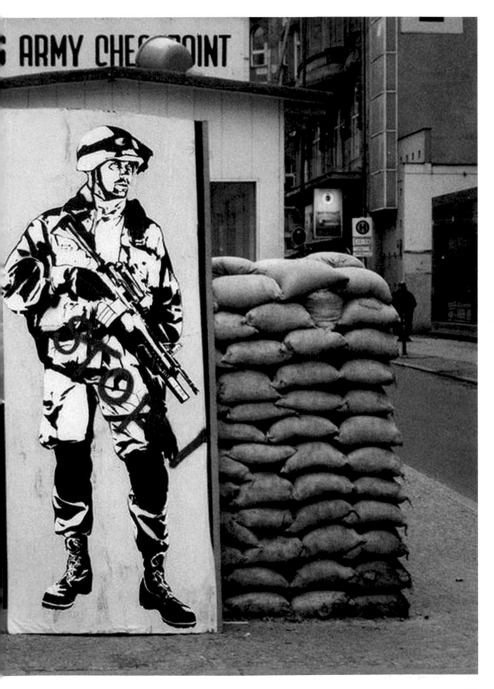

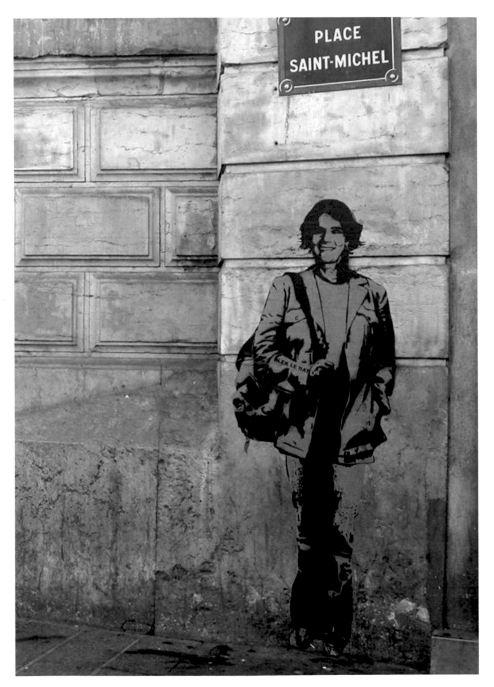

C215

Paris, France
www.c215.com

C215 is a prolific French artist who specialises in intricately stencilled portraits, often of homeless or elderly people, like the figure shown in this photograph taken in London. He has painted in many locations all over the world. Occasionally, he creates likenesses of the work of New York graffiti pioneers like Futura 2000 and Kase2.

Photograph: Mark Rigney

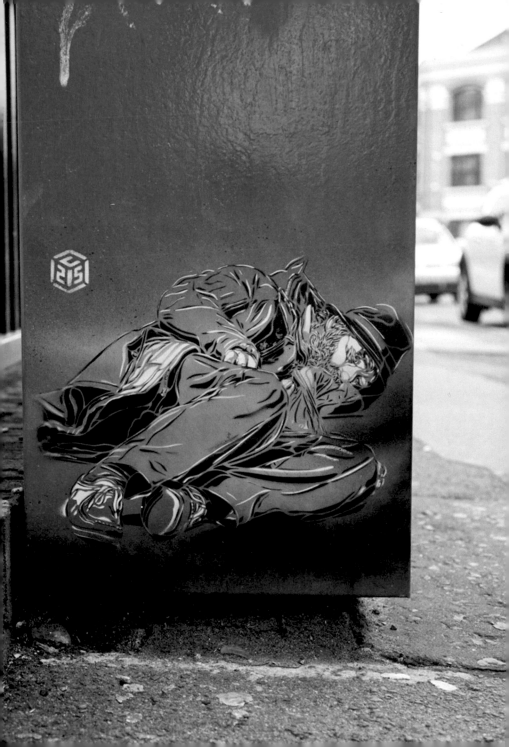

Invader

Paris, France
www.space-invaders.com

Since 1998, the French artist Invader
has been cementing tiled aliens to the
world's walls. Inspired by the Taito
Corporation's classic 1979 arcade game
"Space Invaders", he mimics the
pixellated look of first-generation video
characters with coloured square mosaic
tiles. Invader has carefully planned and
painstakingly installed "Invasions" in
35 of the world's cities so far. He also
produces and sells "Invasion Maps" of
each city, pinpointing the location of each
invader. In Montpellier, the locations
when viewed from above, or seen on
a map, form an image of a giant space
invader character. The pictures on
the following pages show part of the
invasion force in Paris and London.

Photographs: Mark Rigney, Woodrow Phoenix

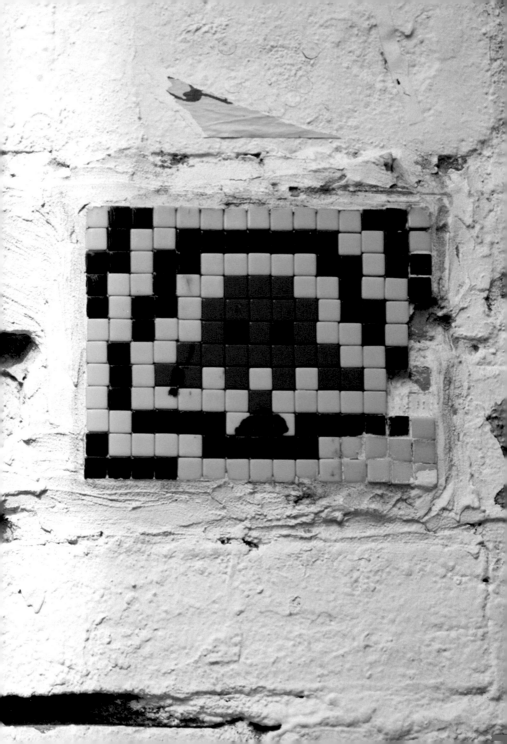

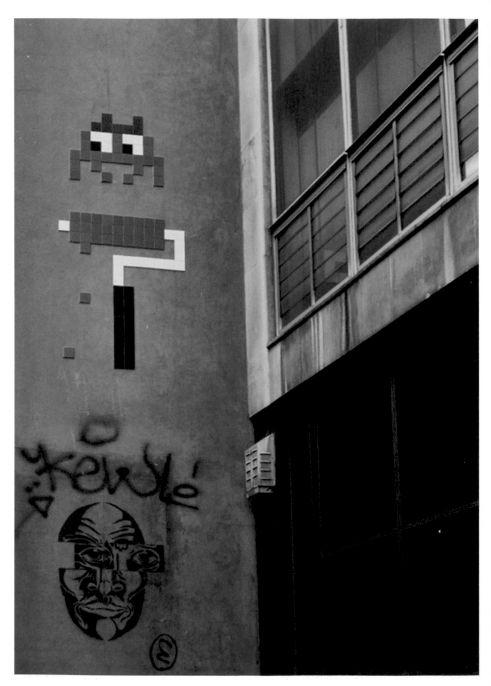

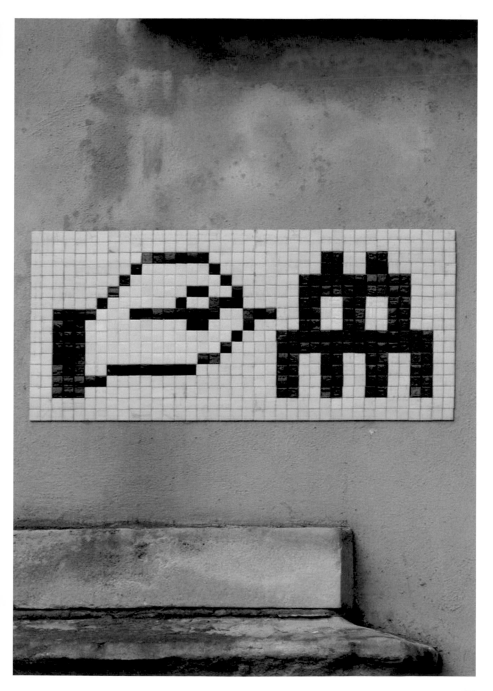

Poch

Rennes, France
www.patrice-poch.com

Patrice Poch cut his first stencil back in 1988, and although inspired by hip-hop graffiti, his work is also informed by rock 'n' roll, 60s' mod culture and ska. Whether using spray paint or acrylic painted paste-ups, like the pieces shown here in Rennes and Lyons, in France, and Mumbai, in India, Poch's aesthetic is always crisp, graphic and eye-catching.

Photographs: Patrice Poch, Fabrice

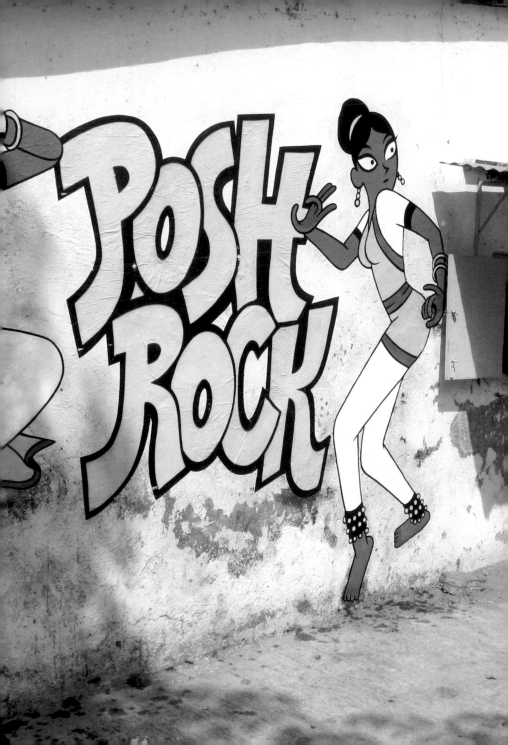

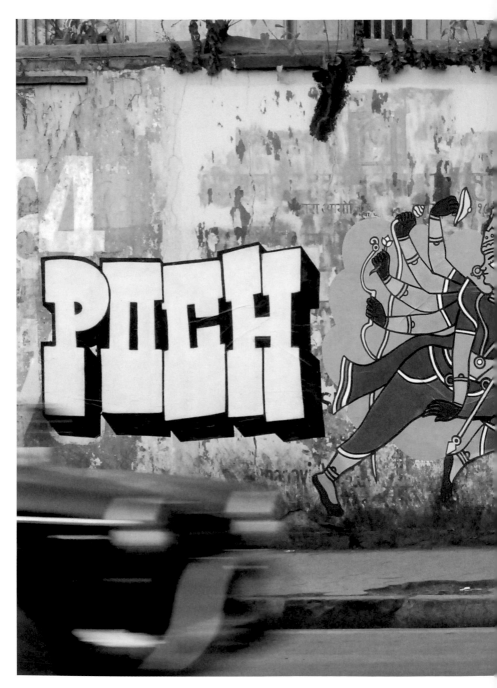

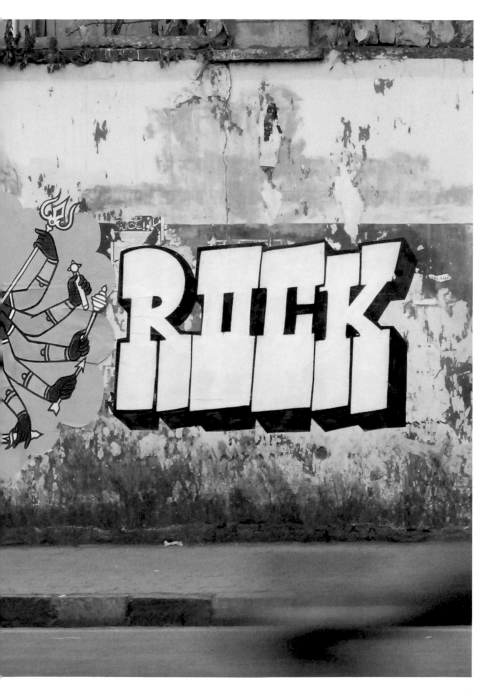

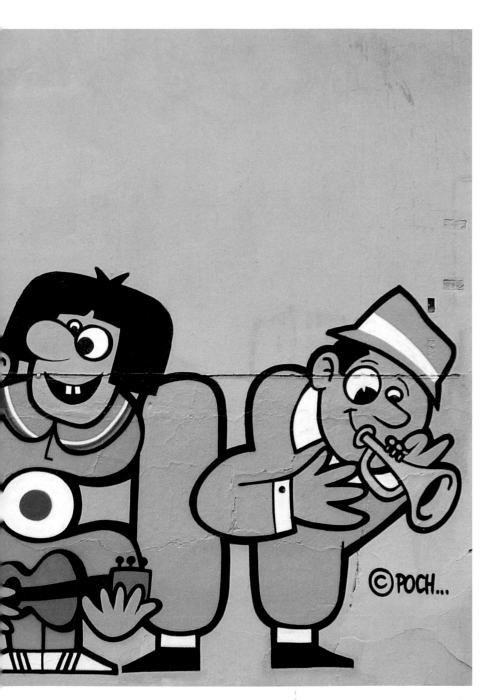

© POCH...

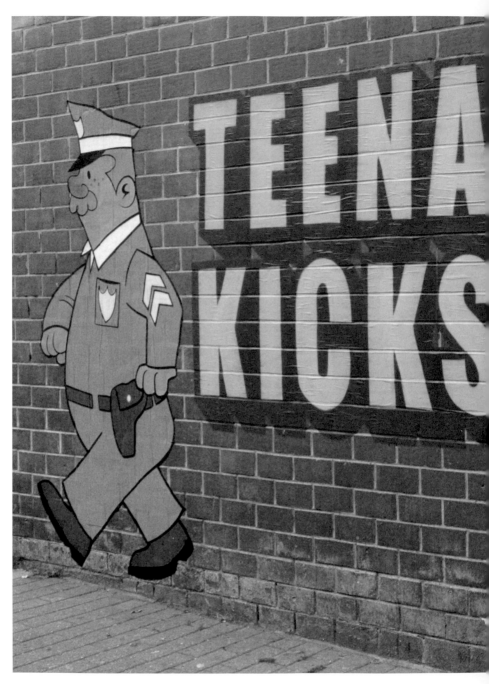

Honet

Paris, France

www.aventuresextraordinaires.fr

Even though Honet has been painting trains since the early 90s, his characters have always been the sharpest characters in street art: all Fred Perry polo shirts and feather cuts in an era when graff and street art were dominated by Nike Dunks and hooded tops. Honet's current characters are styled as urban dandies, always impeccably rendered in his distinctively tight line work. This selection of Honet's work includes the 2010 Turmkunst project in Berlin, where Honet, together with Flying Fortress, Soyzone and KR, converted Bierpinsel Tower into a huge artwork.

Photographs: Honet

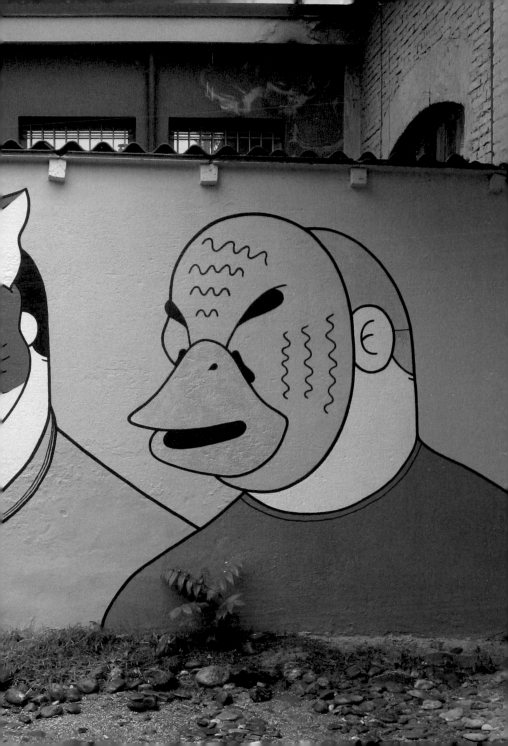

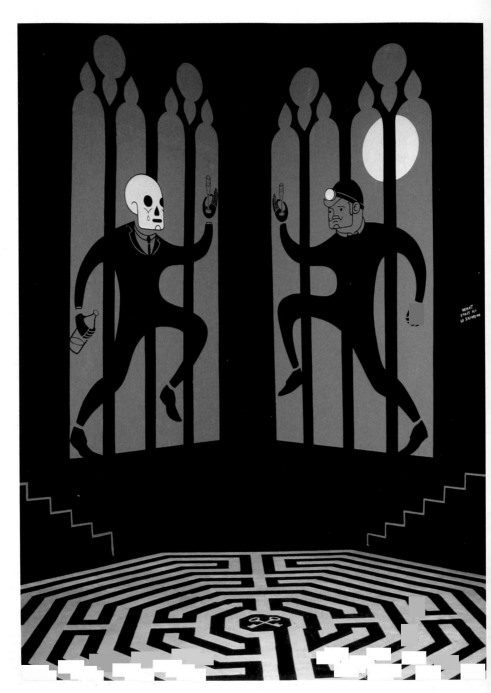

224

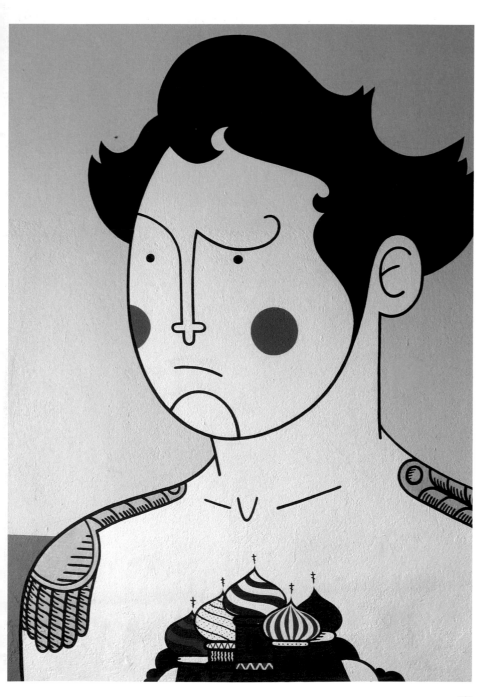

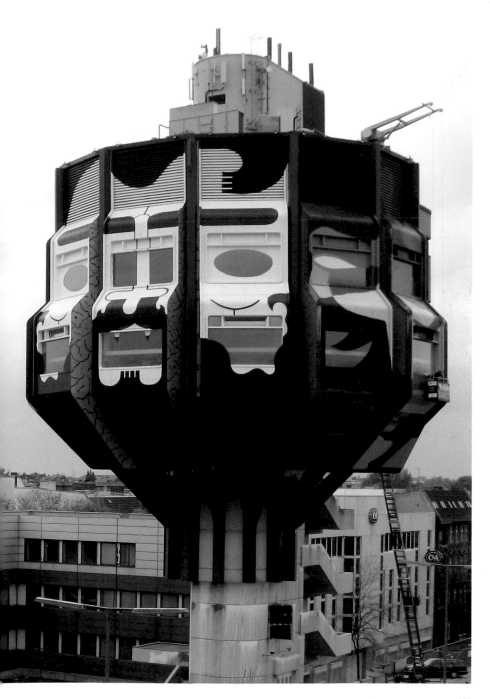

227

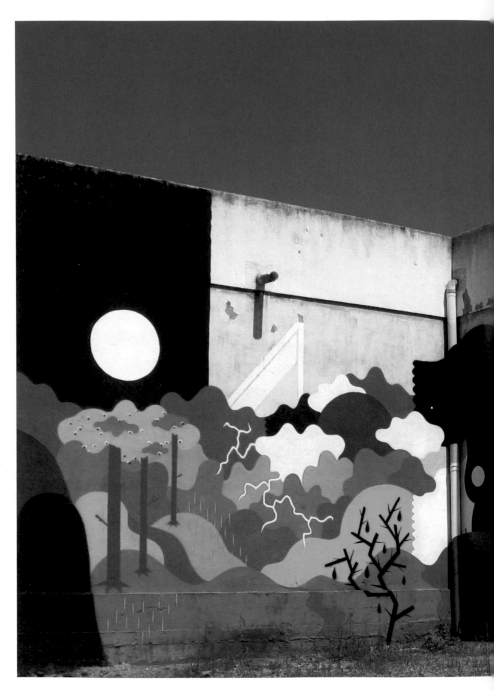

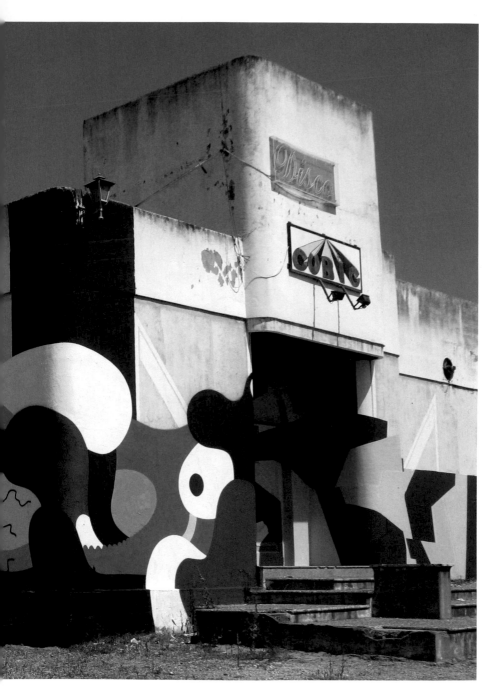

Monsieur Qui

Paris, France
www.monsieurqui.com

Monsieur Qui is a French artist whose drawings of chic women adorn the streets of Paris as if on a fashion-show catwalk. He used both paint and wheatpasting to create these darkly glamorous pieces, which were photographed in the twin fashion capitals of Paris and London.

Photographs: JAKe, Monsieur Qui

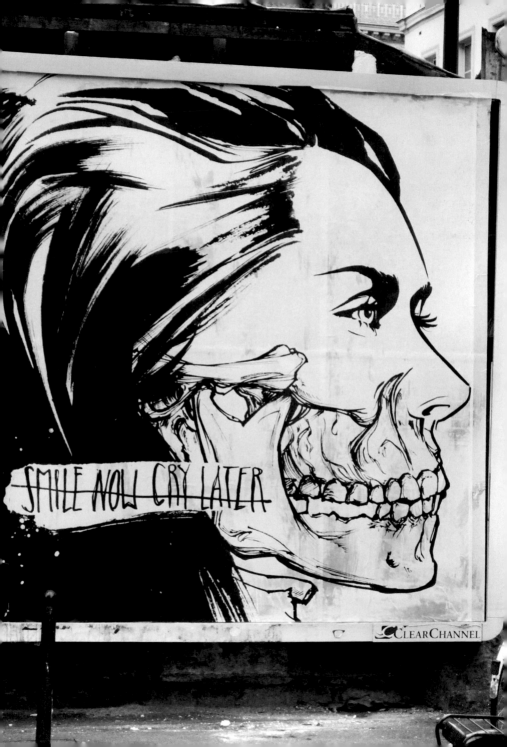

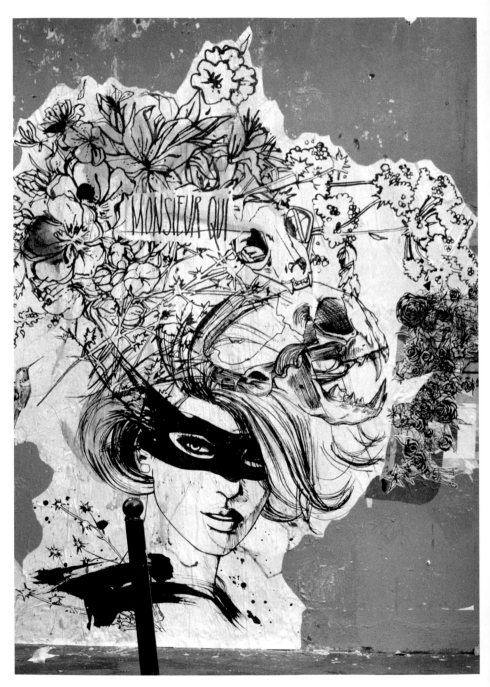

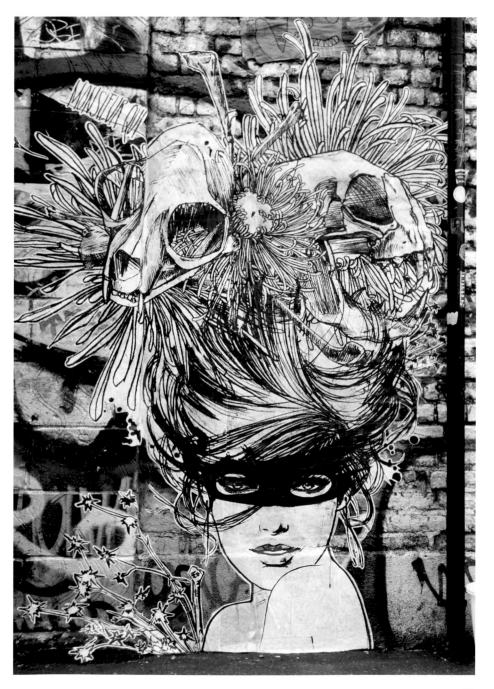

BANKERS WIS

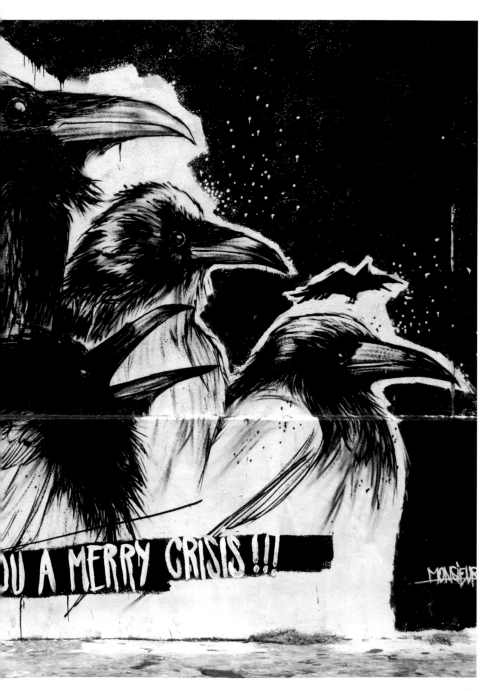

Dave the Chimp

Berlin, Germany
www.davethechimp.co.uk

Now living and working in Berlin,
British artist Dave the Chimp was a prolific
player in the London street art scene of
the 90s, and a founder member of the
Finders Keepers collective alongside
D*Face, Mysterious Al and PMH. Armed
with more talent than some of the more
hyped names in street art, Chimp has
always kept moving, developing new
ways of working and creating an army
of new characters rather than simply
repeating himself. The photographs
here show some of what I would regard
as Dave's throw-ups – fast, loose,
site-specific pieces – painted in London
and Berlin. They reveal Chimp's
mischievous imagination at work.

Photographs: Dave the Chimp

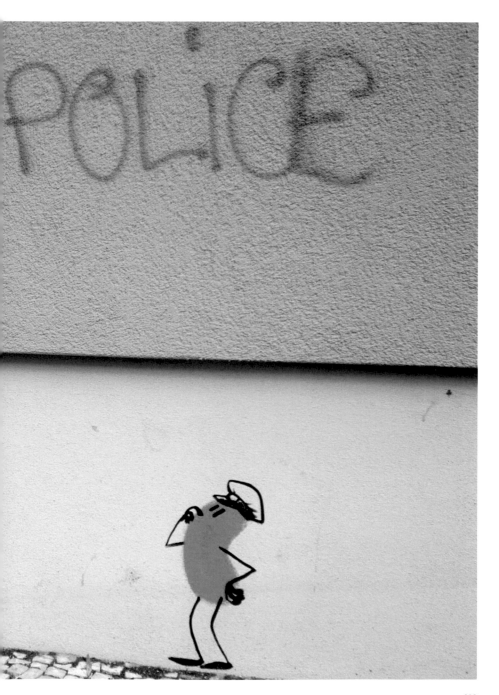

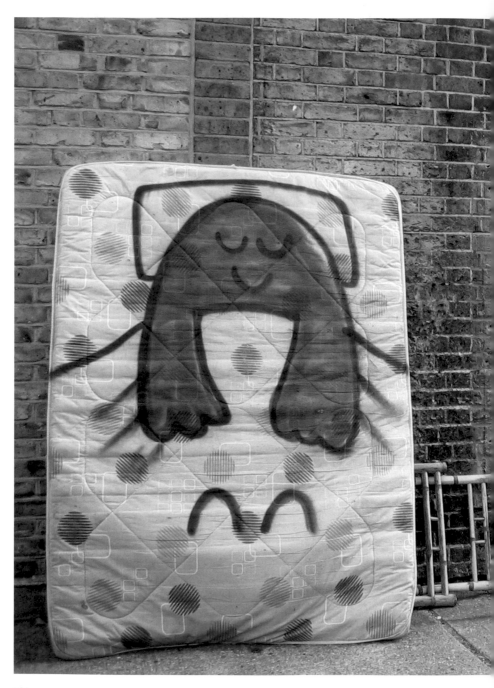

NO PA
RUBBISH
COLLECTIO
POINT
DO NOT BLOC
THIS AREA

Josef Foos

Berlin, Germany
www.street-yoga.de

After reading a newspaper article about Slinkachu's "Little People", yoga teacher Josef Foos was inspired to create his own "korgfiguren", or cork people, which he would bend into yoga positions. The sharp-eyed will spot Josef's "Street Yogis" glued into position all around Berlin.

Photograph: Josef Foos

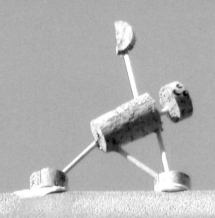

pry of Berlin

eater und Kom

Kurfürstendar

Flying Fortress
Munich, Germany
www.flying-fortress.blogspot.co.uk

Germany's Flying Fortress is long-time graff writer whose "Teddy Troops" characters are a familiar fixture in many cities worldwide. Incredible drawing skills and design sense combined with seemingly effortlessly crisp aerosol skills (plus the artist's mullet and 'tache combo) make FF one of the rock stars of the street art world. These pages show FF pieces in New York, Frankfurt, Hamburg, the Turmkunst project in Berlin and an insane collaboration with the artist Nychos the Weird in Vienna.

Photographs: RockawayBear.com

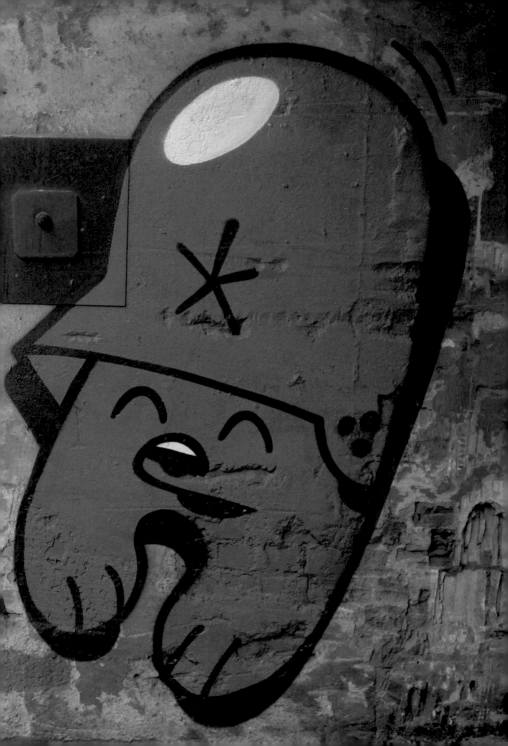

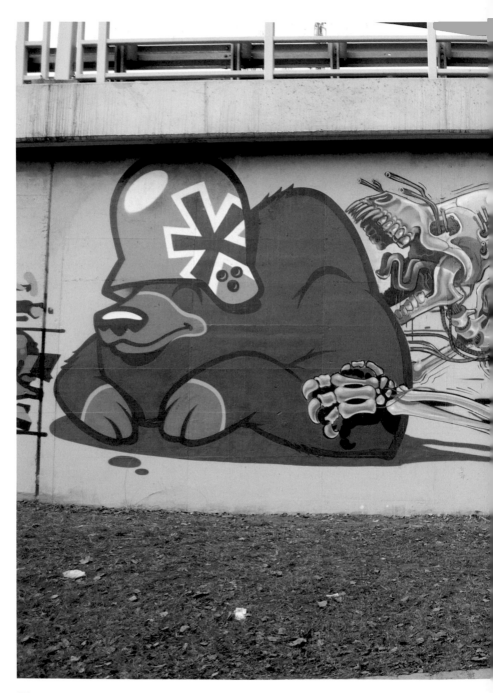

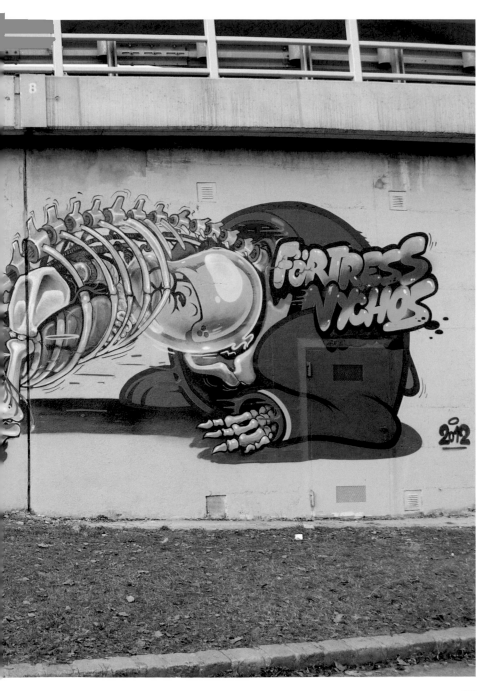

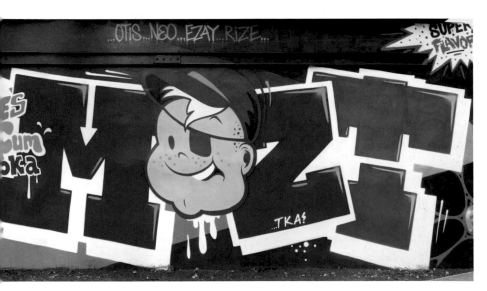

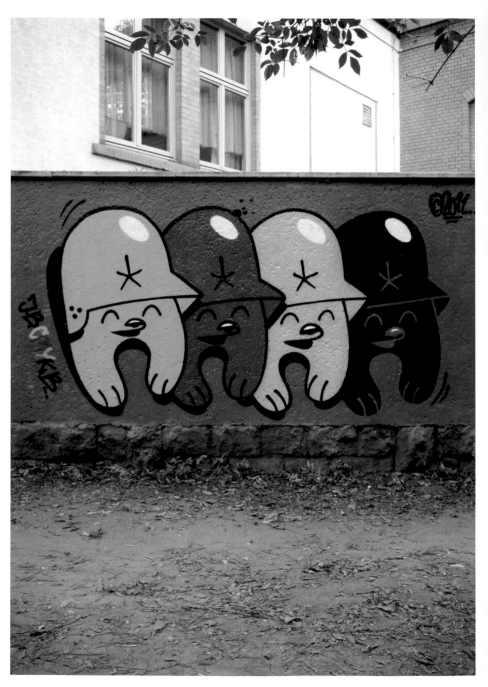

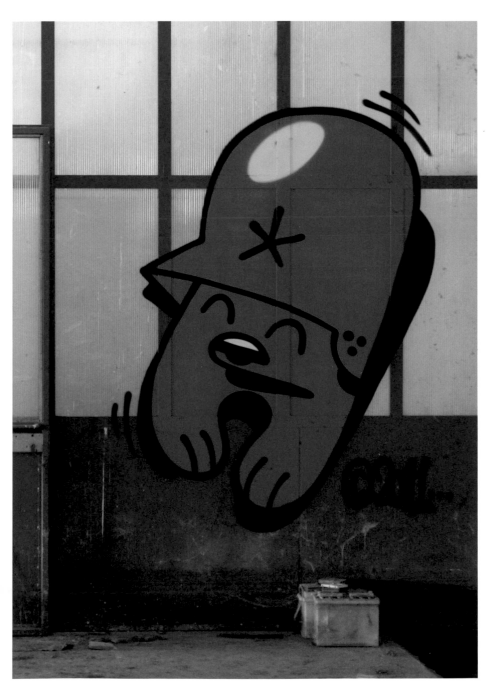

Swanski

Warsaw, Poland
www.swanofobia.com

Polish artist Swanski was born in the last days of the Soviet Empire, and has a distinct style that is reminiscent of engraving or woodcuts. These photographs of Swanski's work, which include a collaboration with Flying Fortress, were taken in Bochum, in Germany, Warsaw and Los Angeles.

Photographs: Jakub Detko, Turbokolor.com

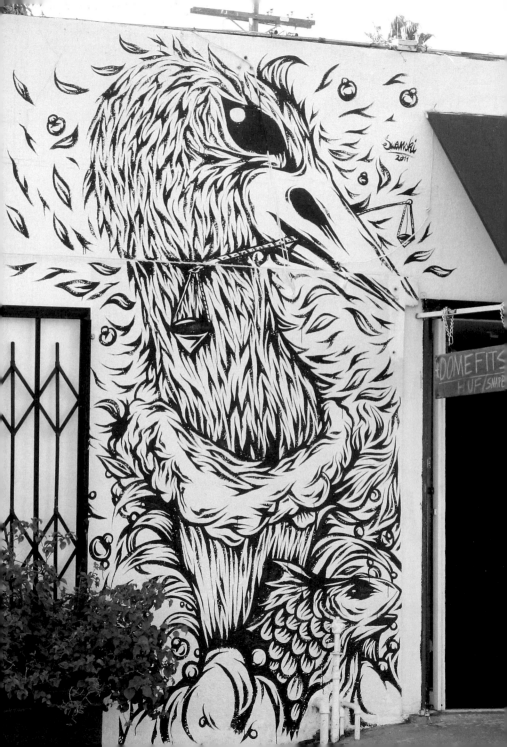

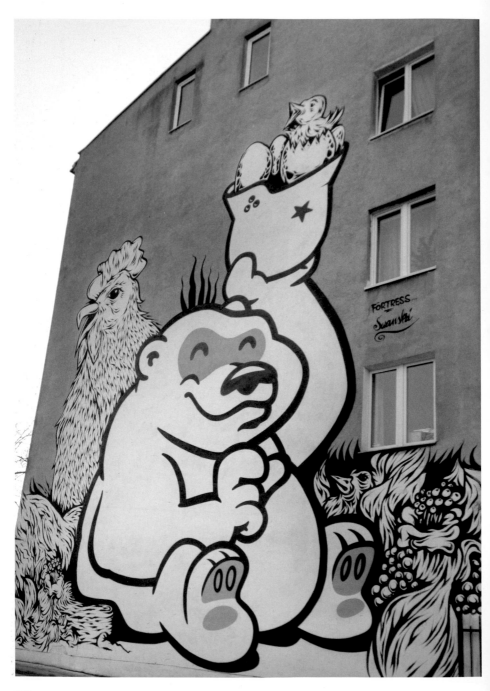

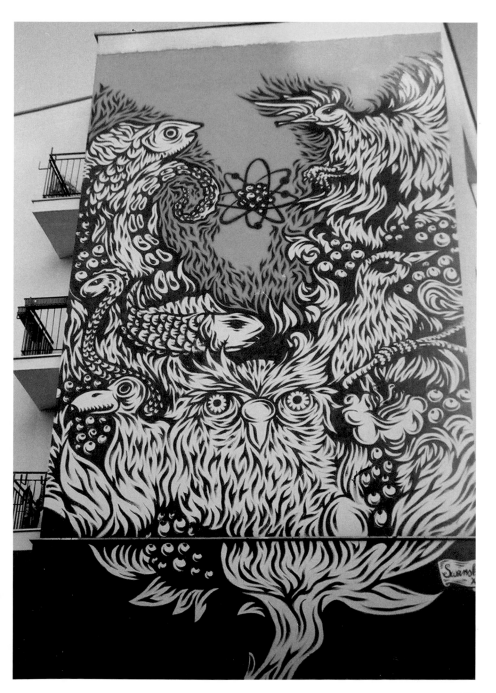

259

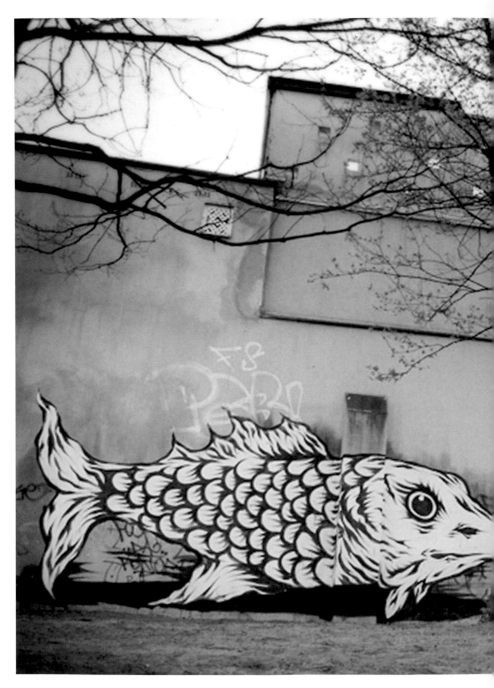

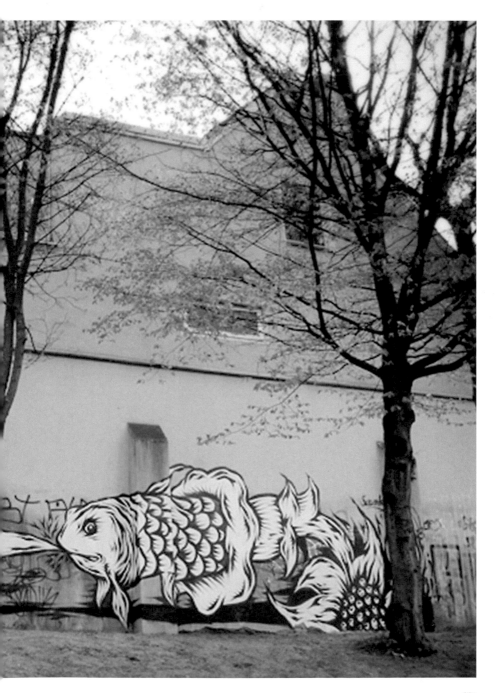

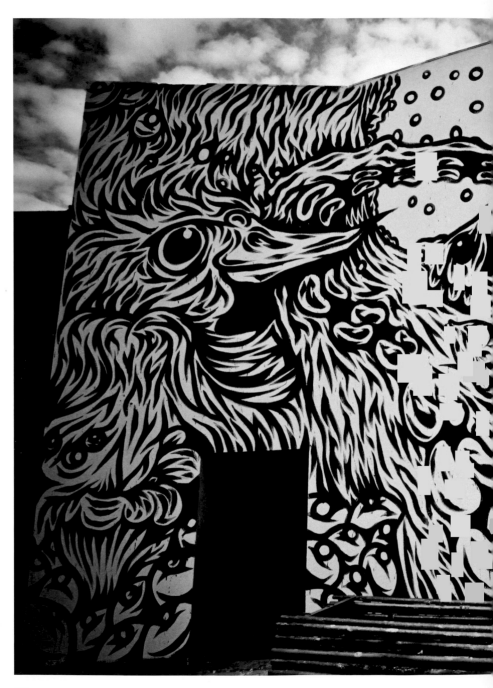

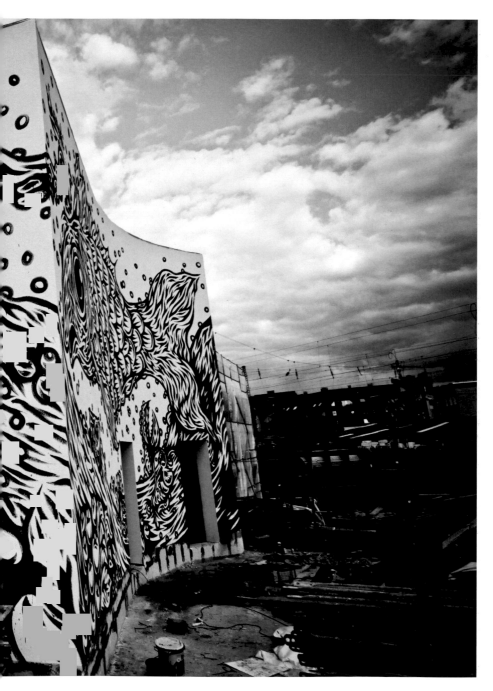

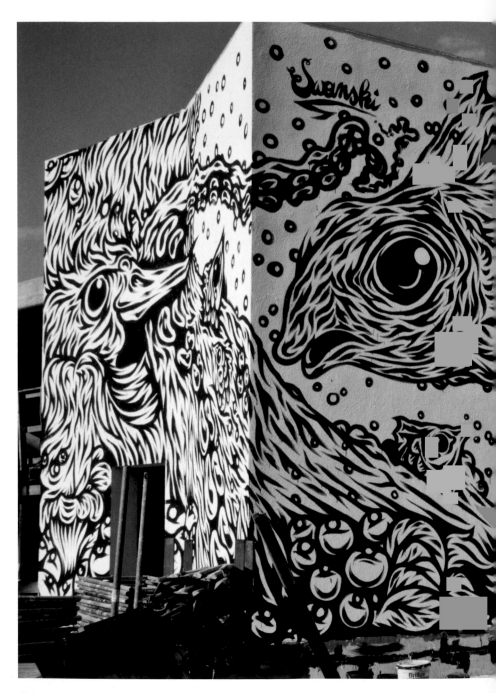

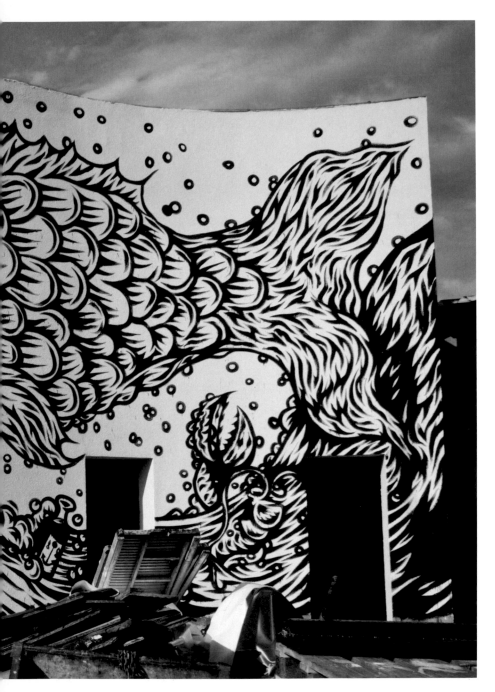

Banksy
Bristol, UK
www.banksy.co.uk

"Every time I think I've painted something slightly original," says Banksy, "I find out that Blek le Rat has done it as well, only twenty years earlier," deftly sidestepping any accusations of plagiarism. Born in Bristol, Banksy is now an international art star. A major factor in the Banksy phenomenon is placement – whilst most graff writers would daub their tags in quiet back alleys, Banksy began to paint large-scale stencils in the kinds of public spaces considered too risky by most graff-heads. His painters' overalls, rather than traditional vandals' garb, encourage passers-by and police officers to assume that the work is legal, while his ad-man copywriting skills and witty juxtapositions and reversal techniques (make something large small; make something violent cuddly etc.), all executed in the stencil technique of protest movements from Paris in 1968 to the present day, make for a potent (Molotov?) cocktail. Once, when I was spraying bright, cartoon-style superheroes – nothing like Banksy's largely monochrome stencils – in the garden of Shoreditch nightclub Cargo, two policemen strolled up and asked, "Are you . . . Banksy?" With detectives like these on his case, it's no wonder that Banksy's identity remains a mystery.

Photographs: Mark Rigney

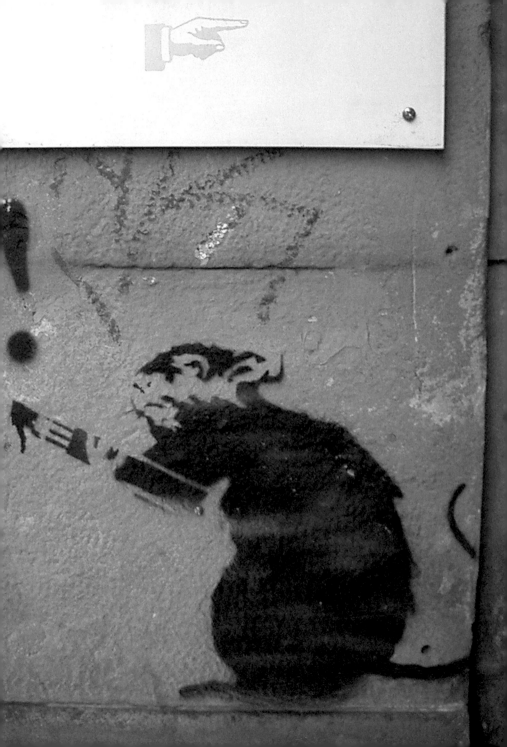

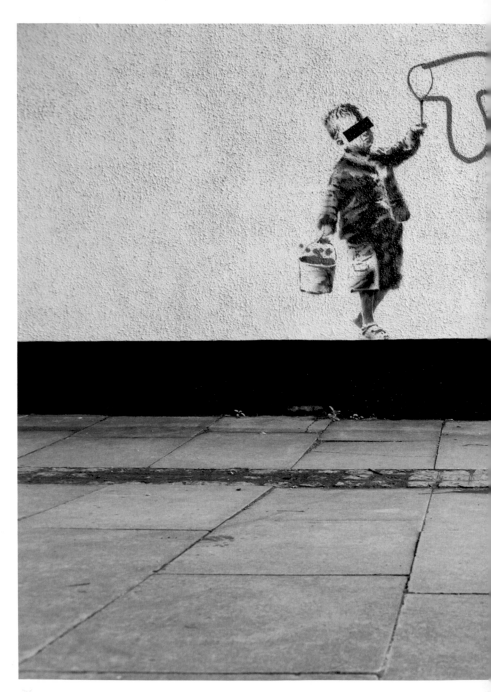

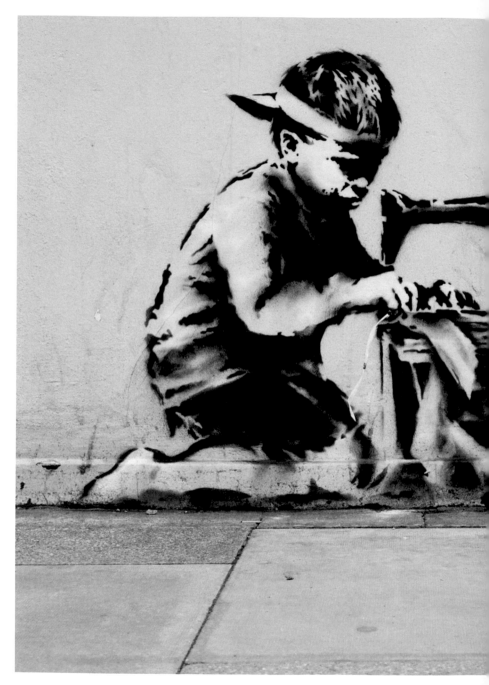

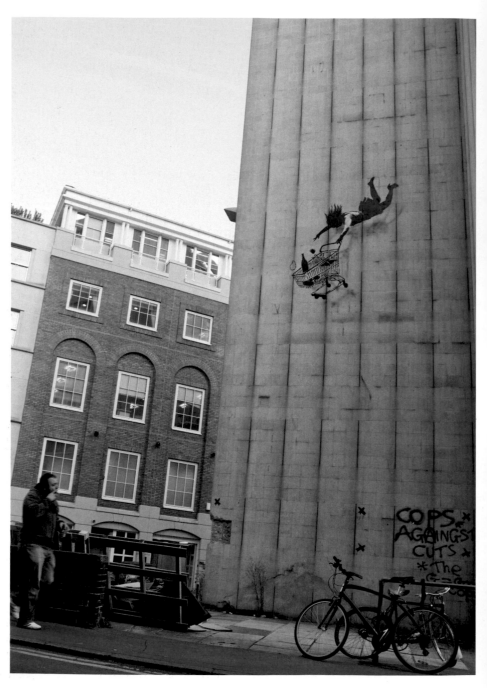

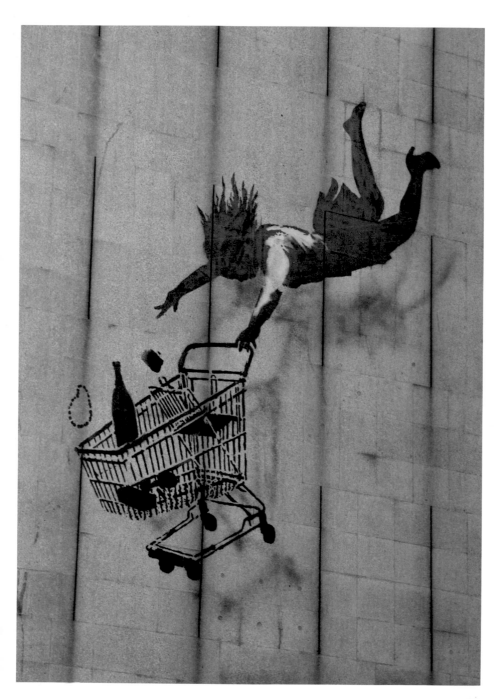

New York, USA

This page, clockwise from top left: Shepard Fairey, Buff Monster, unknown, unknown, Twist.

Opposite, clockwise from top left: Unknown, Retna, unknown, unknown, unknown, BAST.

Photographs: Simon Lambert/ One4Ruby.com

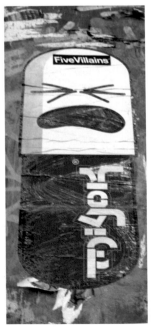

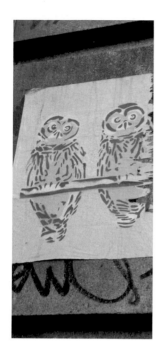

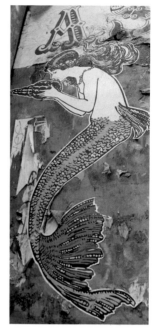

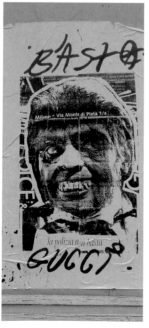

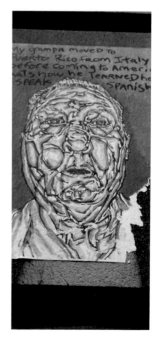

Kello

New York, USA

www.kellotron.com

Kello is the pseudonym of a talented stop-motion animation director based in Brooklyn, New York. The installations shown here are named "Pixel Pours", witty interpretations of 8-bit games graphics which charm passers-by in the East Village and SoHo districts of NYC. I can't wait to see what pixel-based creations Kello comes up with next.

Photographs: www.kneeon.tv,
Benjamin Norman/www.benjaminnorman.com

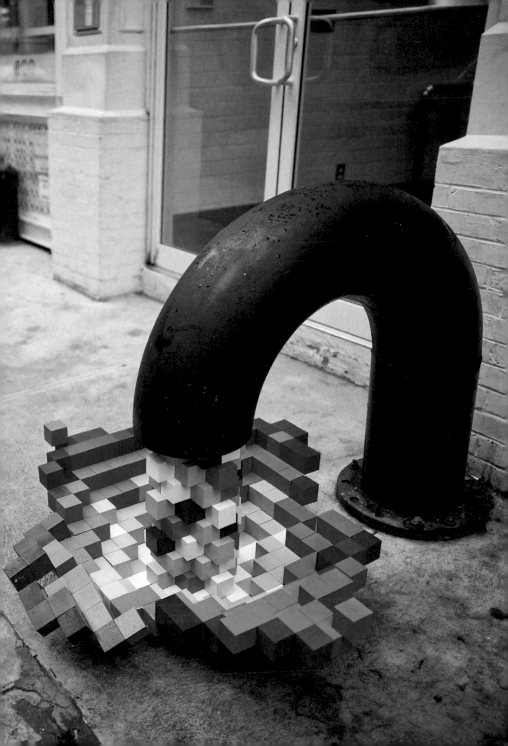

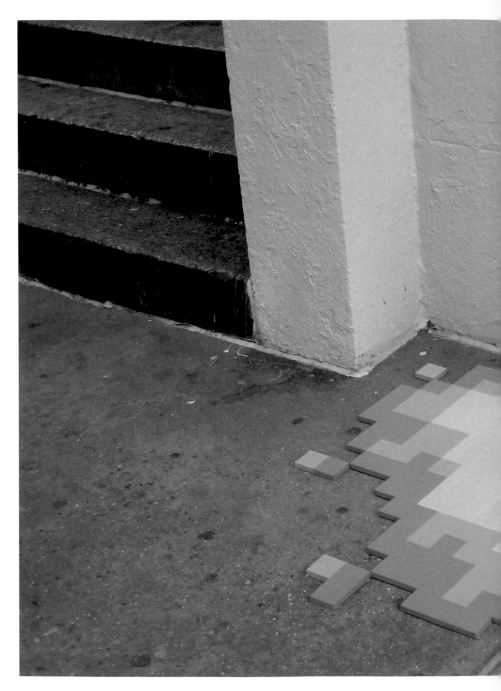

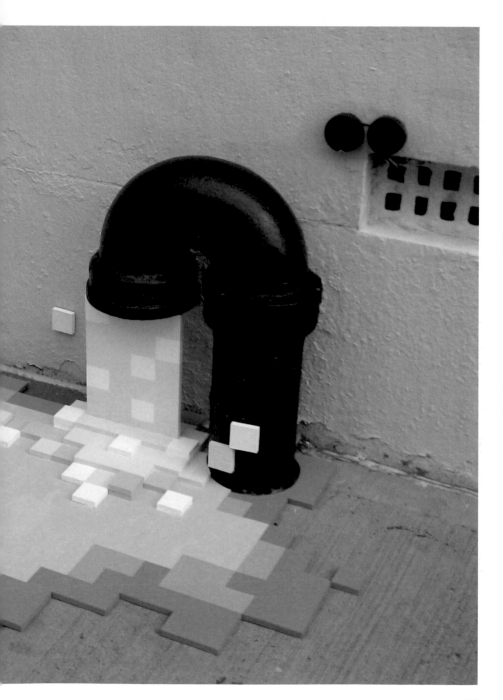

Faile

New York, USA
www.faile.net

Faile are an international collective of
artists, comprising Patrick McNeil, Patrick
Miller and, formerly, Aiko Nahagowa.
Based in Brooklyn, New York, their first
project together had the title "A Life",
of which Faile is an anagram. Their work
is a finely balanced collage of
screenprinted material inspired by
pulp book covers, comic strips and
even the Yellow Pages. I first became
aware of Faile's work in the late 90s,
when they, together with artist Bast,
wheatpasted posters in East London.
The photographs here show Faile's work
in Lisbon, Portugal, and the collective's
mural on the corner of Houston and
Bowery in New York.

Photographs: Faile

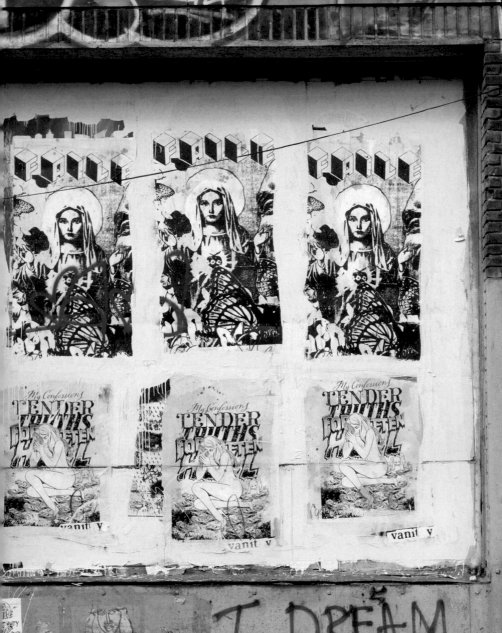

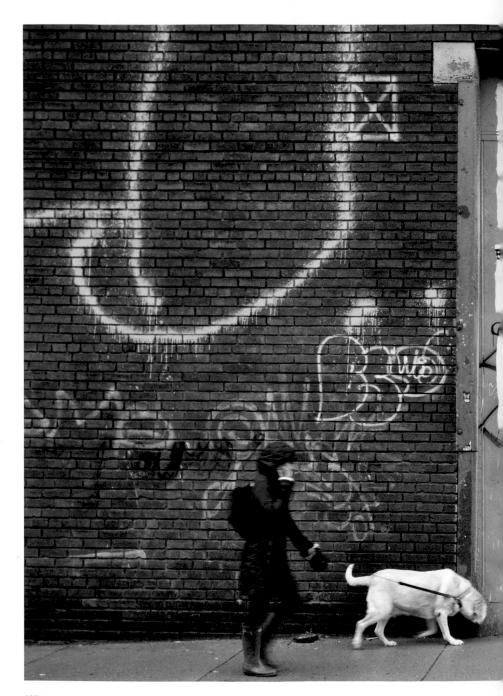

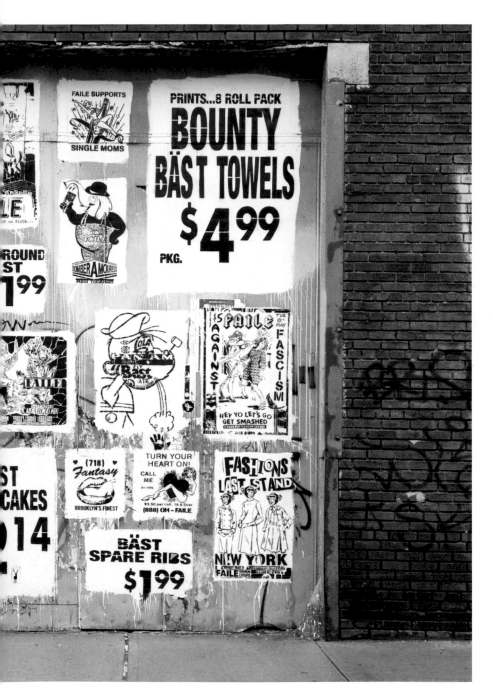

283

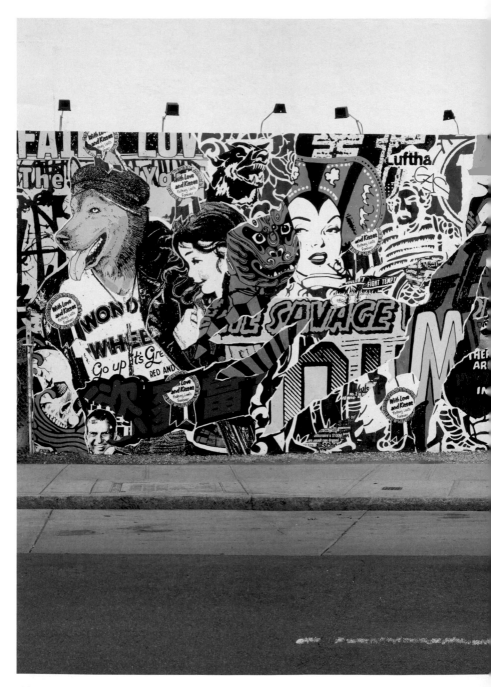

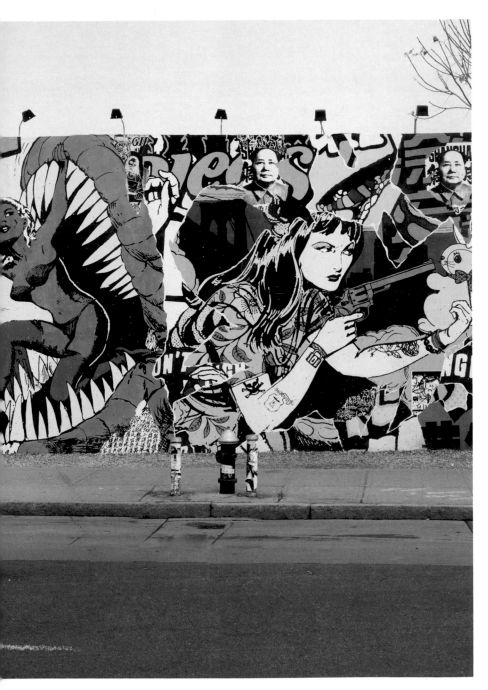

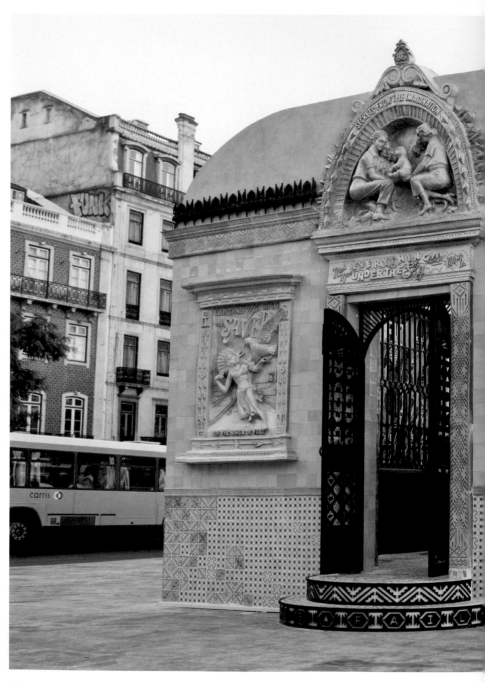

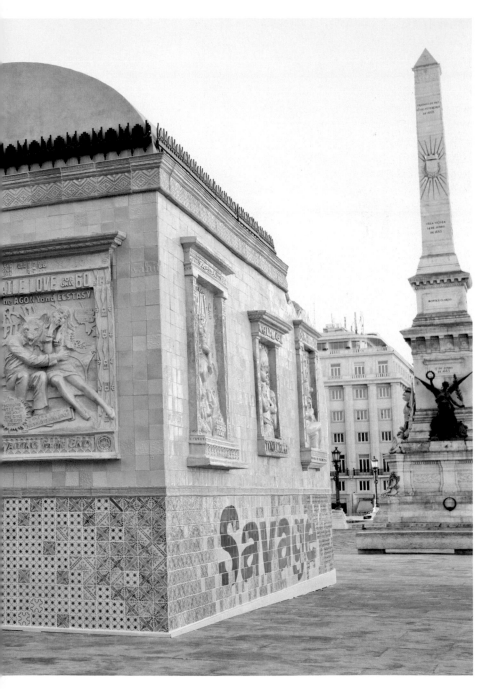

Flower Guy
New York, USA
www.mdefeo.com

Michael De Feo is the The Flower Guy
and although he paints other images, too,
it his his iconic flower design that has
blossomed all over the world since the
first tiny sapling appeared almost 20
years ago. The photographs here show
Michael's blooms in Miami and New York,
including one being tended to by a
stencilled portrait of his young
daughter Marianna.

Photographs: Michael De Feo

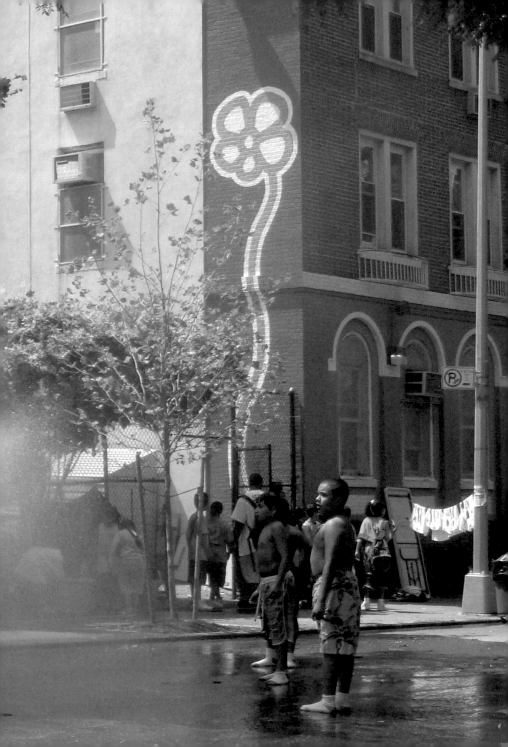

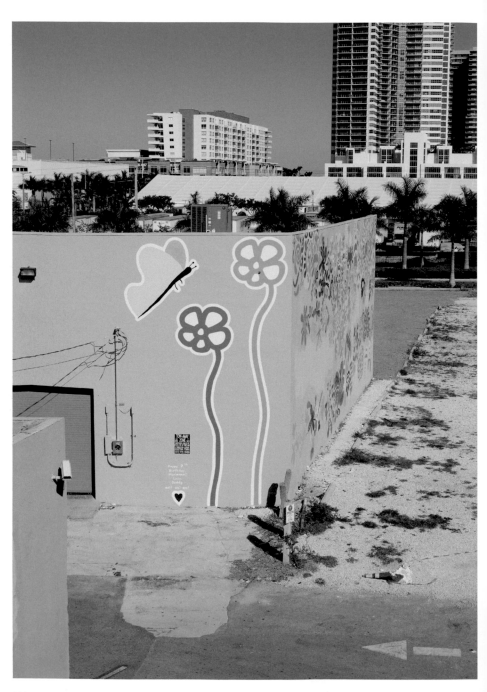

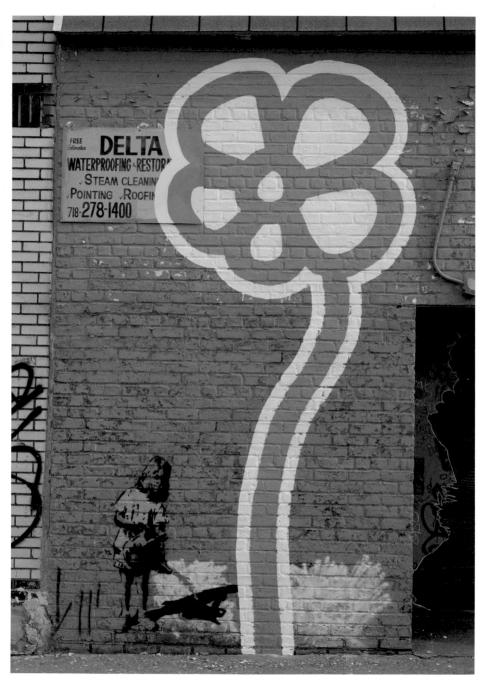

Jon Burgerman
New York, USA
www.jonburgerman.com

To regard Jon Burgerman as just a
street artist would be misleading as this
British-born compulsive doodler has
scrawled his way across walls, wood,
cardboard, canvases, stickers, toys and
just about every other surface known to
man. The photographs here show Jon
adding his distinctive touch to the sidewalk
outside the former site of legendary
Manhattan punk venue CBGB's.

Photographs: Mike Pearce, Jon Burgerman

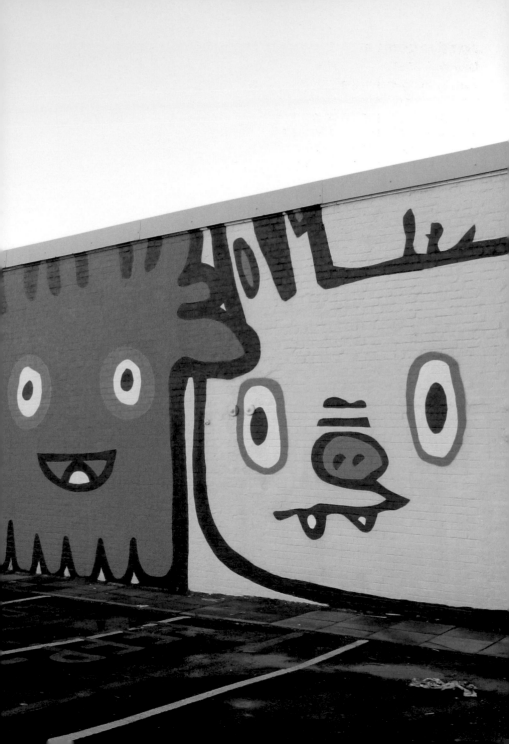

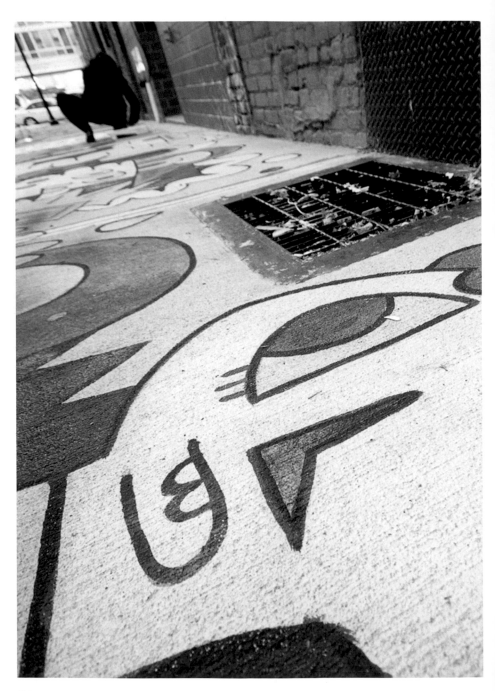

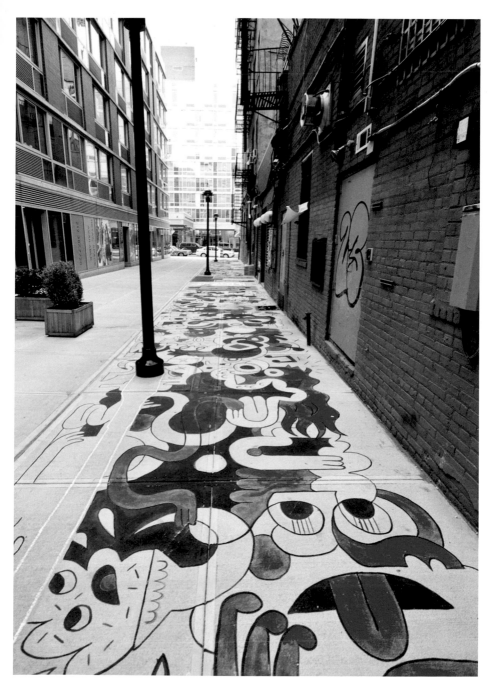

Shantell Martin
New York, USA
www.ShantellMartin.com

Londoner Shantell Martin now lives in New York and creates work using a variety of media. Although she draws on walls using conventional techniques, her innovative projected work (shown here) combines light, animation and digital drawing with elements of live performance.

Photographs: Shantell Martin

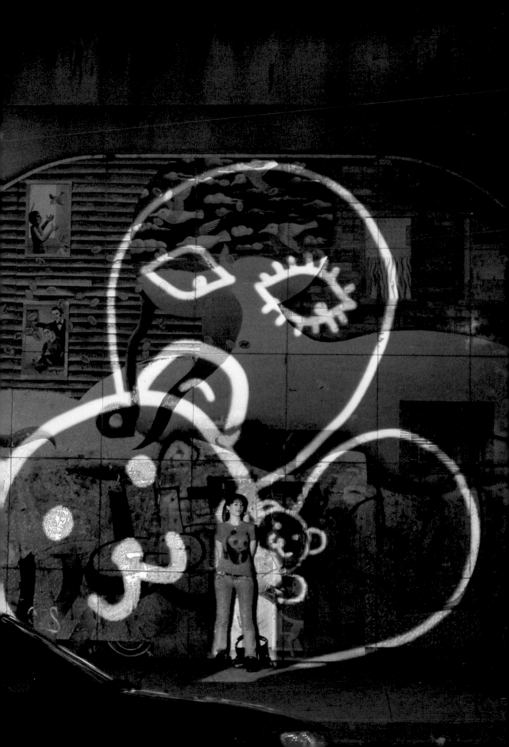

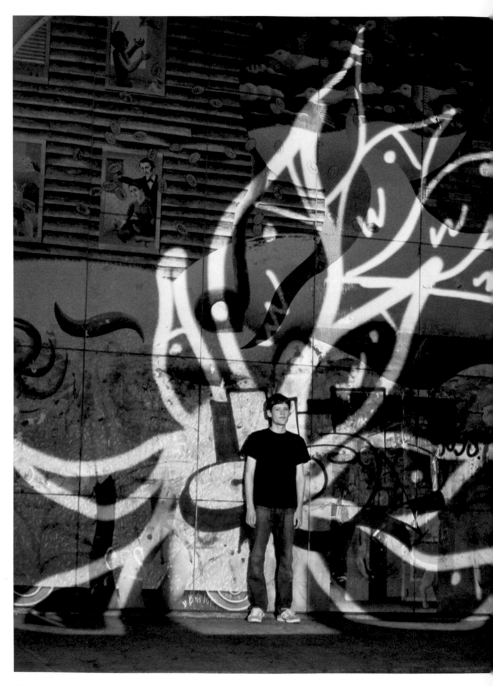

ESPO/Stephen Powers

Philadelphia, USA
www.firstandfifteenth.net

ESPO (Exterior Surface Painting Outreach), aka Stephen Powers, began writing graffiti in 1984 as part of the ICY crew. These pages show some of the 50 murals in his home town of Philadelphia. They are part of the "A Love Letter for You" project, subtitled "Brick Valentines on the Philly Skyline". With backing from the Philadelphia Mural Arts Program, Powers engaged with the local community and enlisted a crew of artists, signwriters and writers to transform a run-down area of West Philly by mixing colourful visuals, heartfelt slogans and elements of traditional signwriting. The result was, as ESPO himself puts it, "Love Celebrated on the Frankford Elevated".

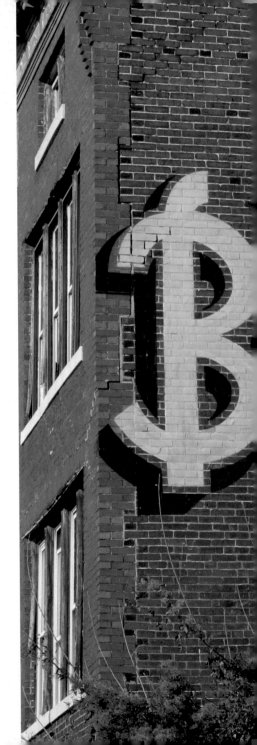

Photographs: Simon Lambert/One4Ruby.com

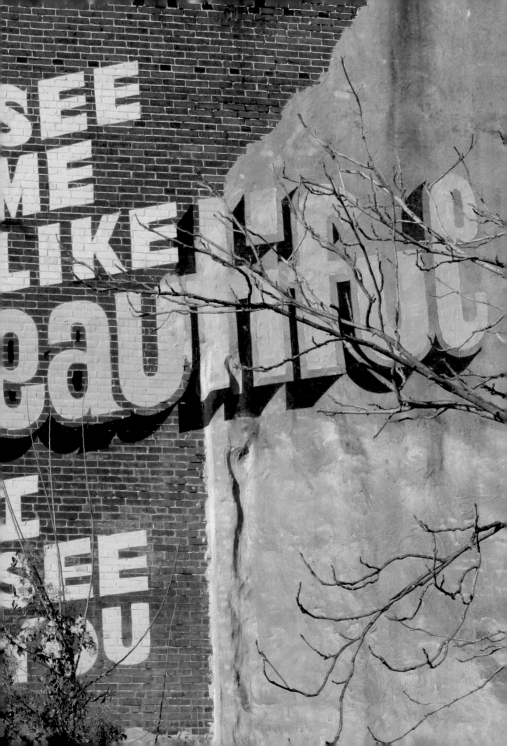

FOR WHAT I *want* I CAN *wait*

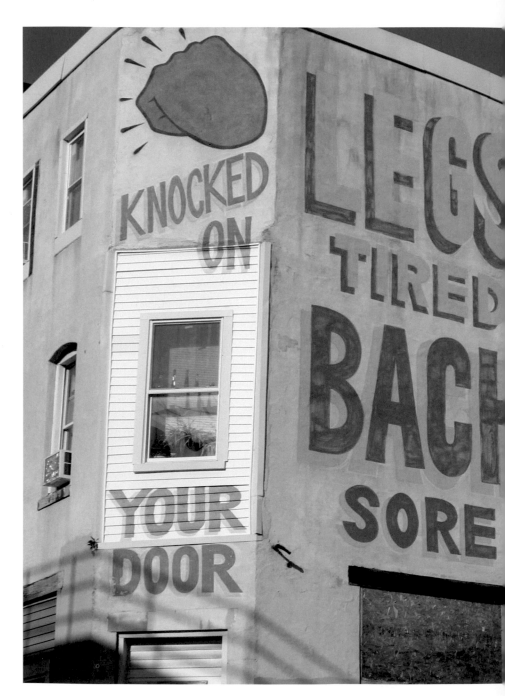

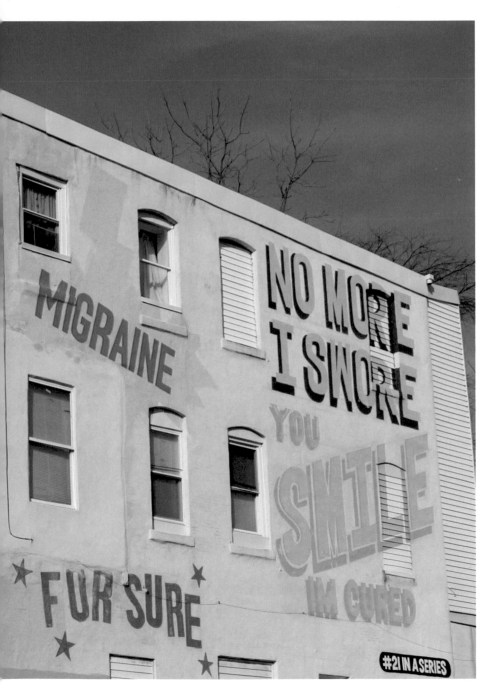

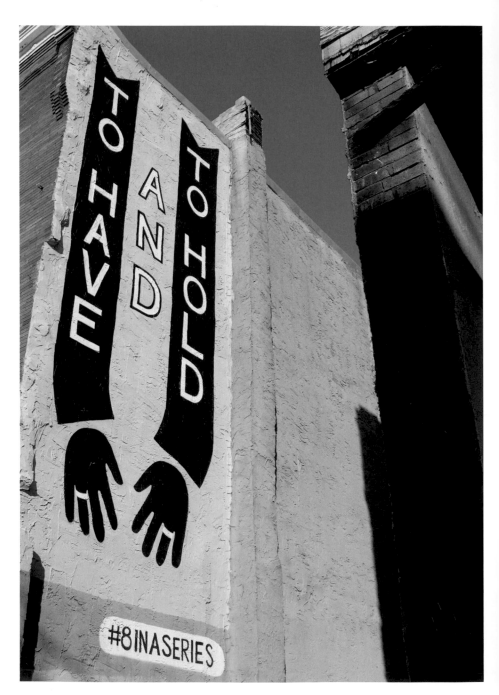

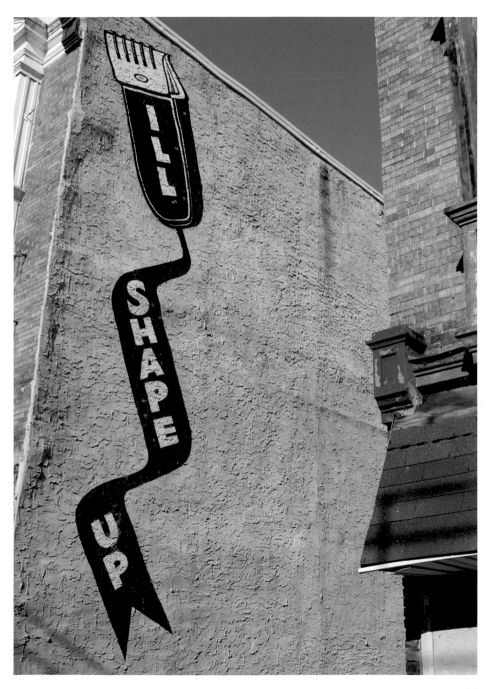

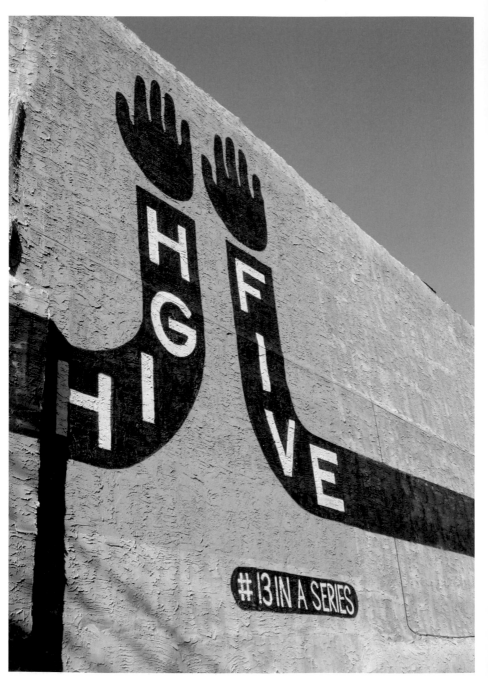

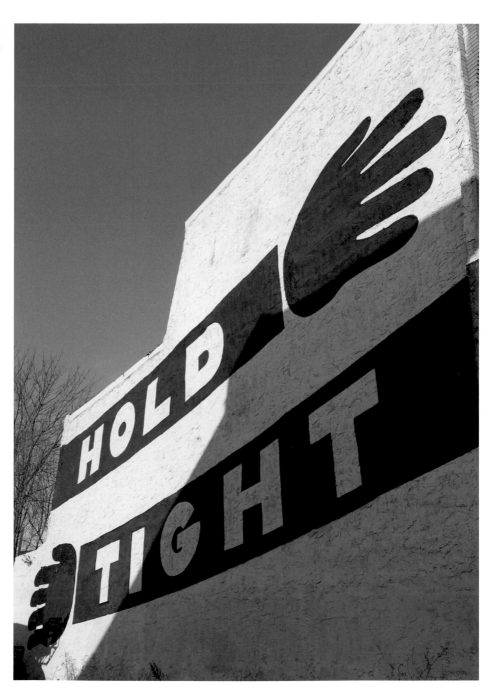

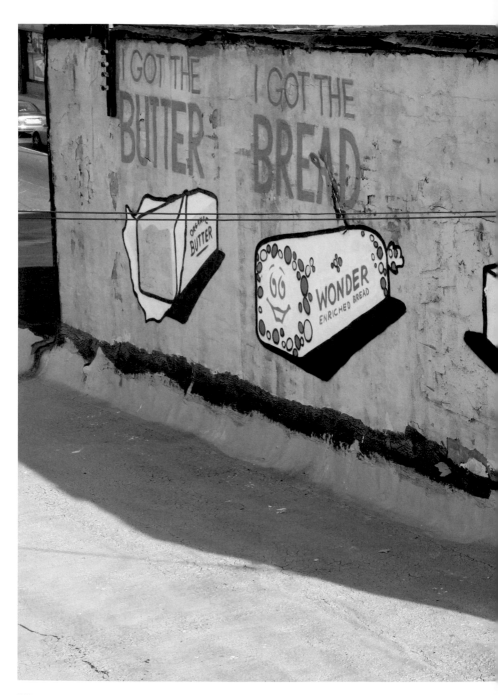

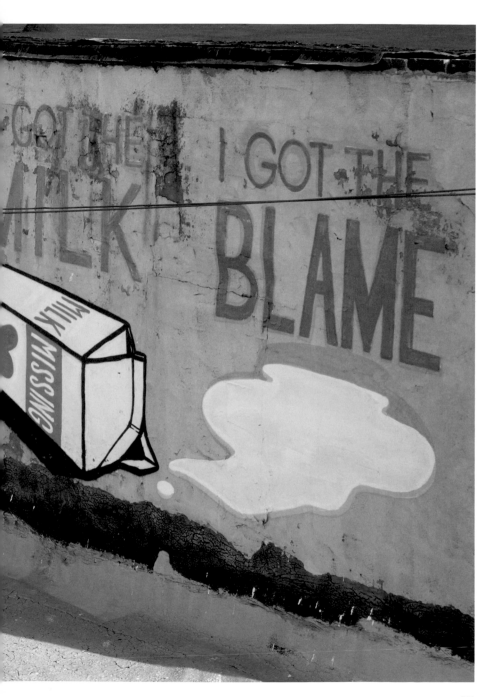

Shepard Fairey
Los Angeles, USA
www.obeygiant.com

Shepard Fairey created the "André the Giant Has a Posse" sticker campaign in 1989 before evolving it into the "Obey Giant" campaign, which grew due to a worldwide network of collaborators replicating Fairey's designs. An appearance in an episode of *The Simpsons* confirmed Shepard Fairey's status as one of the best-known street artists, but the prolific creator of the "Obey Giant" campaign (and subsequent merchandising empire) achieved worldwide fame when he created the iconic "HOPE" poster depicting Barack Obama in the run-up to 2008's US presidential election. Fairey has often been accused of plagiarism – the majority of his work comprises traced photographs – but the "HOPE" poster landed Fairey in court when photographer Mannie Garcia demanded compensation and credit for the image that Fairey had appropriated. Both parties eventually settled, though only after Fairey had admitted that he had tried to deceive the court by destroying documents and manufacturing evidence. It will be interesting to see how Fairey's work develops. Perhaps he will collaborate more openly, as with photographer Aaron Huey in this 2011 Los Angeles piece. "The Black Hills Are Not for Sale" is a common Sioux Nation rallying cry for Treaty rights for the Pine Ridge Indian Reservation.

Photographs: Mark Rigney, Swanski

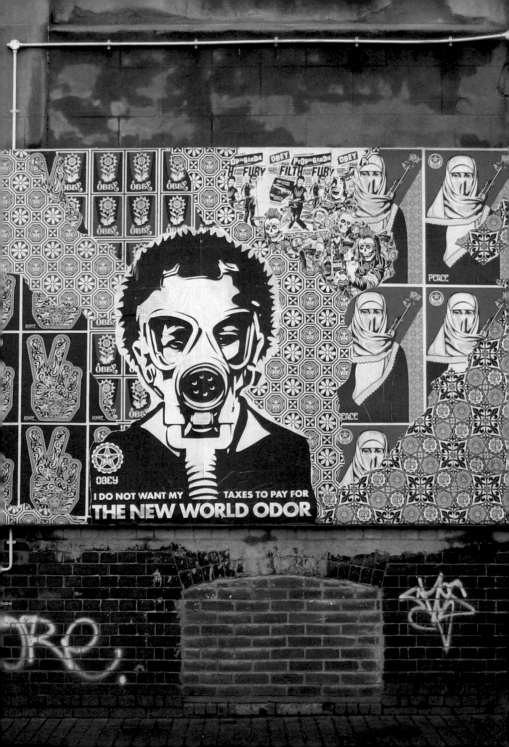

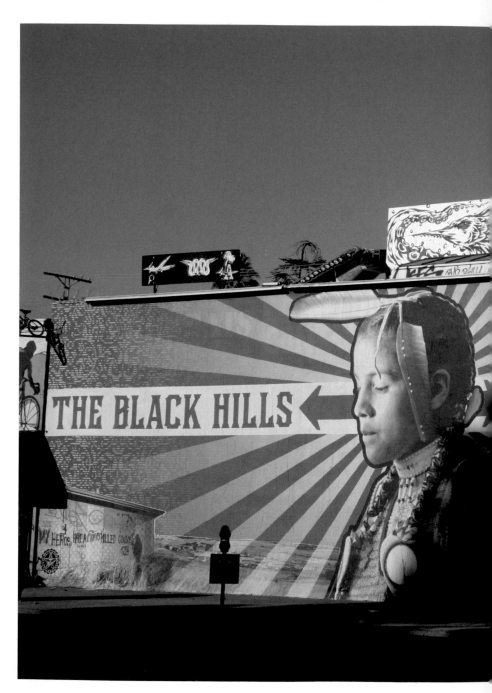

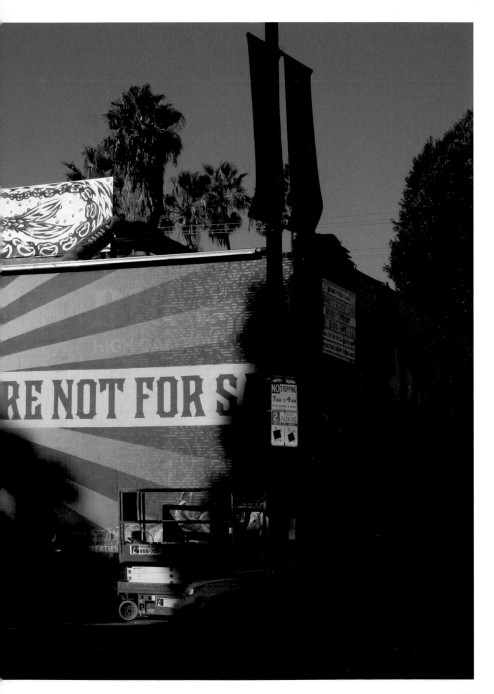

Gomez Bueno
Los Angeles, USA
www.gomezbueno.com

Gomez Bueno is a Spanish artist living
in the United States. His situationist
self-promotion tactics have included
doctoring billboards so that they read
"Gomez Bueno for President". Here is
a selection of his character work in
Los Angeles and Santander, Spain.

Photographs: Gomez Bueno

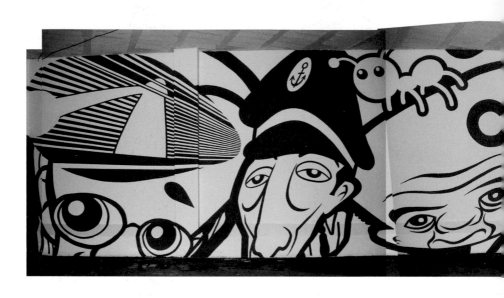

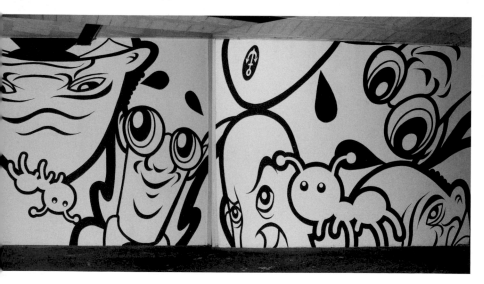

Buff Monster

Los Angeles, USA
www.buffmonster.com

Buff Monster lives in Hollywood where he began to paste silkscreened posters before expanding his reach across LA and further afield. A riot of strawberry-ice-cream-flavoured characters inspired by heavy metal, kid's cartoons and Japanese culture continue to pour from the mohawk-topped mind of the pink-loving Buff Monster.

Photographs: Buff Monster

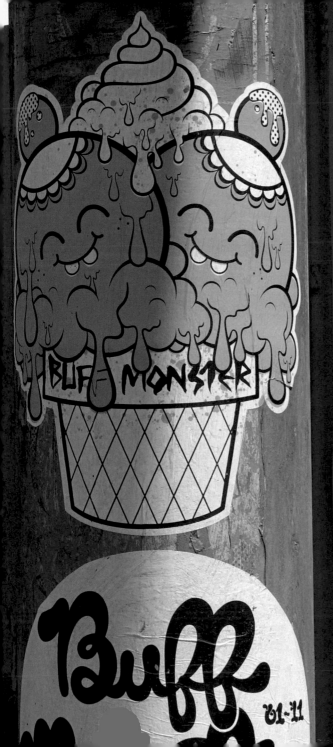

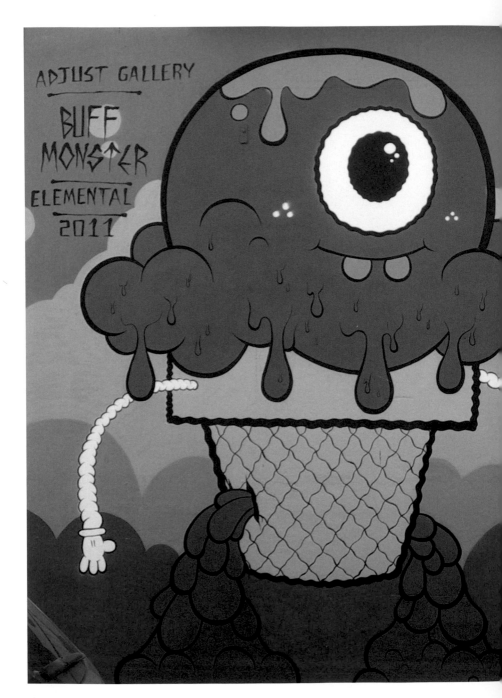

324

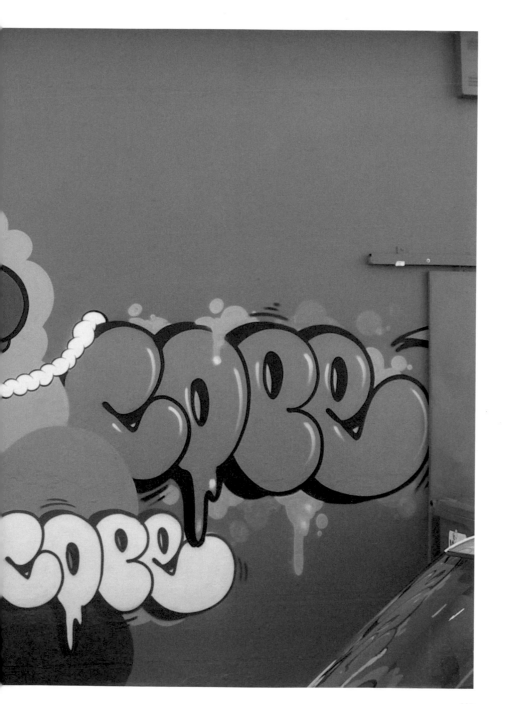

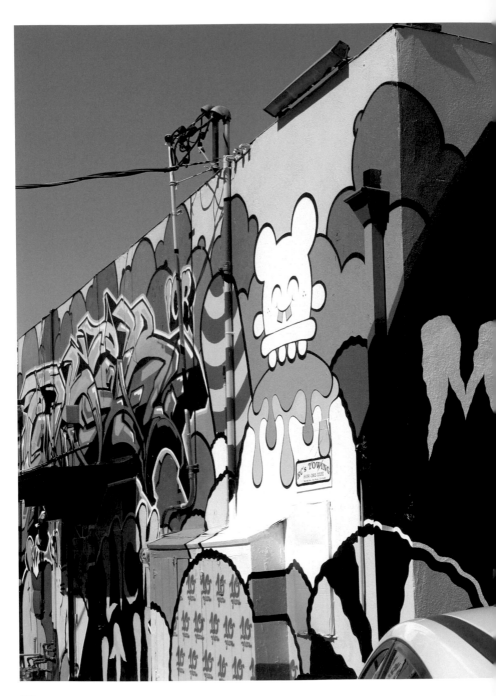

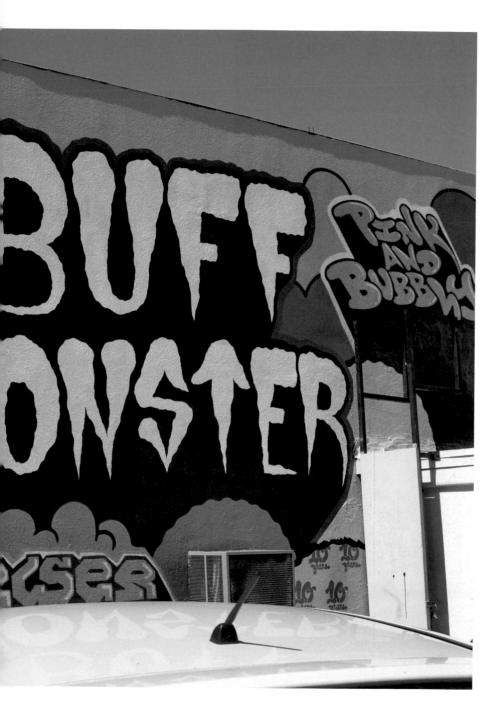

Swoon
New York, USA
www.blackratprojects.com

Active since the late 1990s, Swoon
specializes in life-size wheatpaste prints
and intricate paper-cut work, often placed
in derelict areas. Swoon was born in
Connecticut, raised in Daytona Beach,
Florida, and is now based in New York.
These photographs were taken following
a visit Swoon made to London in late 2011.

Photographs: Mark Rigney, JAKe

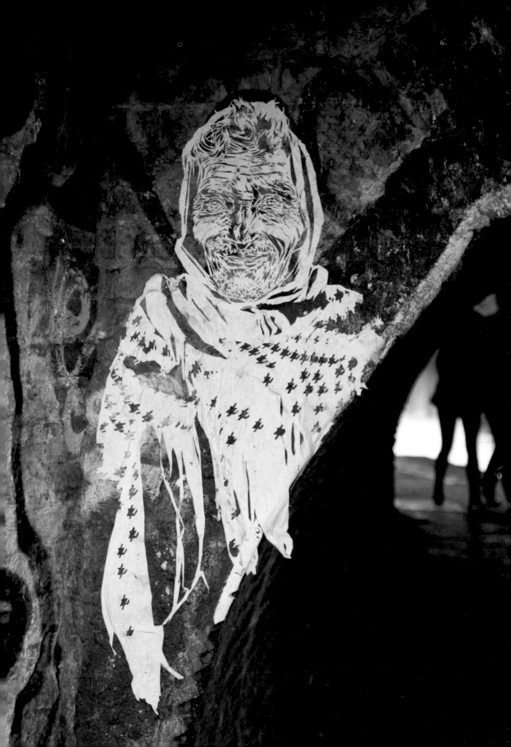

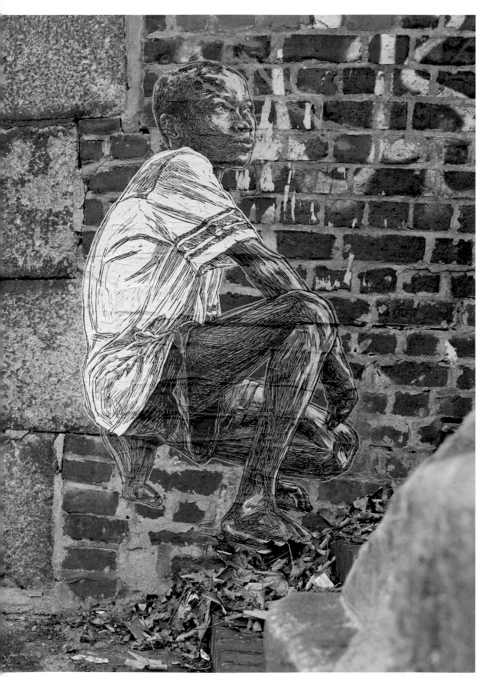

Boris Hoppek

Barcelona, Spain
www.borishoppek.de

Boris Hoppek is a German artist who
lives in Barcelona. He has been making
work on the streets since 1990. These
days his work has achieved a level of
abstraction that allows him to address
political issues such as immigration,
racism and sexuality. These photographs
of some of his site-specific pieces were
taken in Milan and at the Fame Festival
in Grottaglie, Italy.

Photographs: Boris Hoppek

Ripo

Barcelona, Spain
www.ripovisuals.com

Born and raised in New York, Max Rippon, aka Ripo, is now based in Barcelona where he produces text-based work, influenced as much by calligraphy and other hand-drawn type as he is by graffiti. His sense of humour is often apparent in his work, in the "Okupame!" piece shown here, for example, in Bogotá, Colombia – "Okupame!" translates as "Squat me!".

Photographs: Ripo

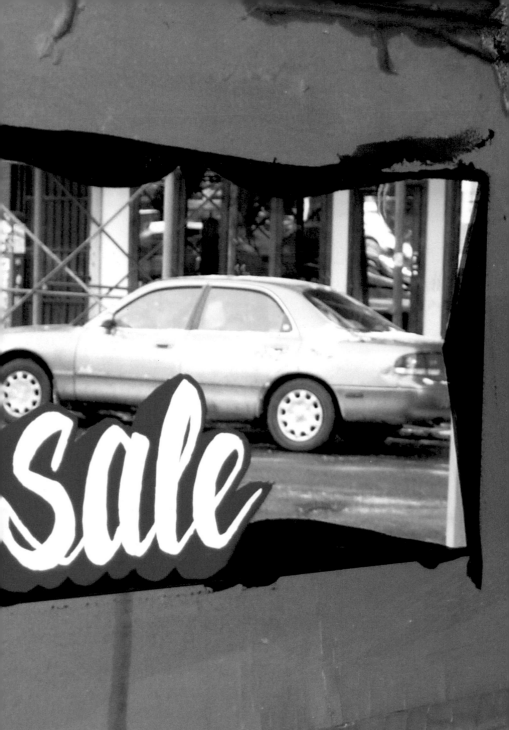

Spike

Luxembourg City, Luxembourg

Spike's work has evolved from traditional graffiti letterforms into highly abstracted forms which are almost organic in nature. Particularly in the context of their carefully chosen locations, Spike's work has a haunting, melancholy quality.

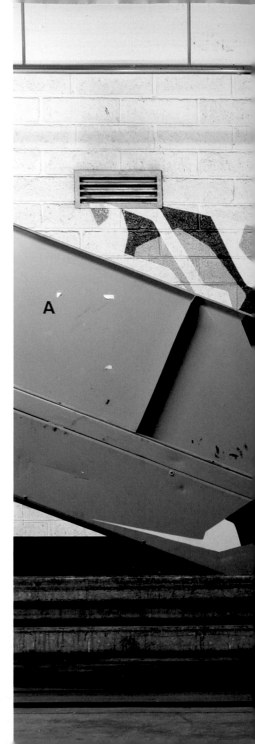

Photographs: David Laurent

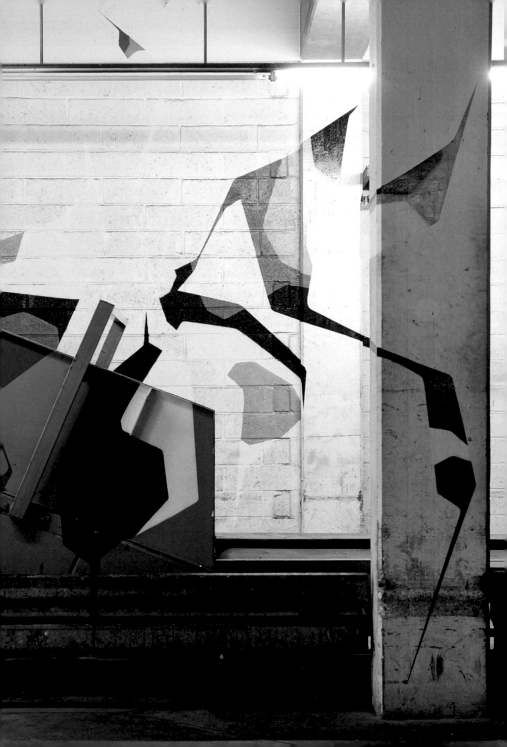

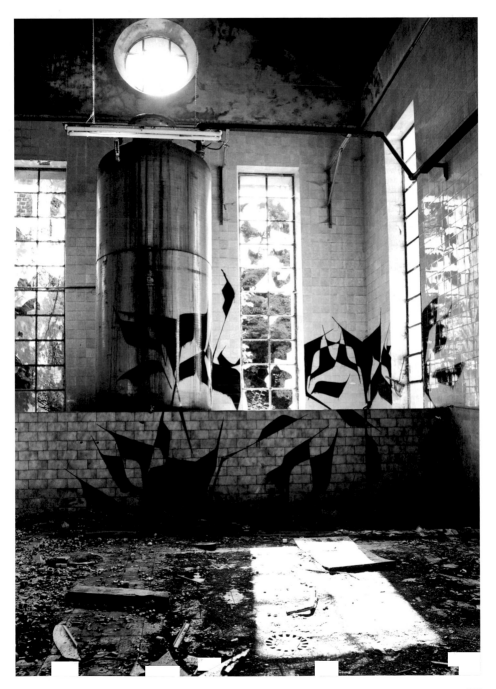

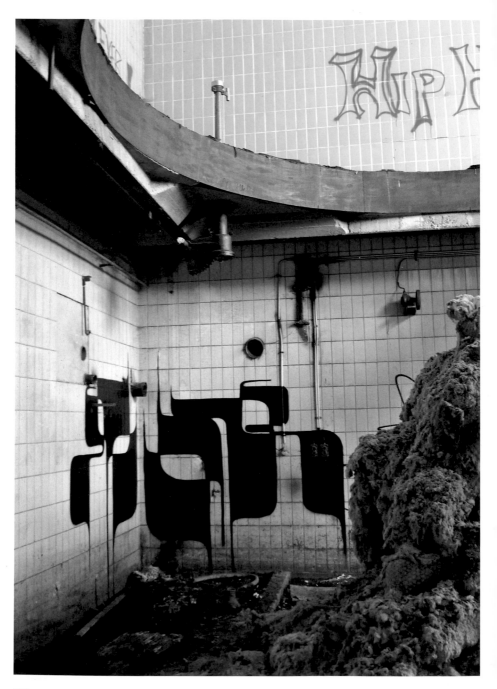

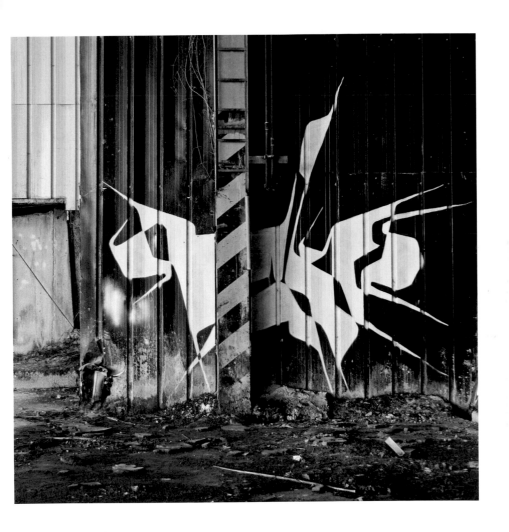

Sumo

Luxembourg
www.sumo.lu

I first saw Sumo's "Crazy Baldhead" characters on stickers in London, which is unsurprising because, as I later discovered, he had lived in the capital for four years, often painting with INSA, before returning to his native Luxembourg.

Photographs: Steve Troes

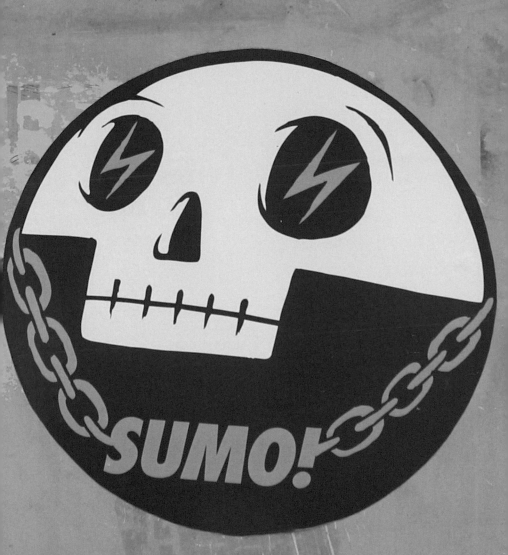

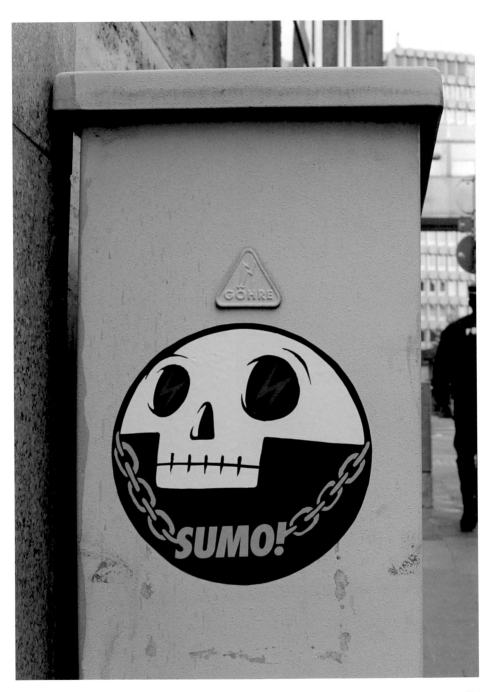

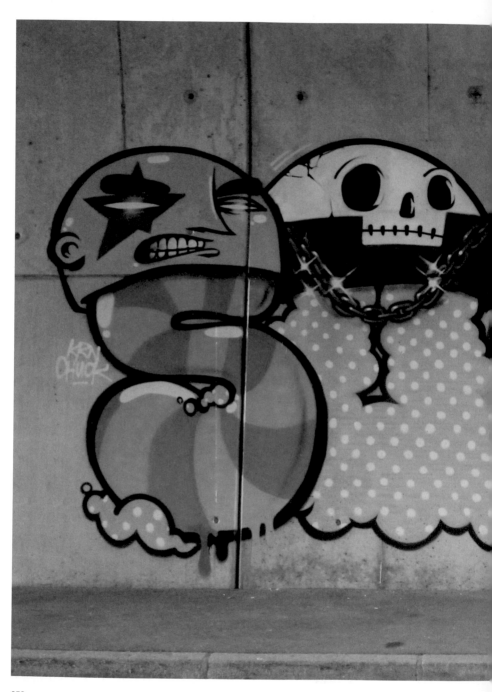

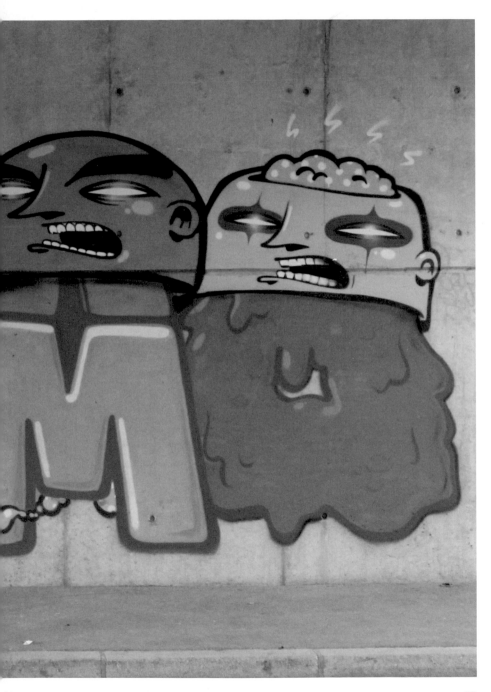

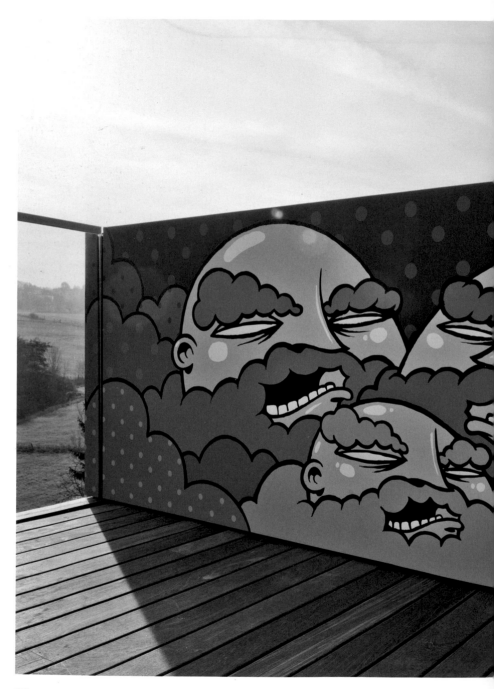

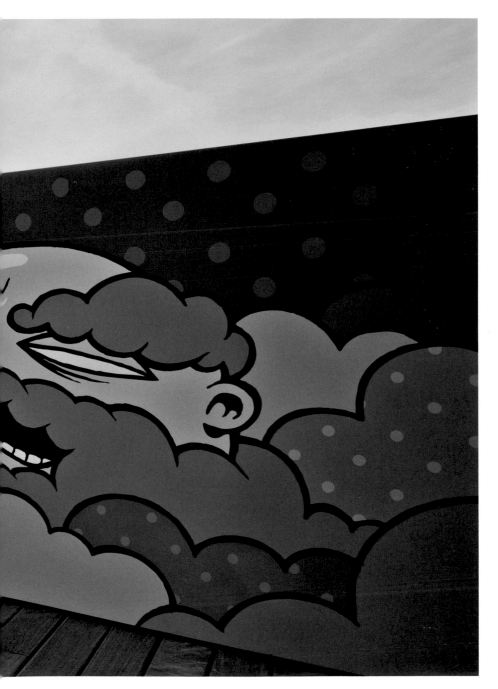

Kenor

Barcelona, Spain
www.elkenor.com

The swirling, abstract, geometric forms of Spanish artist Kenor pulse with colour and movement. His work is always beautiful and often impressively vast. The pieces photographed here are in Dresden, Germany, and Łódź, Poland.

Photographs: Kenor

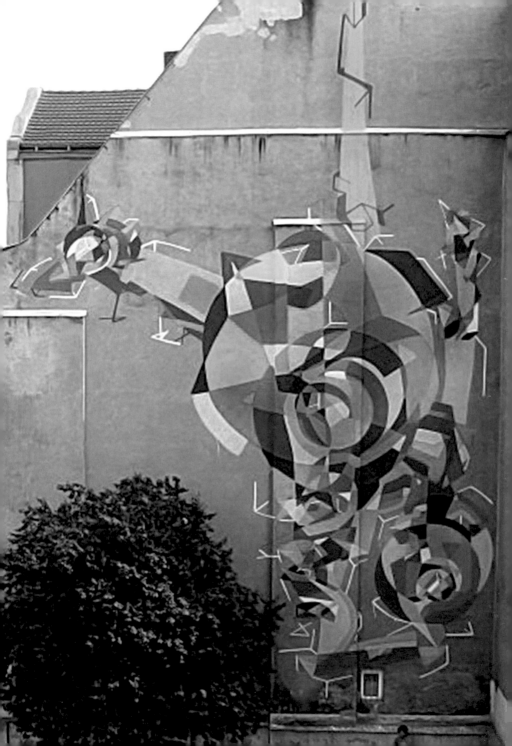

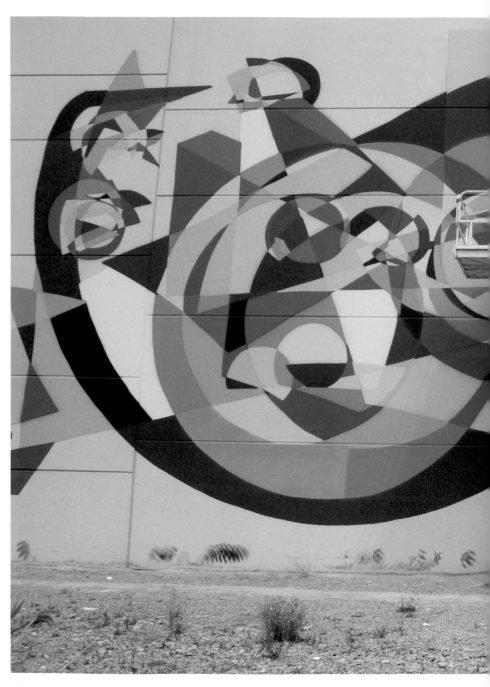

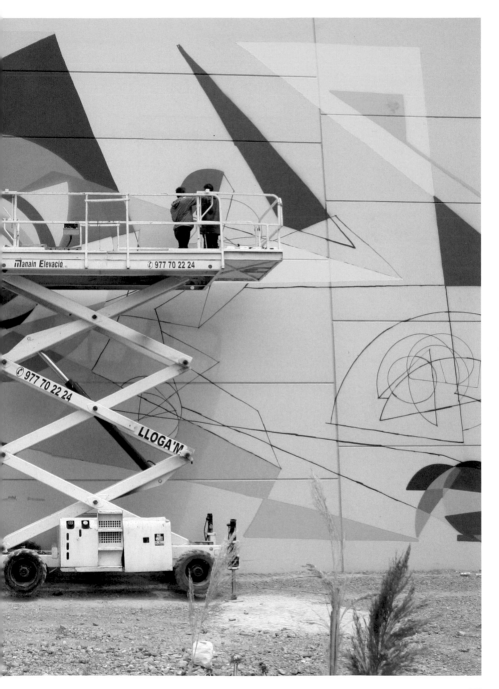

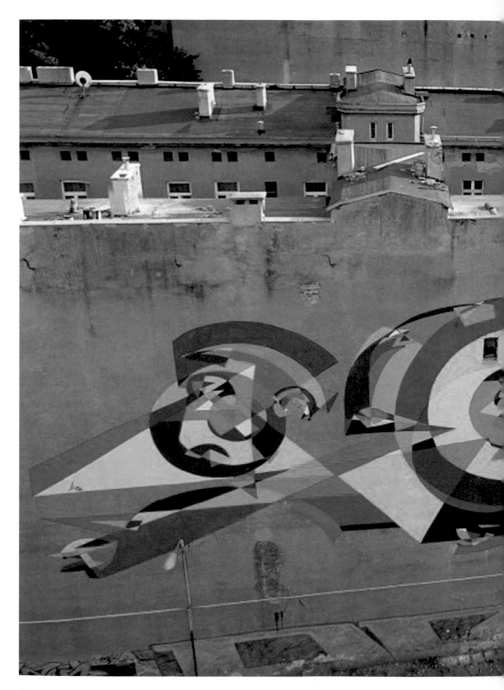

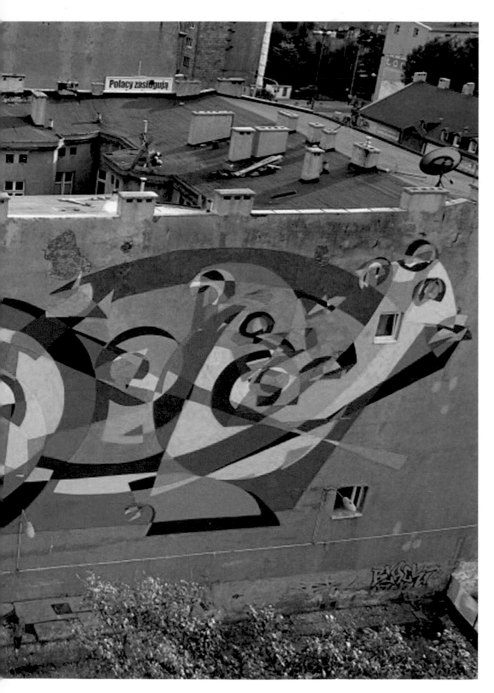

Eltono
Madrid, Spain
www.eltono.com

Eltono started writing graffiti and bombing the trains that connected Paris with his native suburb of Cergy-Pontoise in 1989, under the name Otone. When he arrived in Madrid a decade later he renamed himself Eltono ("el tono" is Spanish for "the tone"), and began experimenting with the image of a tuning fork instead of a tag. Over successive years this became increasingly abstracted until each form that Eltono paints is now improvised in situ to harmonise with its surroundings, as can be seen in these examples from Bilbao, Beijing and Mexico.

Photographs: Eltono

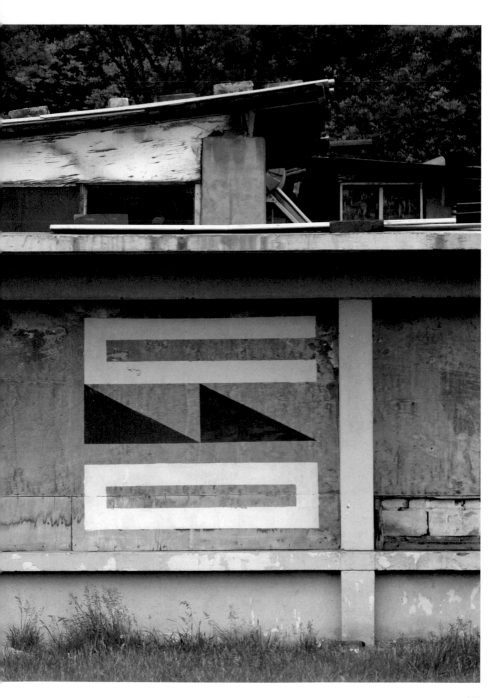

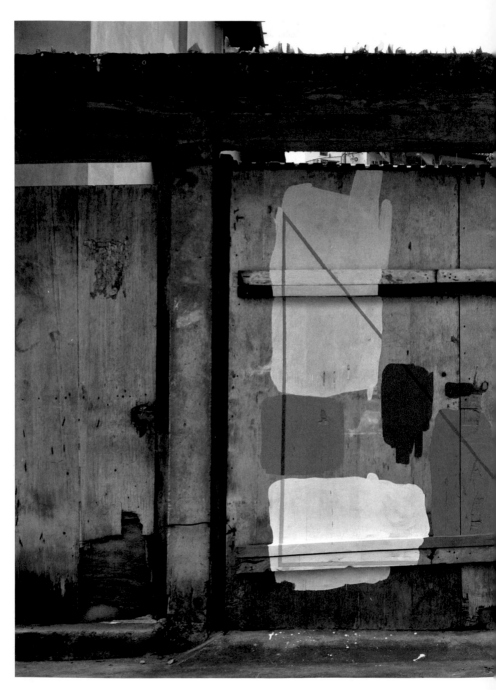

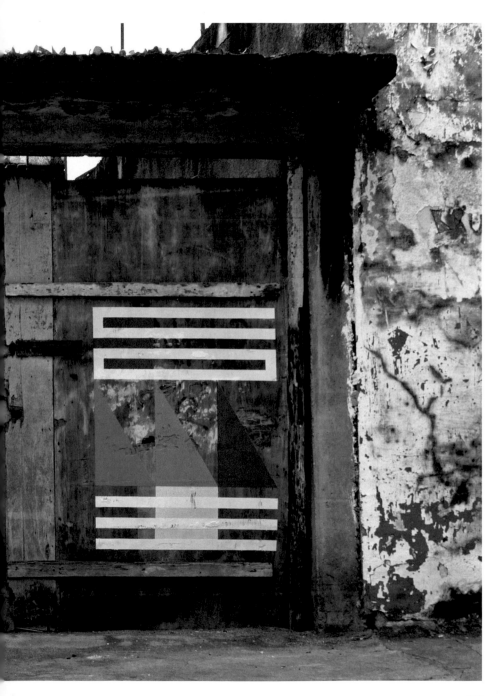

Nuria Mora

Madrid, Spain
www.nuriamora.com

Spanish artist Nuria Mora started
painting on the street with Eltono in an
attempt to reach as many people as
easily as possible "whether they were
sensitive or not to art in general". Nuria
often still works in collaboration with
Eltono and although she employs a
similar methodology, her solo output has
a calmer, more organic feel and often
appears to merge into its surroundings.

Photographs: Nuria Mora

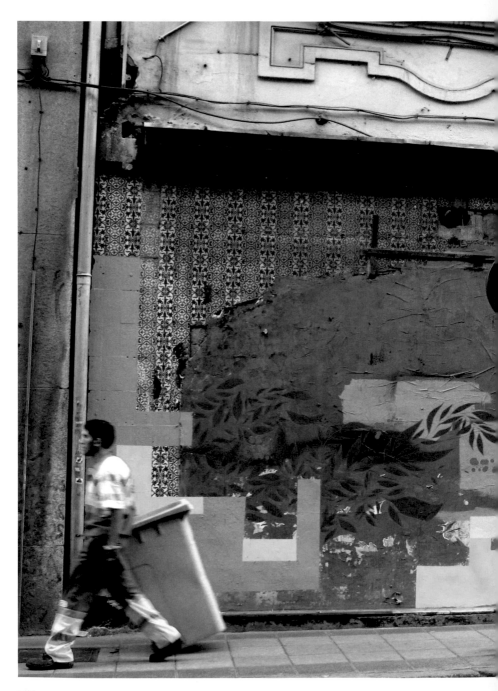

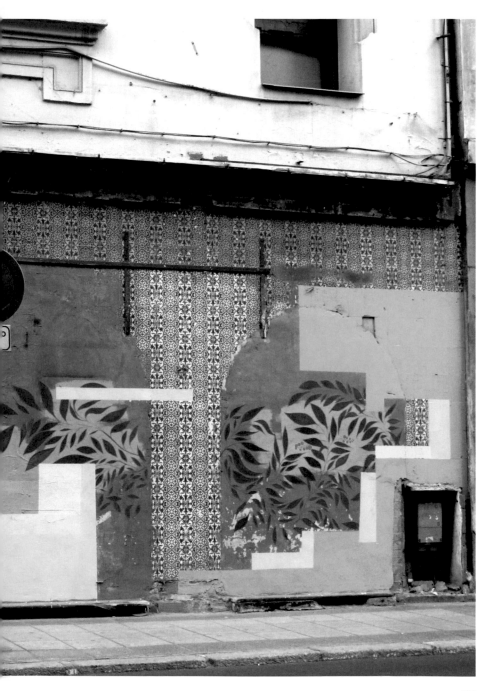

Aryz

Cardedeu, Spain
www.aryz.es

These colourfully surreal and larger-than-life images by cover artist Aryz would be stunning rendered at any size, but the fact that they are so huge makes the skilful use of colour and the quality of the draughtsmanship almost breathtaking. As the seemingly Lilliputian passers-by reveal, the constraints of this particular format do not do Aryz's images full justice. Born in Palto Alto, California, to Spanish parents and raised in Spain, Aryz is now based in Cardedeu, near Barcelona. The pieces shown here were painted in Łódź and Katowice, Poland, and in Grottaglie, Italy.

Photographs: Aryz

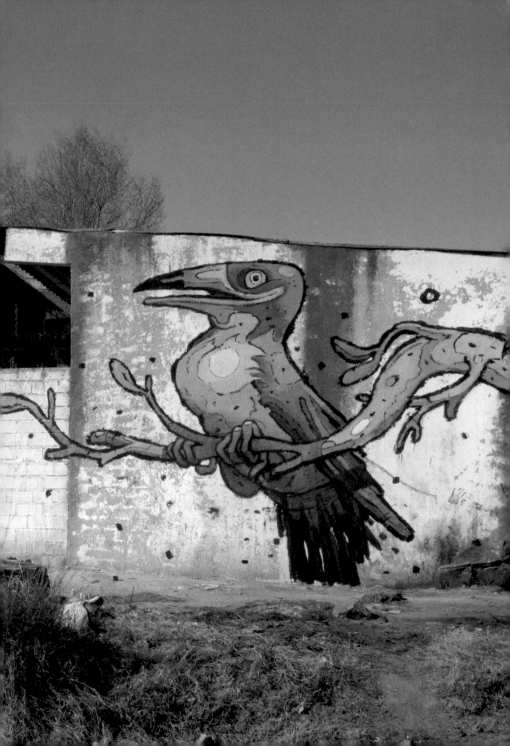

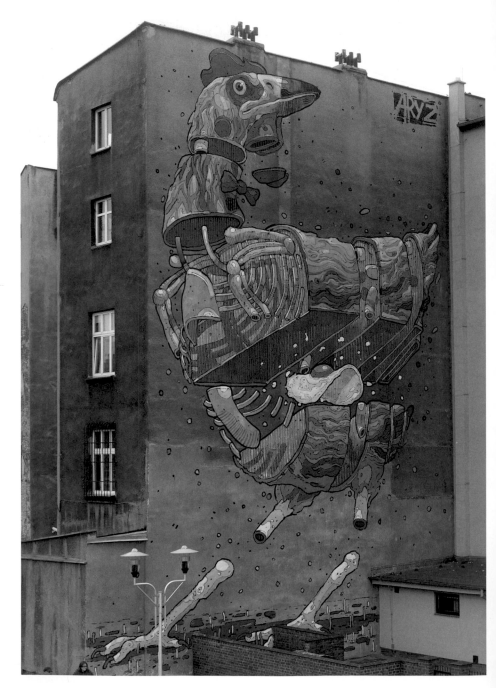

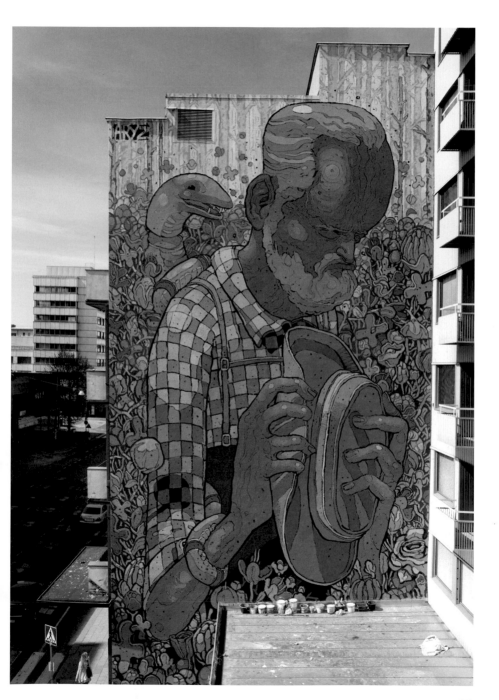

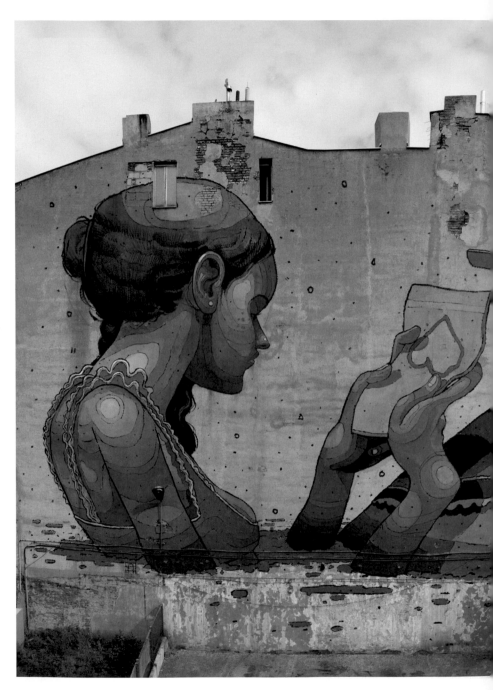

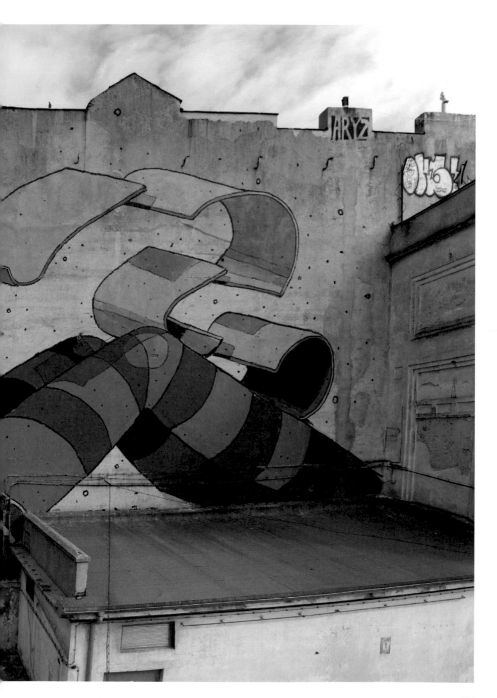

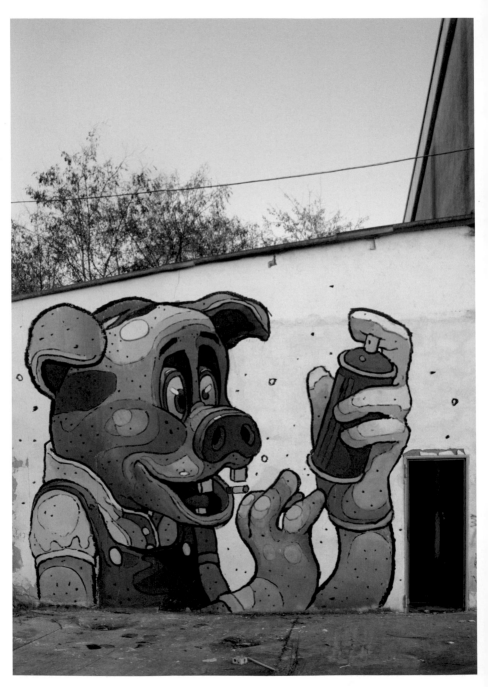

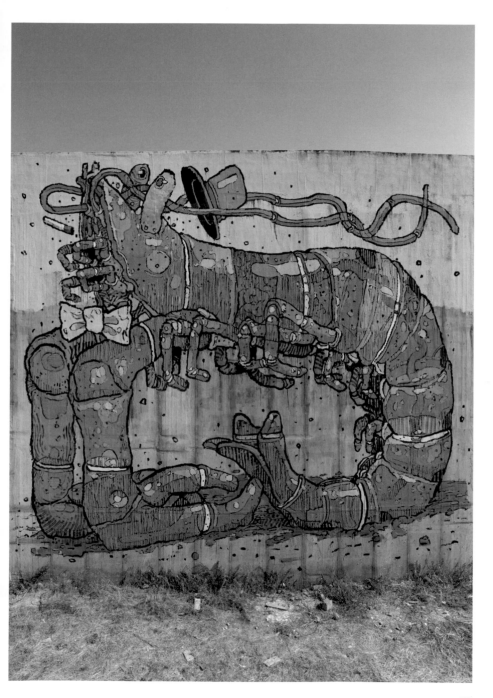

Zosen

Barcelona, Spain
www.animalbandido.com/tofulines

Filled with neon colours, geometric pattern and symbols, Zosen's tribal menagerie immediately sears the viewer's eyeballs. Originally from Buenos Aires, he became an active member of the Barcelona graffiti scene during the 1990s and still paints frequently, sometimes collaborating with Pez and Aryz. The photographs here show Zosen going solo and collaborations with Sixe, 3ttman, Pez and Skount in Barcelona and Aranda de Duero in Spain, Bassano del Grappa in Italy, and Budapest in Hungary.

Photographs: Zosen, just-ryc

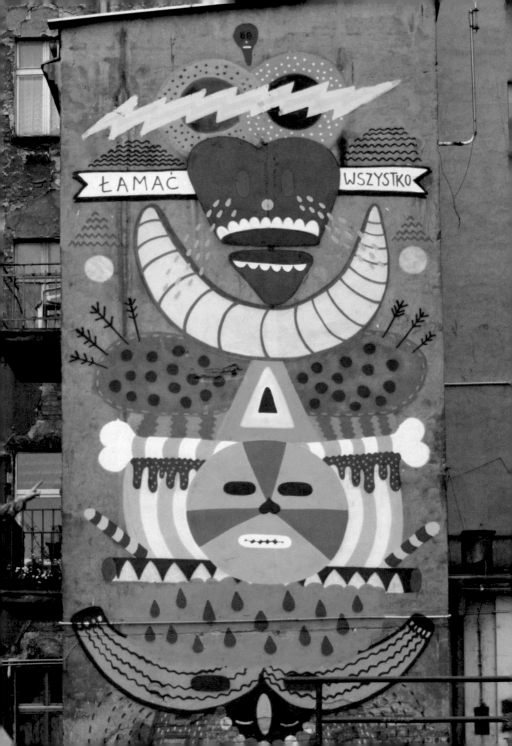

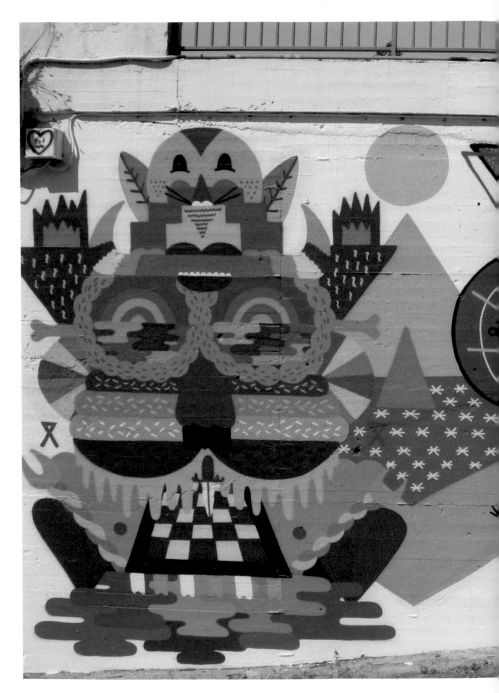

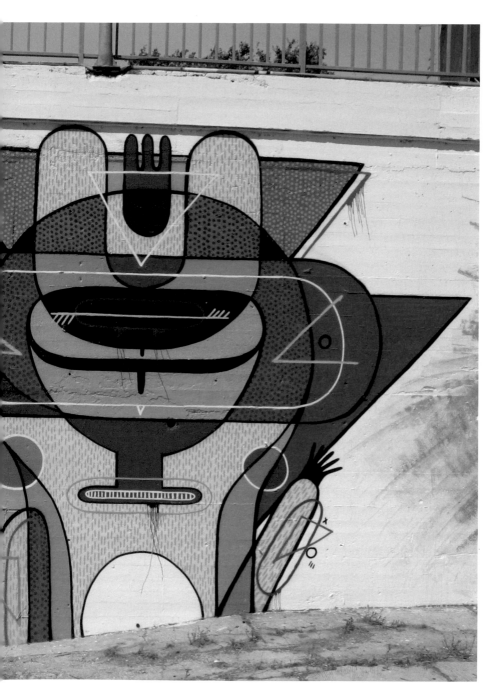

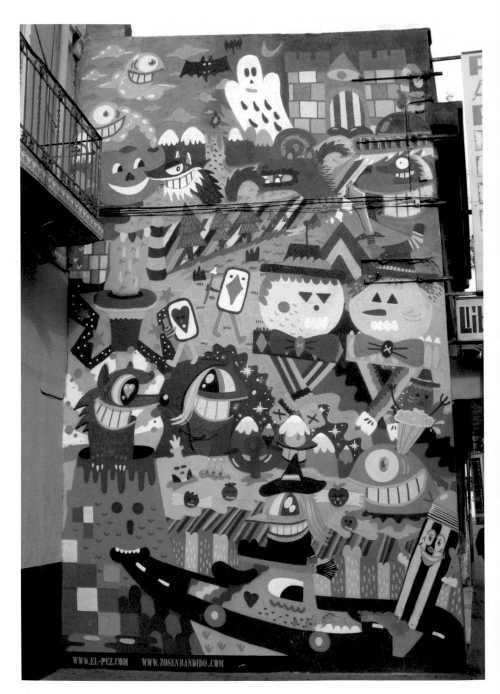

WWW.EL-PEZ.COM WWW.ZOSENBANDIDO.COM

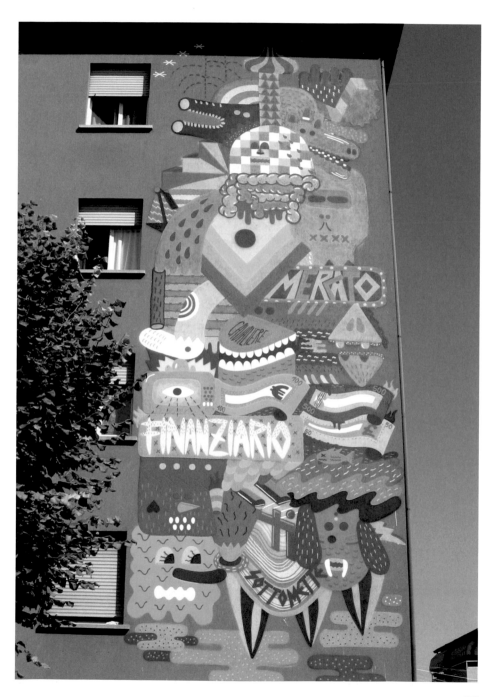

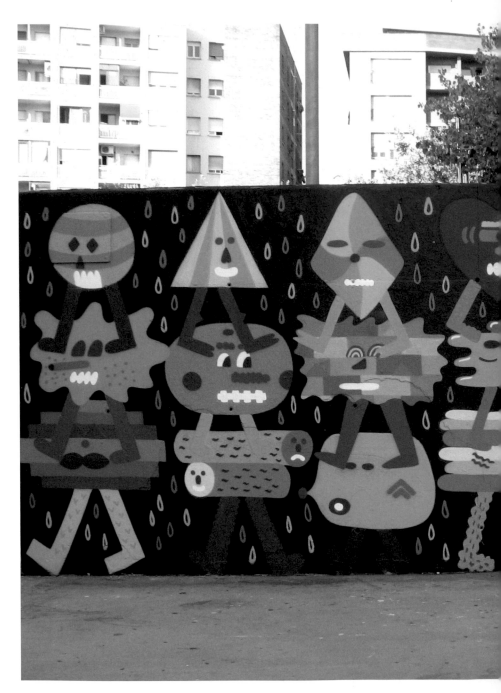

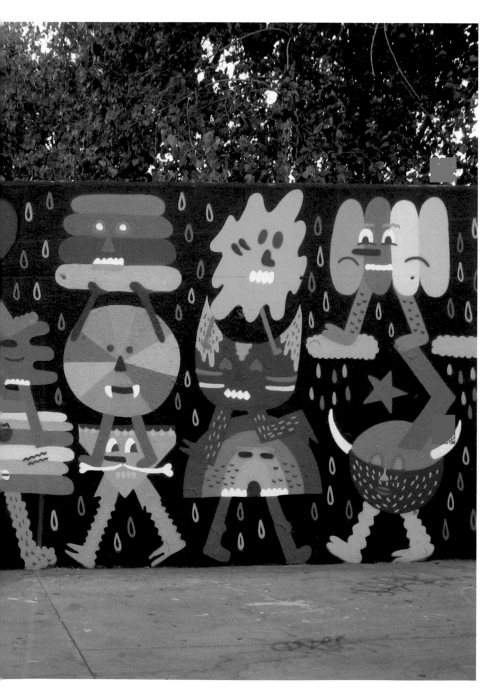

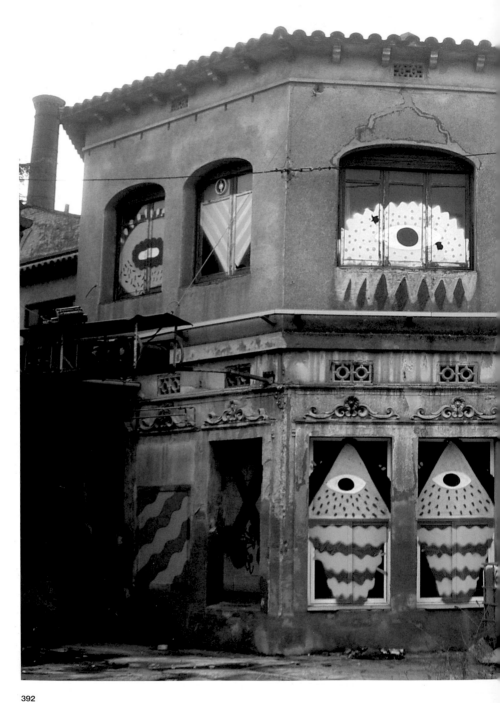

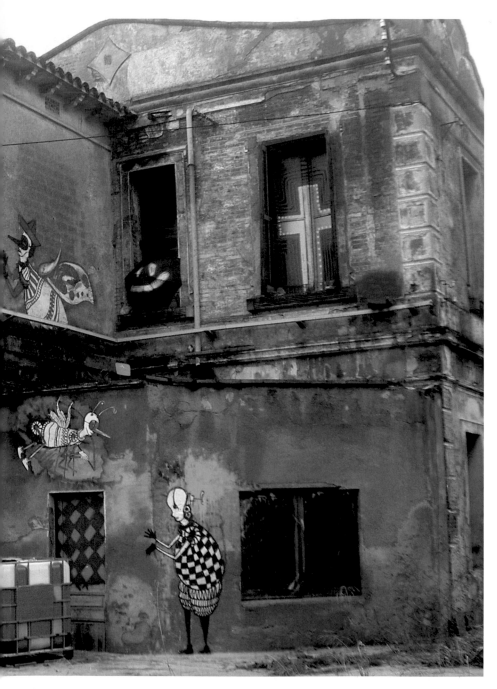

Pez

Bogotá, Colombia
www.el-pez.com

Spanish artist Pez ("fish" in Spanish)
began painting his smiling fish logo in
the streets of Barcelona back in 1999.
Since then, his colourful creations have
travelled worldwide, spreading the
"Barcelona Happy Style". The photographs
on these pages show pieces in New
York and Bogotá, Colombia, where Pez
now lives and works. They include a
collaboration with Brazilian artist Tom 14.

Photographs: Pez

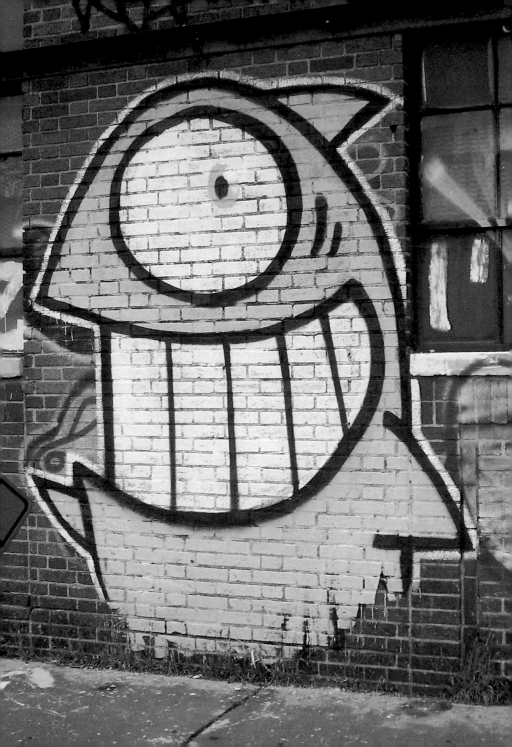

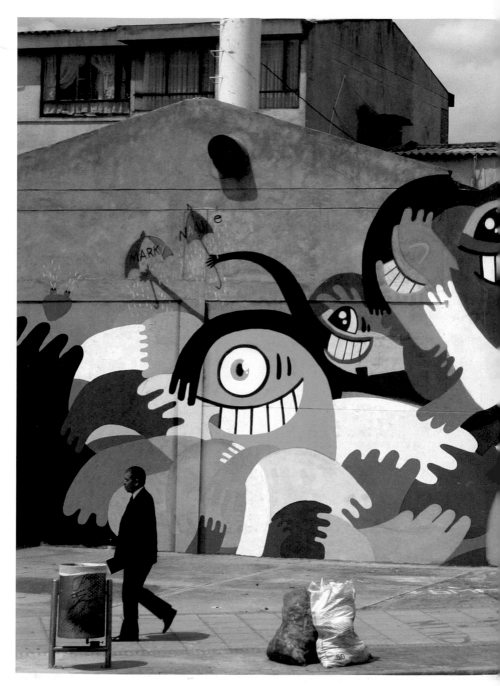

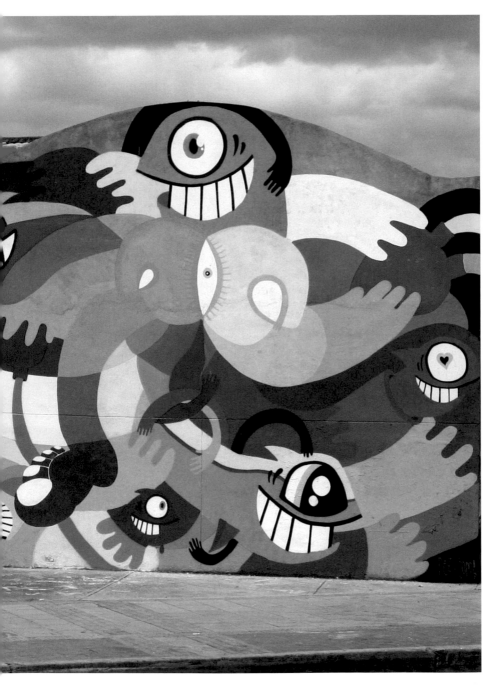

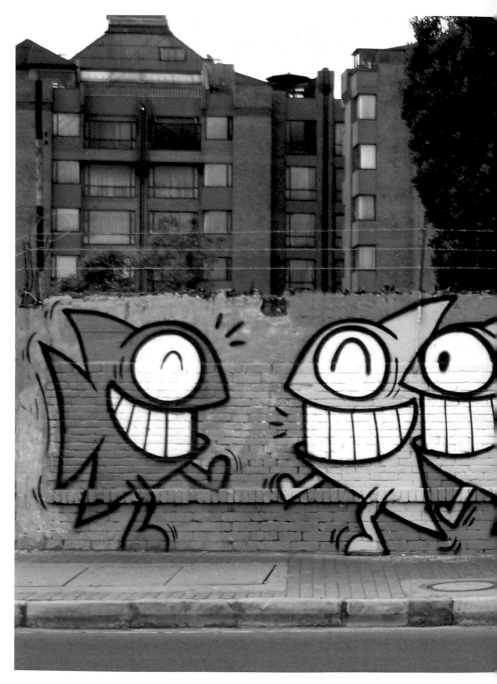

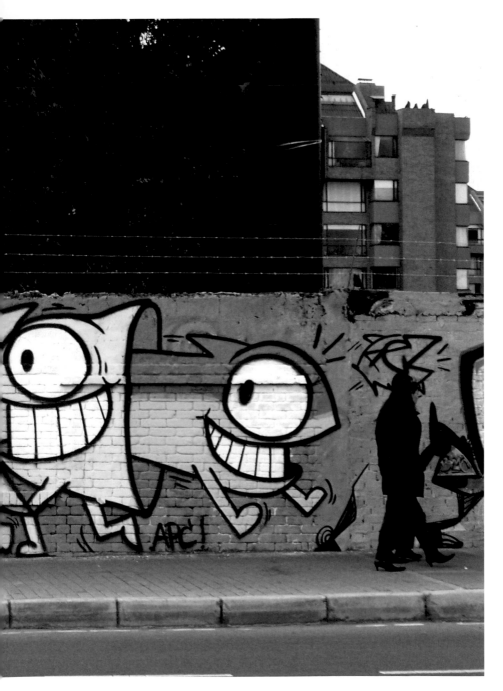

Gola

Rimini, Italy

www.golanimal.com

Gola was born in Cesena in Italy, but now divides his time "between Rimini, Barcelona and the rest of the world". He paints in a shamanic style influenced by psychedelia and his vegetarian beliefs, and explores themes such as genetic modification and animal rights. These photographs show Gola's work in Rimini in Italy and São Paulo and Curitiba in Brazil.

Photographs: Gola

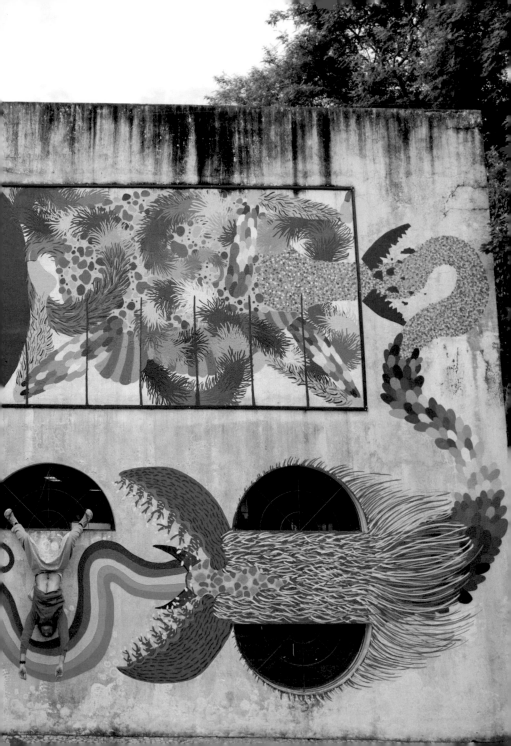

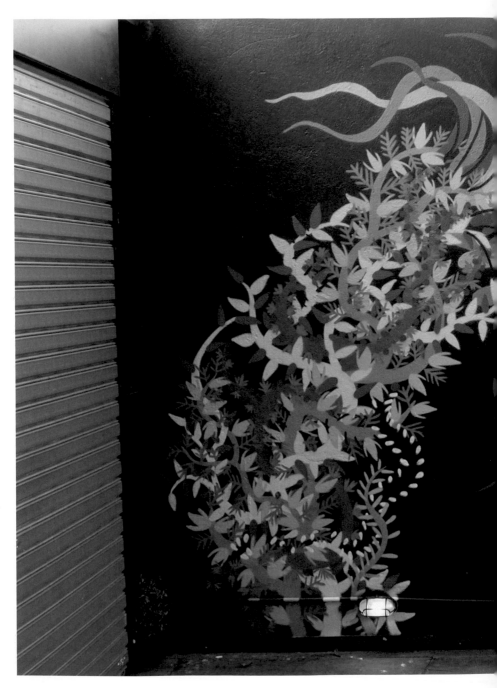

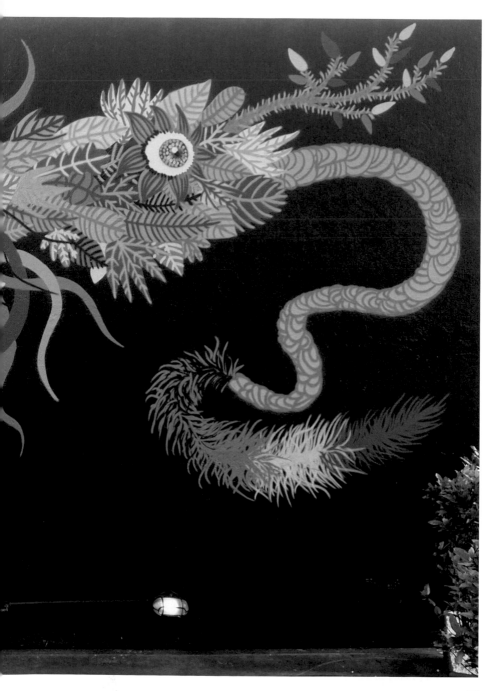

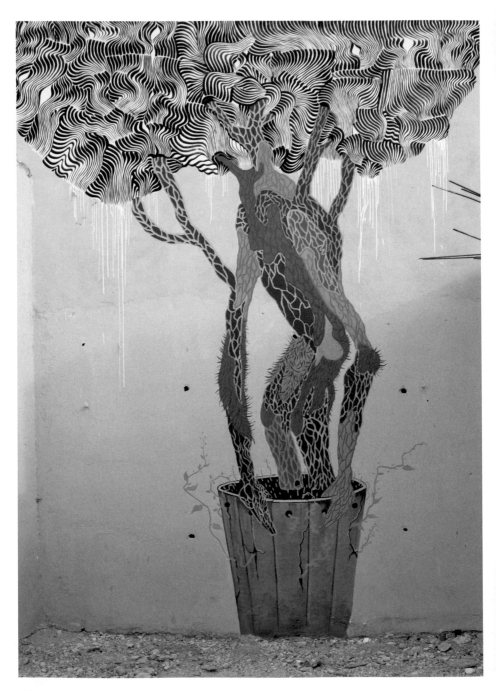

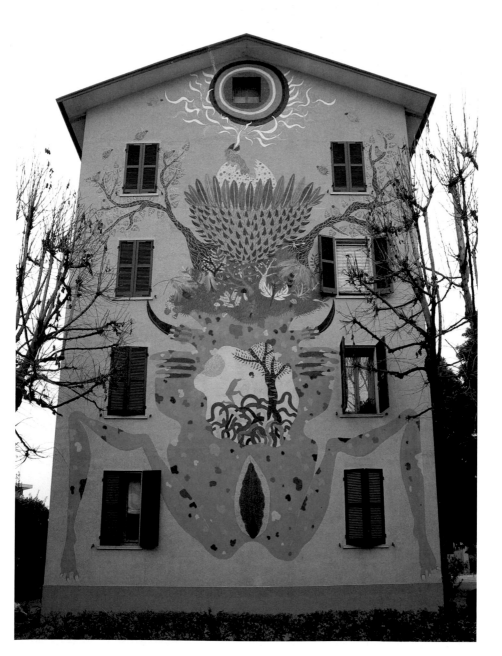

Microbo

Milan, Italy

www.microbo.com

Both Microbo and Bo 130, who often
work together, have been scrawling on
walls since before anyone came up with
the name "street art". Originally from Sicily,
she is now based in Milan where she
has begun to infect the city with stickered
and painted microbes. The viral creations
of Microbo continue to spread, mutating
into ever larger forms.

Photographs: Microbo

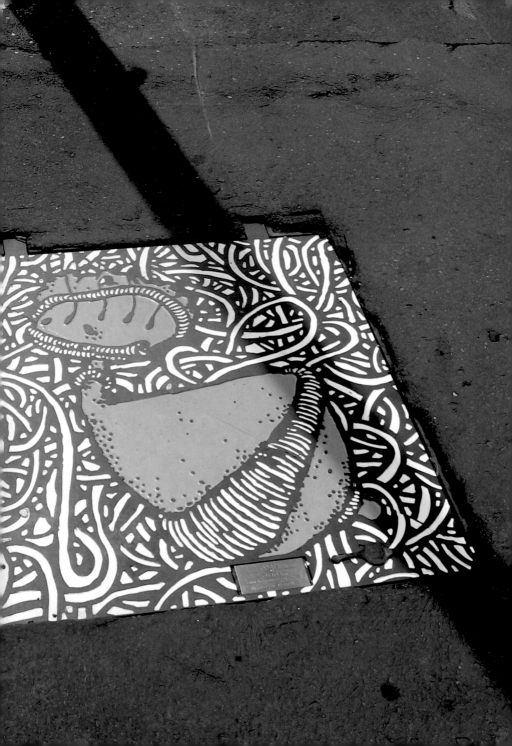

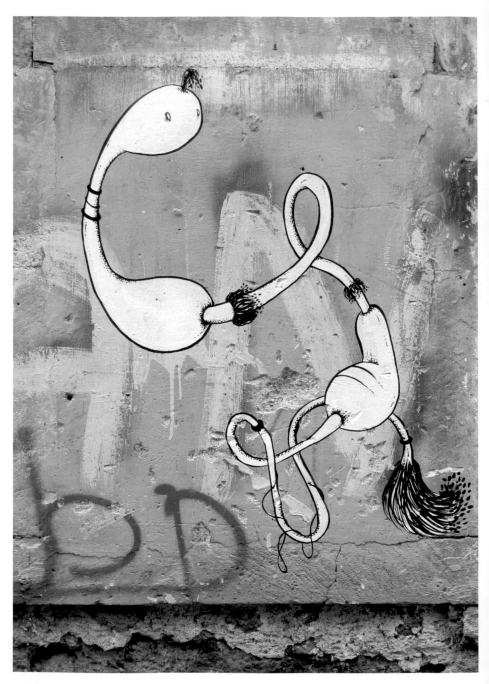

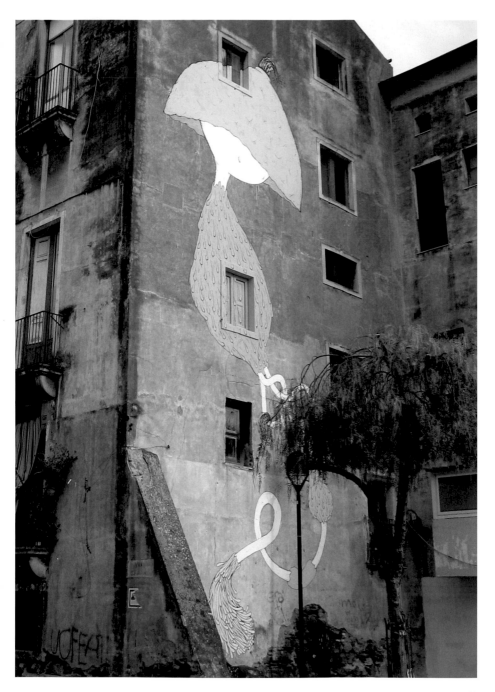

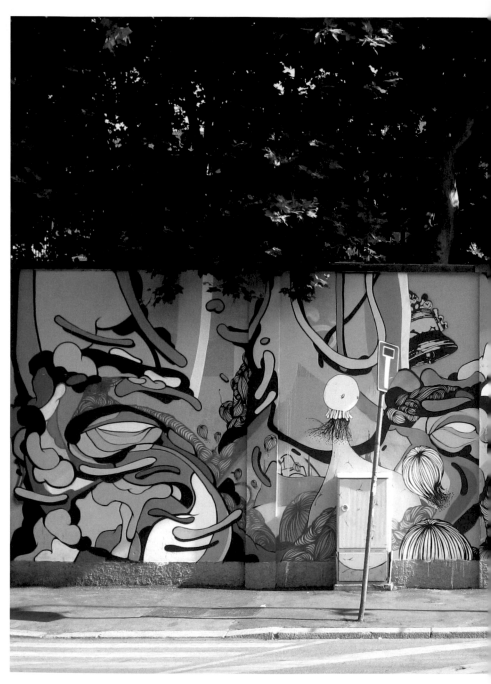

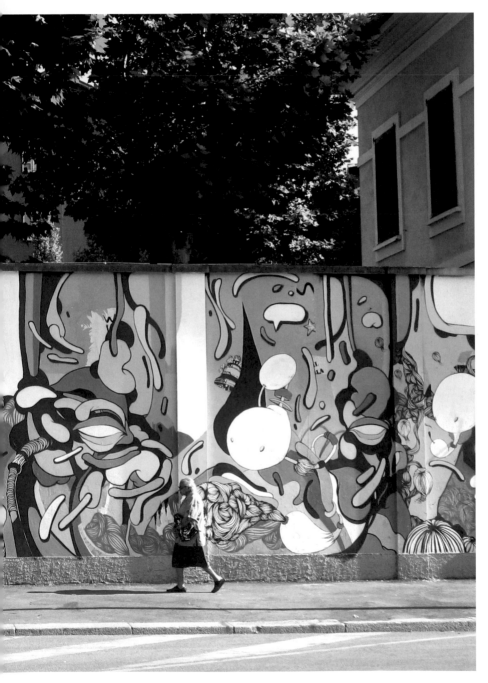

Bo 130

Milan, Italy
www.bo130.org

Alongside partner in crime Microbo,
Italy's Bo 130 combines stickers, stencils,
posters and paint to create his strange
alien forms.

Photographs: Bo 130, Microbo

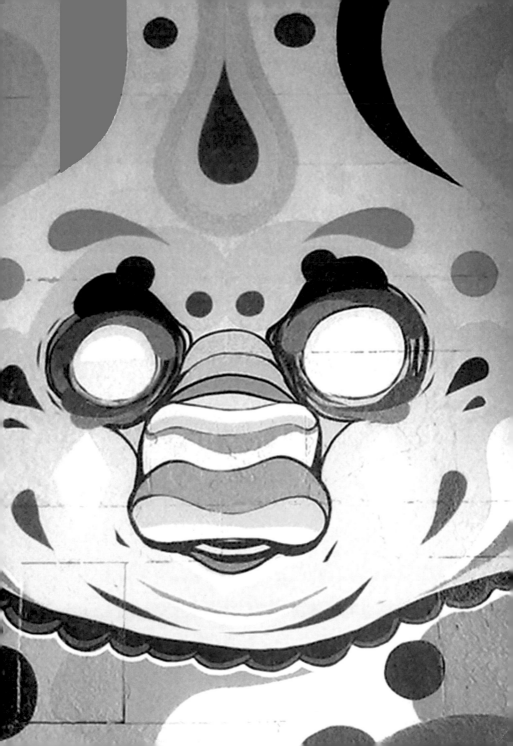

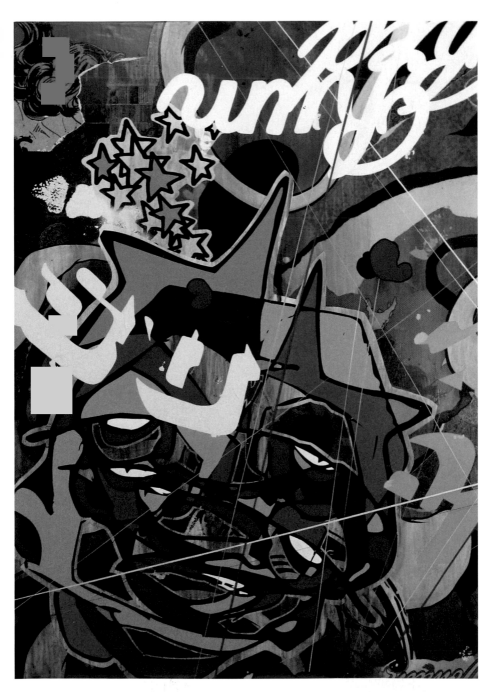

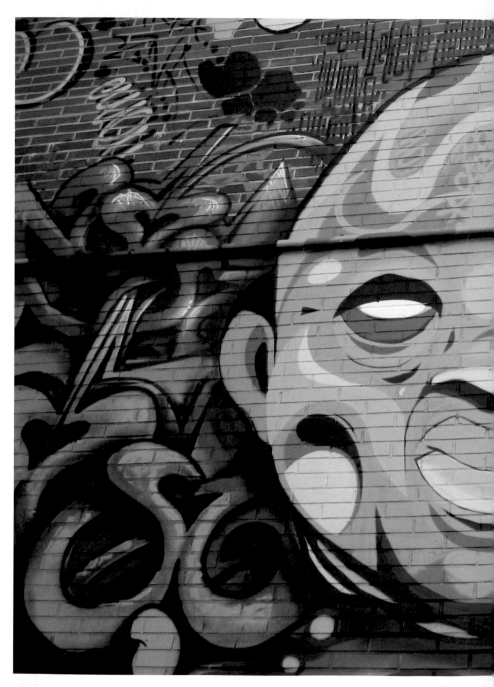

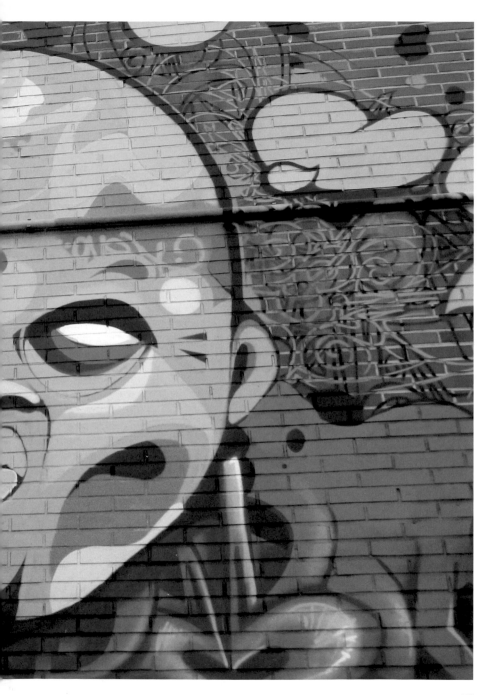

Klone

Tel Aviv, Israel

www.kloneyourself.com

Born in Ukraine, in the former USSR, the artist Klone now lives and works in Tel Aviv, Israel. Drawing influences from Ukrainian folkore and utilising spraypaint, housepaint, wheatpastes and a variety of other media, Klone seems to prefer crumbling, decaying walls as the canvasses for his ghostly images. These pieces were made in Berlin, St Petersburg and Tel Aviv.

Photographs: Klone

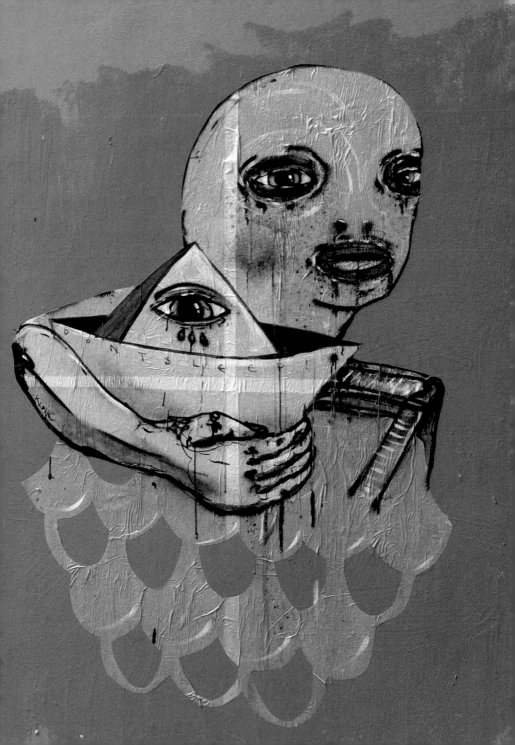

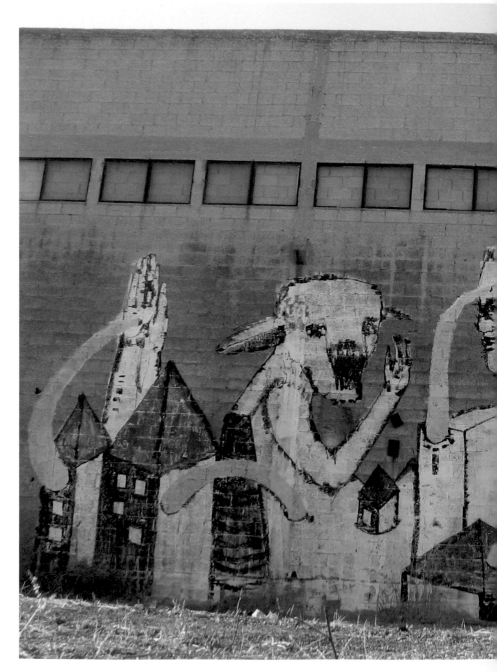

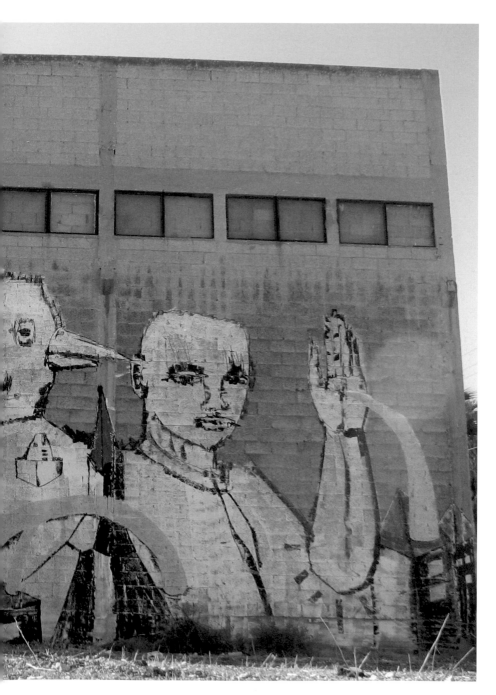

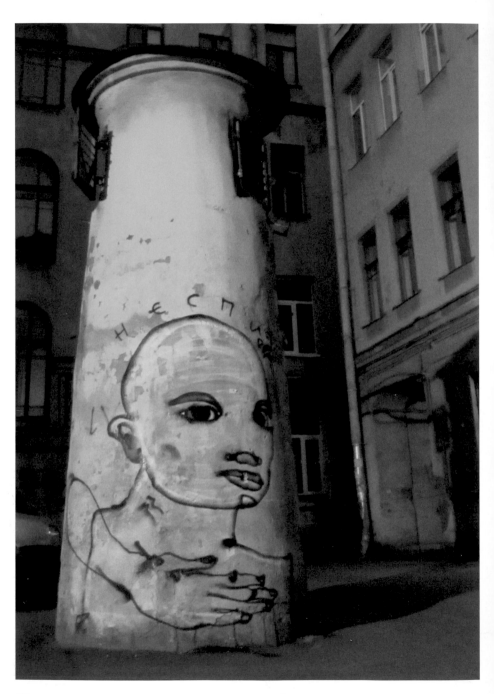

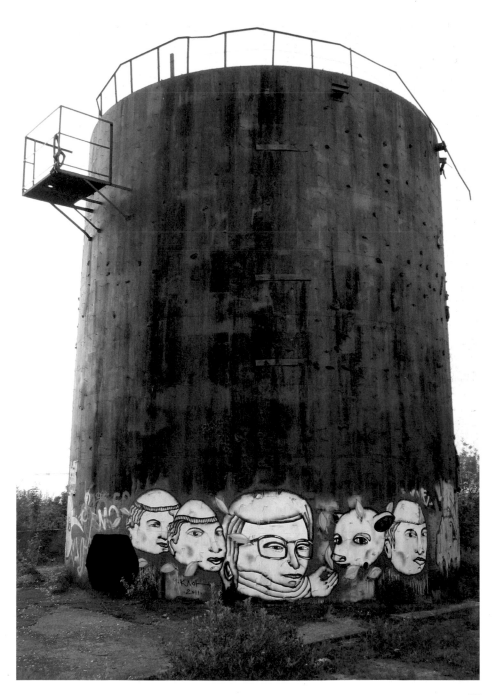

Pavel 183

Moscow, Russia
www.183art.ru

Described lazily by the British press
as "The Russian Banksy", or, as one wag
put it, "Bankski", Moscow street artist
P183's work is often highly site specific.
At first glance, the paintings of riot
policemen may not mean much, but the
powerfully spring-loaded railway station
doors they're painted on are infamous
for battering unwary Moscow travellers.

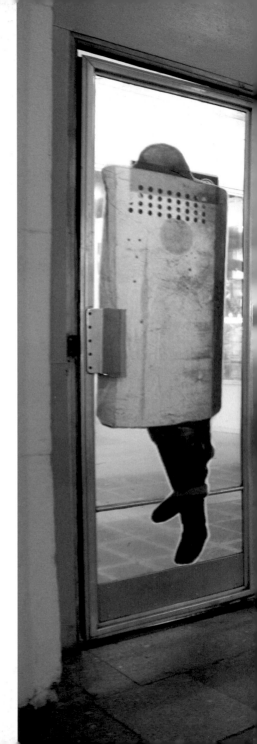

Photographs: P183

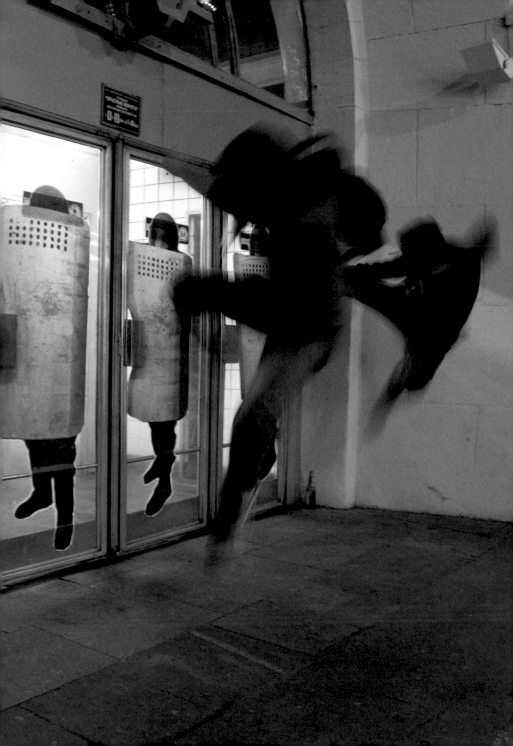

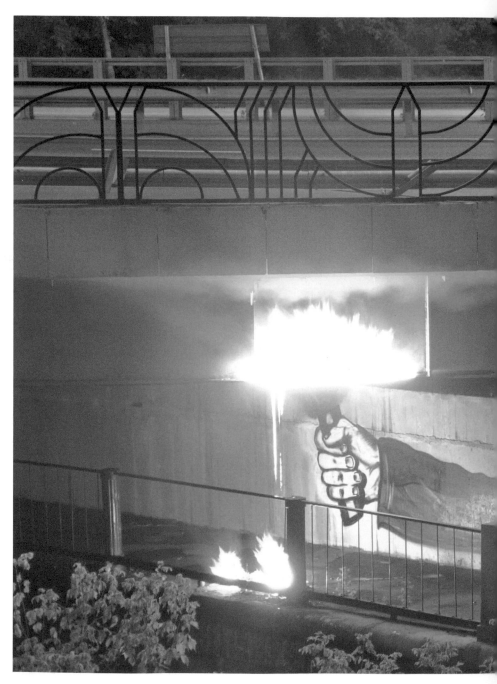

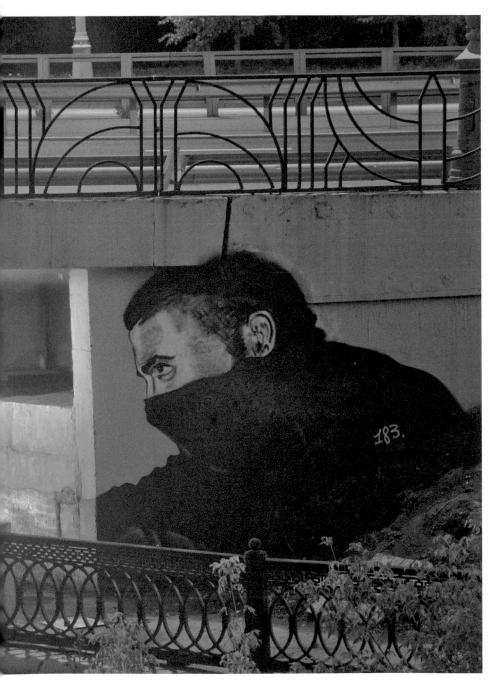

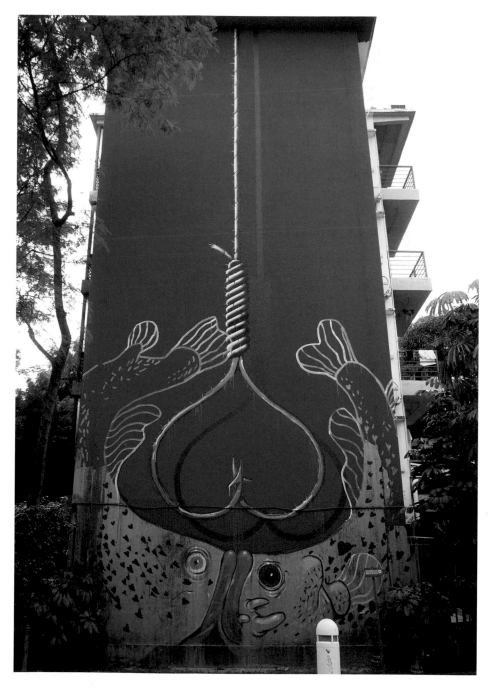

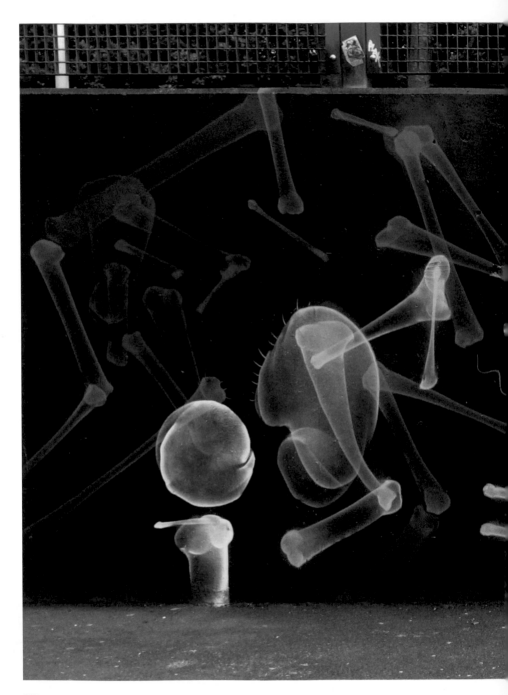

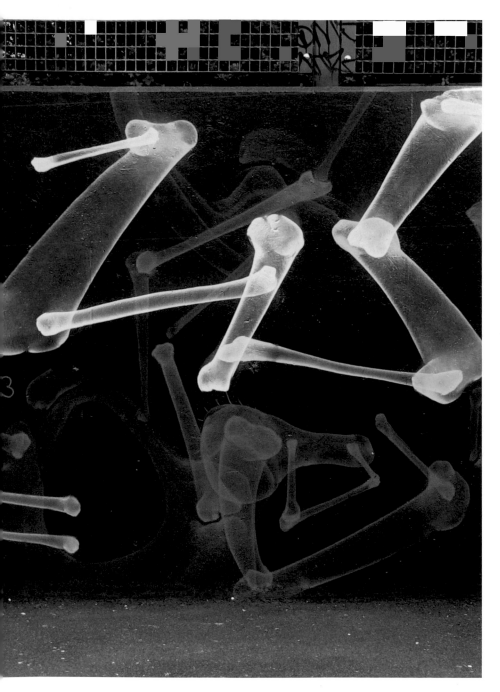

Remi/Rough

London, UK

www.remirough.com

South London's Remi has been in the
game for over a quarter of a century
with his unique abstract expressionist
version of aerosol art. Remi has painted
all over the world, most recently in
Australia, though these photographs
were taken in London. They show
collaborations with Mac1 and SHOK-1.

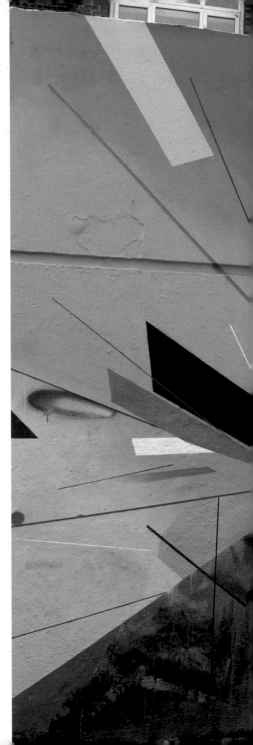

Photographs: Remi, Artofthestate

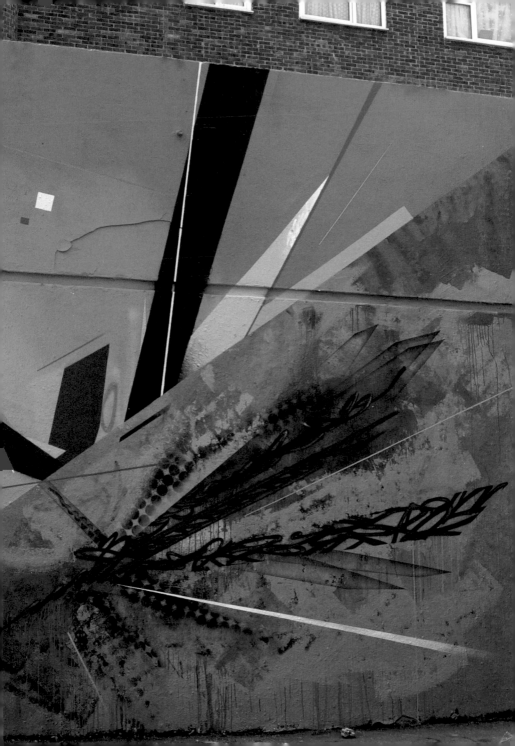

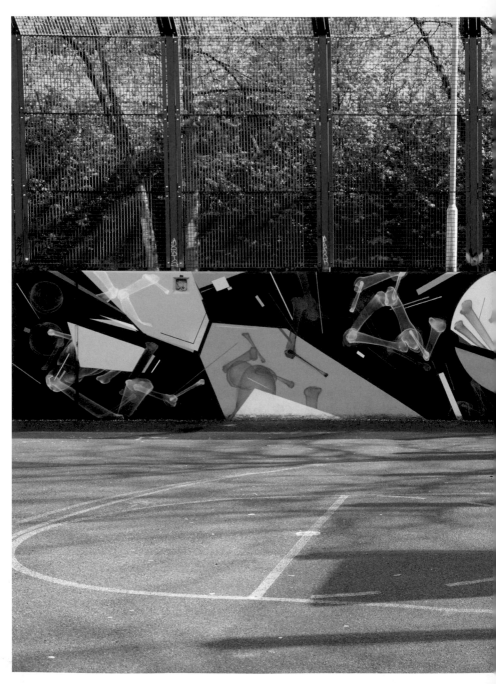

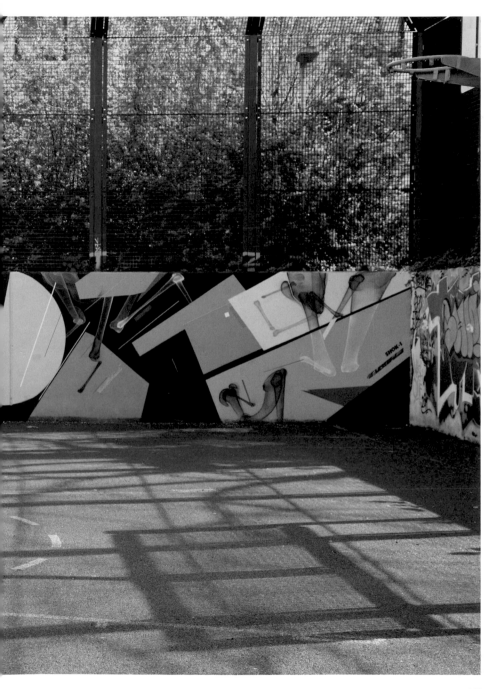

Mark Bode

New York, USA

www.markbode.com

And so we come full circle. Vaughn Bode's Cheech Wizard, the godfather of graffiti characters, still fondly revered by b-boys and nozzleheads worldwide. Mark Bode, veteran graff writer, illustrator, and son of the late Vaughn Bode, continues to keep the legacy of his father's characters alive, not just in spraypaint, but in comics, too.

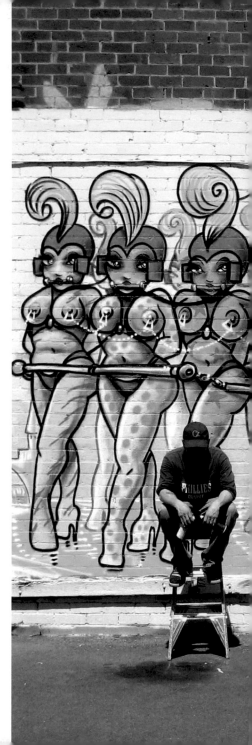

Photograph: Mark Bode

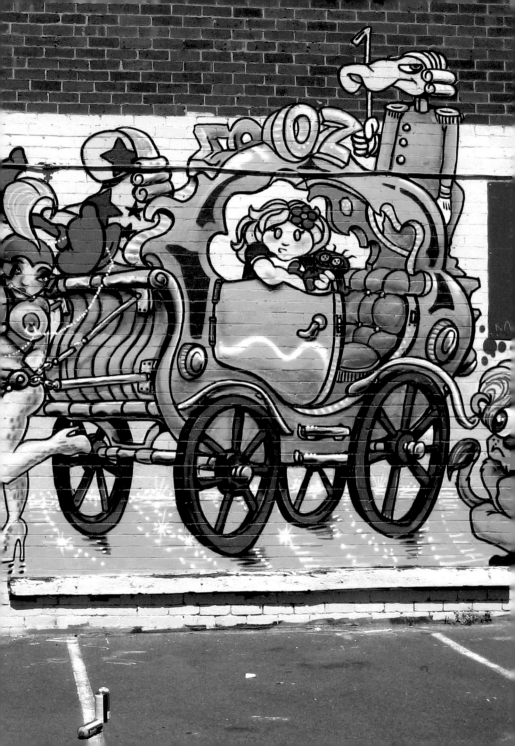

About the Editor

JAKe was born in Hull in the north of England, but now lives and works in London. A graphic artist with a background in graffiti and street art, he has exhibited in London, Los Angeles and Tokyo.

He has worked for a wide variety of clients worldwide including Carhartt, Levi's, Comme des Garçons, The Mighty Boosh, Sony Playstation, XL Recordings, onedotzero, the Sci Fi Channel (Syfy), 2K by Gingham and Gimme 5. His work has featured on music packaging for The Prodigy, Ugly Duckling, Norman Cook, Prince Fatty and Sugarhill Records, and his street art characters have been printed on T-shirts and turned into vinyl toys. JAKe has a longstanding relationship with Lucasfilm and his artwork for the *Star Wars* and *Indiana Jones* properties has been used on products worldwide.

His street art has appeared in books and magazines, including *Graphotism*, *Refill*, *Stick 'Em Up*, *Outside the Lines: The Street Art Doodle Book*, *The Art of Rebellion* and *The Art of Rebellion 2*. His own recent books include the debut graphic novel *Hellraisers* for SelfMadeHero and the bestselling *How To Speak Wookiee* for Chronicle Books.

Very occasionally, he still paints walls.

www.jake-art.com
Twitter: @jakedetonator

Photograph: Nick Sinclair

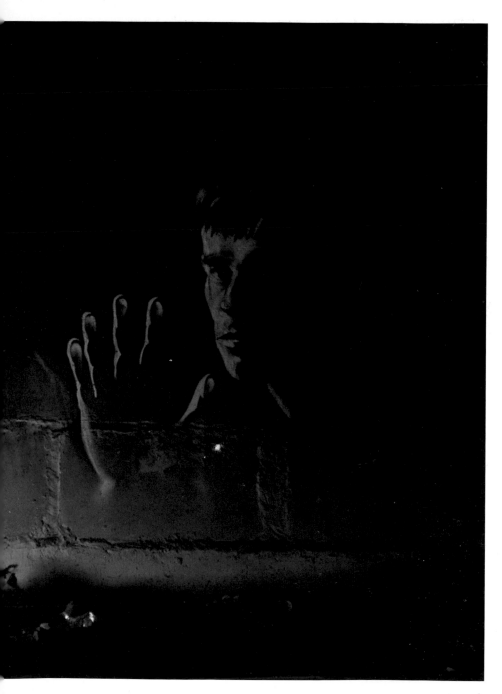

SHOK-1

London, UK
www.shok1.com

SHOK-1 is a British graffiti veteran with roots in b-boy culture who now paints in a variety of modes, including the fresh X-ray spray style shown here. In 2010 SHOK fell foul of Chinese government censorship when a piece he painted for the Shanghai Expo in Shenzen (following page, left) was altered after he had left (following page, right). The picture on the right is the censored version. In SHOK's own words, "I thought that they were going to paint it out. For me, this is far worse. I should add that the painting wasn't intended to be anything about China – it is an icon I have been painting for nearly 10 years with deep personal meanings."

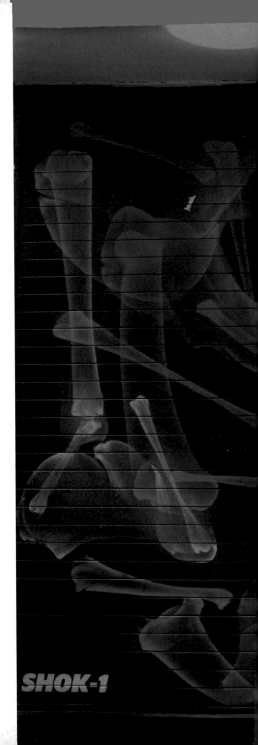

SHOK-1

Photographs: Artofthestate, Alexandros Vasmoulakis, YYY

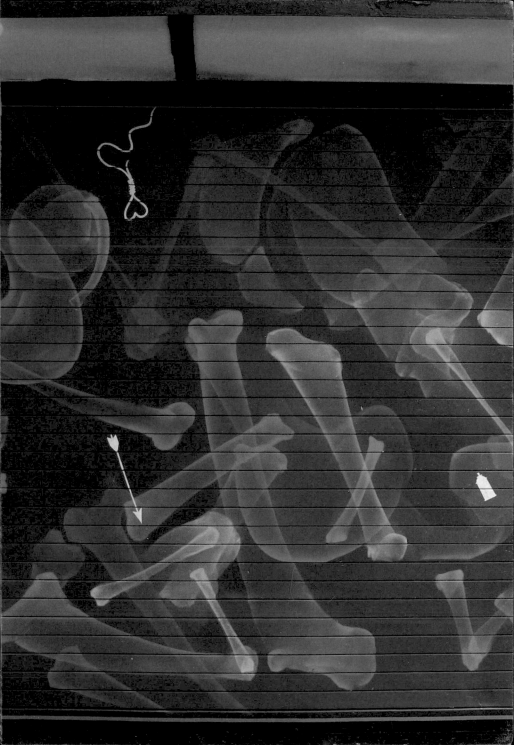

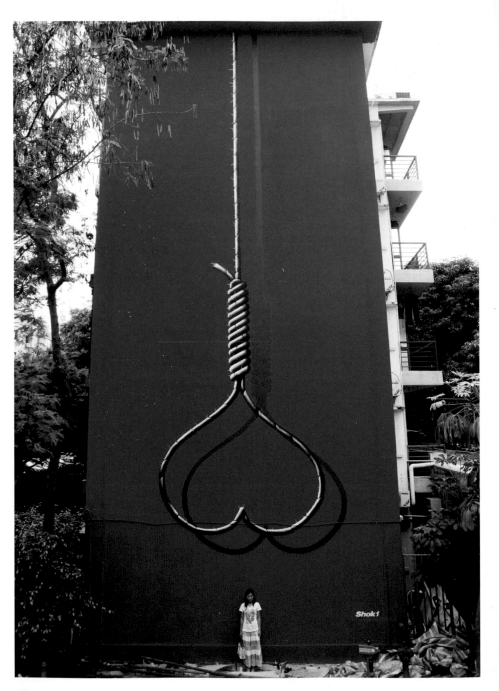

Acknowledgements

I would like to thank all the artists featured in this book, also those who photographed the work, especially contributing London photographer Mark Rigney and contributing US photographer Simon Lambert.

A mammoth thank-you to Ed 'Ilya' Hillyer (that's two books I owe yer). Mad props to the Superadaptoid Woodrow Phoenix for keeping Paris on lock. (Crazy visions, son, check it out, like ... Boom. Any. Colour. You. Want.) Thank you, too, to Sam Blunden, Duncan Proudfoot, Nick Sinclair, Claudie Crommelin, Dave the Chimp, Kid Acne, Dreph, Pez, Mark Bode, Pinky, High Roller Society, Austin Von New, Zen Rock, Dom Murphy, D*Face, Lamp Genie and Tatiana Alisova.

giant

3 1901 05380 1736

FUCKING